HERMAN J. WECHSLER

Great Prints & Printmakers

LA Leon Amiel · Publisher, New York

Reproduction rights reserved by S.P.A.D.E.M. where relevant
Library of Congress Catalog Card Number: 77-73921
ISBN 0-8148-0682-1
Printed and bound in the United States of America

CONTENTS

LIST OF PLATES

FOREWORD

Benvenuto Cellini tells us in his autobiography that on one occasion when he had ingratiated himself with the Pope, he dared to request absolution, not only for the crimes he had already committed, but for those he was yet to commit.

I, too, at this point wish to list in advance the lapses, the lacunae, the slights to great artists. This done, I will plead in defense of my purpose that this book serves as an introduction to the art of printmaking and to the artists whose work has elevated it to greatness.

It is hoped that in the following pages some recurrent questions relative to the nature, the merit, and the making of a fine print will be answered. This will not be a history of the graphic arts, nor a handbook for the advanced student or the printmaker. Many splendid and scholarly works are available for the collector and the professional, and reference will be made to these to aid those readers who would pursue further the study and appreciation of an art form which has enchanted the thoughtful observer and connoisseur for many centuries. Here, an attempt will be made to tell something of how fine prints—woodcuts, engravings, etchings, aquatints, and lithographs—are made, in what ways they are *original* works of art, and why they have been prized and collected through the years.

I hope I may be forgiven if I have taken some of the material, especially technical notes on graphic techniques, from my own earlier *Prints and Printmaking*, a paperback volume which was published in 1960 by the FAR Gallery.

It is also the purpose of the book to present a number of outstanding master printmakers and to describe the many different mediums through which they made their creative statements. The artists here considered have lived during six centuries, and within different historical, artistic, and political climates. As personalities they exhibit startling contrasts, and their works also vary greatly, according to their temperament and training, the atmosphere of the time, and the purpose for which the woodcut, engraving, or lithograph was intended.

Lessing J. Rosenwald, a businessman and an art collector of exceptional knowledge and judgment, in 1943 presented his superb collection of prints and drawings, one of the finest in the world, to the National Gallery of Art in Washington, D.C. At present this collection is housed in the Alverthorpe Gallery, a small museum which Mr. Rosenwald built for it in Jenkintown, Pennsylvania. Prints and drawings are brought to Washington for exhibition or study.

In 1943, Lessing Rosenwald wrote the foreword to the catalogue of an exhibition of prints and drawings titled *Selections from the Rosenwald Collection*. All that I would like to say about the selection of prints, he has already said in a most thoughtful and poetic manner:

These prints and drawings are not intended to be a cross-section of graphic art from the earliest times to the present day. They are too few and are not properly distributed to give such a presentation. Nevertheless, there are specimens from the earliest attempts, down to some of the best work of our time. The major techniques are all represented—woodcuts, engravings, etchings, mezzotints and lithographs. . . . An attempt has been made to include prints that are interesting in themselves or those where the visual enjoyment of them will be enhanced by relating stories associated with them. Many phases of print collecting contribute to the formation of a well-rounded cabinet. Naturally, first and foremost is the attraction of the print itself. It may be in the pictorial value alone. Then again, it may evoke a spiritual or emotional reaction, and sometimes, it may awaken an association which will endear it to the observer. Often it is the technique which fascinates; sometimes the perfection or, its opposite, the crudity of the early craftsmen, that enthralls. It is as impossible to predict why a print in itself appeals to the individual as it is unnecessary to discover the reason.

I have chosen not to burden the text or the illustrations with indications of the condition of the print. The quality of an impression cannot always be discerned in

reproductions, but the quality of all the originals from the Rosenwald Collection, and the major portion of this book consists of these, is uniformly high.

I have attempted to select examples which were not oversized in the original. I hoped thus to avoid, insofar as possible, the discrepancy which inevitably occurs when a very large print, many times the page size of this book, is reduced.

We reproduce a few works in black-and-white which, in the original, have color. Some are early examples which were, in fact, printed in black-and-white and later hand-colored. They suffer very slightly in reproduction, since the pigments were almost always employed in transparent washes and show up in reproduction only as faint tones.

All of the black-and-white works illustrated, with the exception of those in the introductory section, are from prints belonging to the National Gallery, or from early illustrated books—the source of some of the rarest engravings and woodcuts—belonging to the Library of Congress. These are all part of the Rosenwald Collection. However, several of the reproductions dealing with techniques, in the opening pages of this book, were taken from the files of the FAR Gallery, in New York. The colorplates are from various sources.

I find it most difficult to write an acknowledgment. Though I am afforded an opportunity to thank the many individuals who so graciously aided me in this work, I fear that some will be forgotten, or that my appreciation of their help will not be adequately expressed.

It is particularly difficult to express my gratitude to Lessing Rosenwald, who, in every sense of that much-used phrase, made this work possible. At the Alver-thorpe Gallery I was given the opportunity to study and enjoy the magnificent prints and illustrated books which Mr. Rosenwald has so generously contributed to the National Gallery of Art and the Library of Congress. On a number of occasions I was further privileged to examine the books and prints in the presence of Mr. Rosenwald himself and to profit by his observations—an amalgam of love and learning. I wish to thank the staff of the Alverthorpe Gallery and especially Dr. Richard Field, who aided me immeasurably with this work.

I am also grateful to the National Gallery of Art and the Library of Congress for granting me permission to reproduce the original works shown in the following pages.

I would like to pay respects to the late Paul J. Sachs, teacher and friend, in whose classroom at the Fogg Museum in Cambridge, Massachusetts, I was first exposed to an appreciation of prints and printmaking.

A special acknowledgment is due my colleagues at the FAR Gallery for their rare combination of tolerance and help. Gratitude is expressed to Murray Roth, Charles W. Yeiser, Ruth O'Hara, and Kiye Roth.

I also want to thank my wife for her patience and understanding during the preparation of this volume.

Lastly, I would like to express my appreciation to all those scholars—past and present—whose "brains I picked." This expression I heard from my first employer, a remarkable lady, who advised, "When you meet people much smarter than you are, never feel ashamed to pick their brains." This I have unabashedly done. By listing their names in the bibliography at the end of this book, I hope somewhat to minimize this literary larceny.

Herman J. Wechsler

NOTE ON THE PICTURE CAPTIONS

Unless otherwise indicated, height precedes width in the dimensions given for the works reproduced

in these pages; and, unless otherwise specified, all measurements refer to image size

(i.e. the actual size of the "picture," as distinguished from the size of the plate or of the paper

on which it is printed). Many prints shown are actual size; none is larger than the original.

Great Prints & Printmakers

GRAPHIC ART—A DEFINITION

The term "graphic art" will be defined in this initial statement as it is employed in this text. Critics and art historians have generally begun their commentaries on the history of graphic art with a discussion of the nature and the technique of drawing. Paul J. Sachs in his splendid work, *Modern Prints and Drawings*, gives equal consideration to *printed* impressions taken from wood and metal, and the unique drawing or sketch produced in silverpoint, graphite, crayon, or brushed washes; for he, along with some historians, considers the print to be a variety of drawing. Here, however, the choice is limited, with an occasional exception, to impressions and images on paper where some printing method, however primitive, was employed to produce more than a single example of the artist's work.

It is important to emphasize the fact that most artists engaged in making a print have *intended* that their work was not to be unique—that is, a single example— but rather a *multiple* statement. Any trained and experienced technician (and all the artists represented here were experts in their craft) realized that the transferring of a drawing to a wood block, metal plate, or stone would materially alter the quality and character of the work. Moreover, they were experienced artists who elected to use the graphic technique, knowing in advance that it offered opportunities for specific, calculated effects not readily obtainable with graphite, ink, or wash. It may be necessary to qualify this statement when we consider certain lithographs made in the late nineteenth and twentieth centuries, by which time technical developments made it possible to approximate

the autographic quality of a drawing with alarming verisimilitude. But even then, it may be contended that certain qualities, for example richness of surface, were obtainable only through the use of printing inks and the pressure exerted by the press, or by other implements. It will certainly become apparent to any student of the

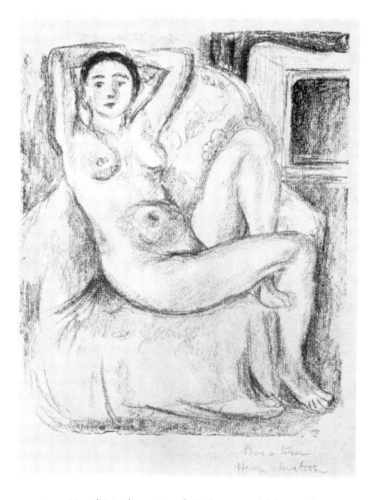

1. Henri Matisse. *Seated Nude.* 1925. Lithograph printed in sanguine (*bon à tirer*), $12\frac{1}{4} \times 9\frac{3}{8}''$

[9]

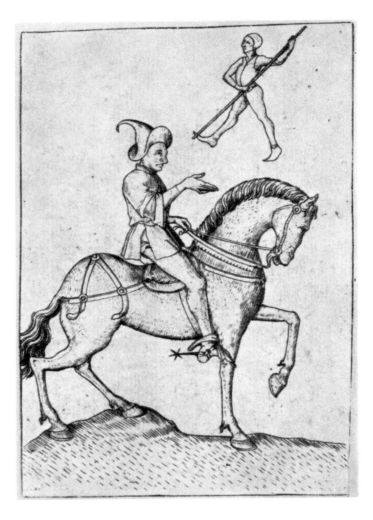

2. Master E. S. *Knight Playing Card.* c. 1450.
Engraving, 5⅛ × 3½″

would be imposed by the printing process. (However, in eighteenth-century France a print produced as a book illustration was judged satisfactory only when it was an exact copy of the original drawing.) But if there were limitations, there were also rewards. Special qualities, both rich and surprising, were often the "gift" of the press—the happy accident, which in the course of history has led to stunning discoveries and inventions.

This writer has had the privilege, on several occasions, of standing beside an artist when a proof of one of his drypoints was lifted from the press. It is difficult to describe our anxiety as we scrutinized the first, still damp impression. At times the result was all that had been desired, all that had been hoped for. At times it was even more. But there were disappointments too, as when after two proofs were pulled, the artist decided that changes were required. The copper plate was removed from the press and taken back to his studio, where he used diamond point, graver, burnisher, and scraper to rectify errors and to prepare for another state and a better print. It is this kind of adventure that makes printmaking so exciting an experience for the artist. To the student and collector this collaboration between man and a simple machine seems a form of magic, mak-

history of printmaking that the artist never intended that his drawings be simply *reproduced* by graphic technique. Most of the masters used their drawings and sketches as points of departure, as a kind of springboard in the planning and development of engravings or etchings, as well as of paintings and sculpture. Goya made thousands of sketches which served as inspirations for his series of aquatints; there are also drawings by Rembrandt which were models for his prints. When such a drawing and the resulting print are examined side by side, the changes made in translating the one into the other, as well as the basic differences, become apparent. Some artists, Hogarth being a prime example, often made complete paintings first, and, using these as their models, translated them into engravings or etchings. What should be noted particularly is that they did not copy their sketches or paintings, but *interpreted* them with full foreknowledge of the modifications that

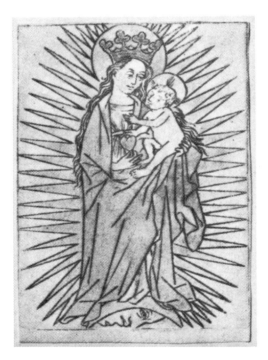

3. Anonymous German Artist.
Virgin and Child with Pear. c. 1440–45.
Engraving in the manner of a woodcut
(slight hand coloring), 3½ × 2½″

ing prints one of the most challenging of all art forms.

The study of the fine print, when approached with an open and inquiring mind, may well become a seductive invitation to learning, for the print is always a product of, and a reflection on, the age and the environment which saw its birth. The contemplation of this rich material, the yield of six centuries, lures the student and collector to look beyond the piece of printed paper, and through his own imaginings, to discover the life, past and present, which prints so poetically reflect.

THE FINE PRINT AS AN ORIGINAL WORK OF ART

The term *fine print,* as employed here, requires some explanation, for in English we have no adequate equivalent for the French word *estampe* (a generic term including all the superb examples of graphic art which are the subject matter of this book).

Unfortunately, there seems to be a pejorative meaning associated with the word *print,* suggesting to many modern readers a commercial product for which elaborate machinery is employed and where the output is vast. In addition, the word is also associated with newspapers, journals, and commerce in general; it is understandable that it does not immediately suggest a *work of art.* Yet this term, as employed here and in the many reference works recommended to the reader, refers to works in which the artist has striven to express himself as he would with paint and brush, with chisel and mallet, or any other tools of the craft. Wooden blocks, copper plates, special kinds of stone, and other materials are only part of the equipment required to achieve the artist's ends. The term *print,* then, in its present context, is a noble term. It is hoped that this will become more apparent as the reader peruses these pages and contemplates the illustrations.

The utmost confusion seems to result when the term *original* is applied to a print which has been produced by one of the various methods to be described later. Perhaps the following remarks and observations will help dissipate a common misconception.

It has been previously stated that the prints under discussion are not unique—that is, not one of a kind. Indeed, varying quantities of prints are "pulled" from the plates, wood blocks, or stones on which they are drawn. Each impression, however, is an *original* work of

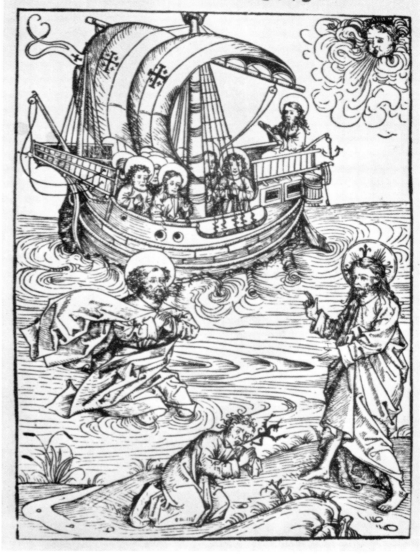

Die neununddreyssigist figur

4. Michael Wolgemut (?). *Christ's Miracles on the Sea of Galilee,* illustration for Stefan Fridolin's SCHATZBEHALTER. 1491. Woodcut, 9⅞×6⅞"

art—or *multiple-original,* to employ a more precise term. It is original because the artist's intent from the very outset was to create an etching, woodcut, or lithograph, and when he planned the making of his print, he had foreknowledge of what was to be transferred from block, plate, or stone to paper. An experienced craftsman is prepared for the surprises, both pleasant and unpleasant, which not infrequently await him. He knows that the choice of paper, the method of inking the plate, the pressure exerted on the press, the very temperature and humidity of the day, will combine to please or confound him. The fastidious artist makes many changes and

5. Lienhart Holle. Illustration for THE FABLES OF BIDPAI
(folio XXXIX). 1483. Woodcut, $3\frac{1}{2} \times 4\frac{3}{4}$"

Appearing at about the same time as these Bibles, a number of printed works known as *block books* were issued in the Netherlands, Germany, and elsewhere. In these publications the pictures and the text which accompanied them were both carved on the planks from which the pages were subsequently printed. It was necessary for the text to be carved in reverse so that the words and sentences could be read normally after the impressions were made. Although it would seem logical that this primitive method should have preceded the faster method of printing with movable type, this was not the case. Many block books actually carry later dates than books printed with movable type, and both methods were often employed simultaneously by one publisher. Arguments in favor of the block book were the facts that although it was a more laborious method,

corrections, either himself or with the aid of his printer, until he arrives at the point where he is moved to mark on the proof *bon à tirer*, ready to print (*fig. 1*). All the materials he has used are simply tools to achieve this end, in the same sense that canvas, brushes, and paint contribute to the making of a painting. The result is a direct, autographic statement of the artist's intent— an *original* work of art.

EARLY PRINTS

The earliest prints which were produced in quantity and sold at low prices were playing cards, used for the purpose of amusing and entertaining (*fig. 2*), and small prints, devotional in nature, bearing images of Christ, the Virgin, or any number of saints, and created for spiritual uplift (*fig. 3*). Generally, these popular cards were first printed in black-and-white; for the deluxe editions they were hand-colored, probably with the aid of stencils (*plate 6*).

When the art of printing with movable type was developed, publishers discovered that they could enliven a book by incorporating wood-block illustrations into the text. At times the blocks were sent from one city to another to be reused by other publishers. The same picture may appear in two different Bibles, one printed in Cologne and the other in Nuremberg. Today it is still possible to find, at modest prices, pages from these two Bibles, as well as excerpts from other books (*figs. 4 and 5*) printed before 1500.

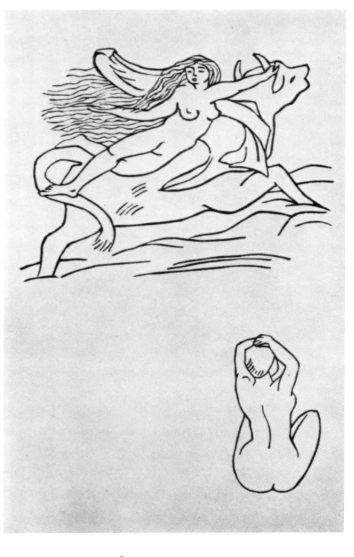

6. Aristide Maillol. *Europa and the Bull*, illustration
for ODES OF HORACE. 1939. Woodcut, $8\frac{1}{4} \times 5\frac{1}{4}$"

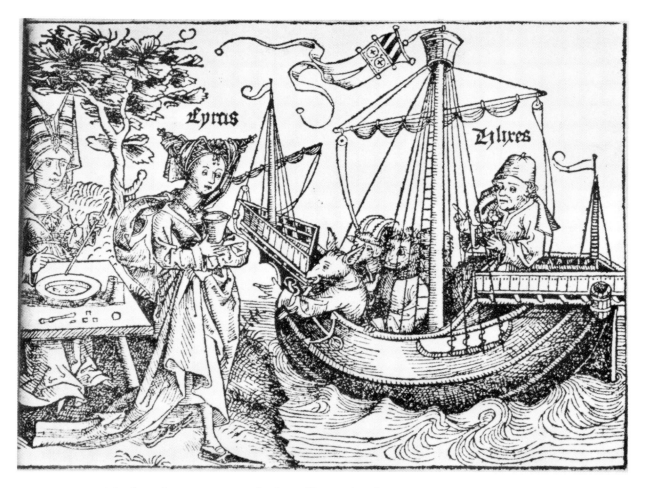

7. Michael Wolgemut. *Circe and Ulysses*, illustration for THE NUREMBERG CHRONICLE.
1493. Woodcut, 4¾×6⅛"

the printer ran no danger of exhausting certain letters of his type face, and that the blocks, once completed, were readily available for subsequent editions. Among the more famous of these block books were *Ars Moriendi* (*plate 1*) and *Biblia Pauperum* (*plate 2*). Scholars refer to all this material as incunabula, to indicate that it represents the infancy, the cradle period, of the art of printing.

Simultaneously with the appearance of playing and religious cards, and books, individual *full sheet* pictures were published for the instruction or entertainment of the purchaser. At first these were primarily religious in character, but they were soon supplemented by editions of decorative, historic, or satiric prints. From the fifteenth century to the present, the art of the fine print has always been closely related to that of the illustrated book. Some of the most cherished examples of fine printmaking are pages from such disparate works as Holbein's *Dance of Death* (*plate 28*), Bewick's *History of British Birds* (*fig. 9*), Goya's *Caprices* (*plate 46*), *Proverbs*

(*fig. 20; plate 49*), and *Disasters of War*, Audubon's *Birds of America*, and the volumes illustrated by Rouault (*fig. 21; plate 74*), Chagall, and Picasso (*fig. 22*). At the present time, although such rare collector's items are still issued, the trend is toward the individual print.

The early prints illustrated here are conceded to have been produced north of the Alps, in Germany and in the Netherlands. The first printmakers were often trained goldsmiths, and thereby active in a craft which required and refined the art of engraving designs on metal. Another craft which produced printmakers was that of the armorer, who practiced the incision of lines into hard metal. Probably the first engraving came from such a shop, and the first impressions were perhaps the result of accidental discovery, when it was found that an incised line filled with ink or color could be printed on paper or fabric.

Italy had talented engravers, goldsmiths, and armorers, and, according to the Renaissance historian Giorgio Vasari, the craft of printing on paper from an

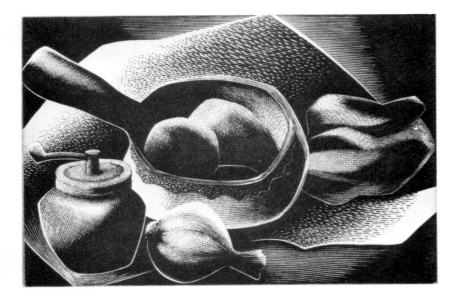

8. Paul Landacre. *Still Life, Some Ingredients.* 1953.
Wood engraving, 5⅛ × 7½"

engraved plate originated in the shop of one Maso Finiguerra, the fifteenth-century Florentine goldsmith. But history proves Vasari to be wrong, for, as we shall see, earlier examples are now known.

THE SUBJECT MATTER OF EARLY AND LATER PRINTS

The primary purpose of the first prints (except for playing cards) was to uplift and to instruct, to evoke religious sentiments, or to relate stories from the Old Testament, the Gospels, and the lives of the saints. With the Renaissance and the spread of Humanism, pagan legends and myths came to be graphically retold, bringing new richness to the subject matter of the printmakers (*plates 12, 22*). Albrecht Dürer, although the author of many religious works, sometimes used his prints to spread news of startling events or discoveries—a whale marooned on a beach or the appearance of some malformed freak of nature—occurrences or wonders that he had traveled many miles to observe. He also made portraits of celebrities, for example of Erasmus, and some illustrations for books, such as those for *The Ship of Fools.*

From the beginning, many artists had been interested in mankind and his activities, as well as in sacred characters from the Old and New Testaments. Rembrandt was one of the greatest to concern himself with the sheer beauty of a landscape, and the human figures

in his landscape prints appear dwarfed and insignificant before the grand beauty of trees and rolling hills (*plates 37, 38, 39*). Both Bruegel (*plate 31*) and Hirschvogel (*plate 30*) preceded Rembrandt as landscape print-makers by almost seventy-five years, but they produced a less impressive body of material, and are therefore referred to less frequently. Although Dürer had made numerous sketches in places he visited—countrysides, medieval towns, exotic birds, animals, plants, and grasses—his attitude was that of a sensitive observer of the natural universe, anticipating the later trend toward naturalism in art and literature. His sketches and watercolors lack the emotion and passion of Rembrandt's, in which as early as the seventeenth century may be found a sentiment which two hundred years later was

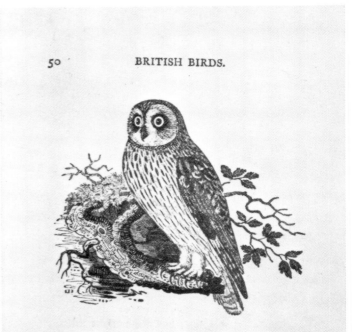

9. Thomas Bewick. *The Female Horned Owl,*
illustration for HISTORY OF BRITISH BIRDS. 1797.
Wood engraving, 2½ × 2¾"

so sensitively expressed by the English Romantic poets whose verses celebrated the song of skylark or nightingale, and the music of the west wind.

Prints have always performed another major function: apart from their aesthetic values and their use as decorations, they were and continue to be indispensable aids for historians and archaeologists. In the eighteenth century the magnificent achievement of Giovanni Battista Piranesi in representing the ruins of Roman and other Classical monuments made available a vast, personally observed record of the remains of the grandeur that was Rome. A 1946 edition of Edward Gibbon's *The Decline and Fall of the Roman Empire* (originally published in 1776–88) was illustrated with reproductions of Piranesi's famous views—unquestionably the finest visual reminders of the Classical past.

William Hogarth, through the medium of his didactic prints, preached against immorality and cruelty (*plate 44*). Other Englishmen, led by Thomas Rowlandson, elected to satirize current usages and customs and to make their observations ribald and bawdy (*plate 15*). Many of the greatest masters chose, on occasion, to titillate the viewer with scenes of nudity and seduction, at a time when the naked model was forbidden to the artist and student. Some prints went well beyond the risqué and became flagrantly erotic. These were sold at high prices and often plagiarized in foreign lands. Goya exhibited another variety of daring when he commented pictorially on morals and abuses in his native Spain, though partially concealing his message and meaning in esoteric symbols. He very narrowly escaped the persecution of the Inquisition—and this in the nineteenth century. Daumier's bitter and searching political prints (*plates 55, 58*), bitingly critical of Louis Philippe, brought him a jail sentence. His more kindly observations of the French bourgeoisie, which first appeared in journals and newsprint, were later compiled and issued in comic albums. Also in the nineteenth century, the American firm of Currier and Ives dispatched members of its staff to report on events of the day—a great fire, an important sports event, a bloody battle. Statesmen and entertainers were honored with portraits, as were pretty girls in stylish costumes.

Thus, for six hundred years, the print has enjoyed a varied existence and has served religious as well as secular interests, the recording of history as well as the representation of beauty.

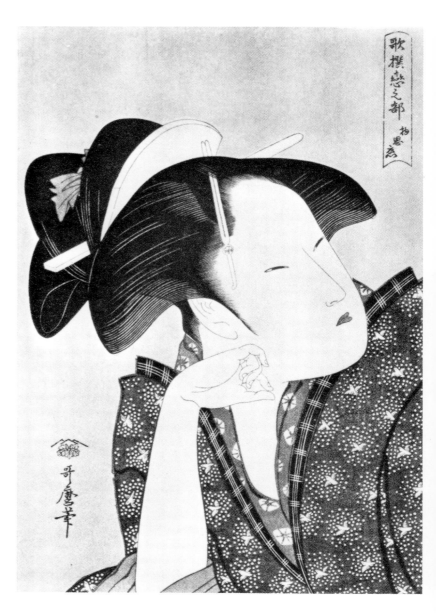

10. Kitagawa Utamaro. *Young Woman.*
Late 18th century. Color wood-block, $15\frac{1}{8} \times 10\frac{3}{8}''$

THE TRADITIONAL METHODS OF MAKING FINE PRINTS

The basic methods of making prints lend themselves to relatively simple explanation. Some of the processes date back to remote periods, but two are comparatively modern. As with all discoveries and inventions, the passing of time produces innovations and technical improvements. Some of these will be touched upon briefly, but actually the basic methods described have undergone few radical changes since they were first employed. We shall discuss relief, intaglio, planography, stencil, and variants such as monotype, cliché-verre, and rubbing.

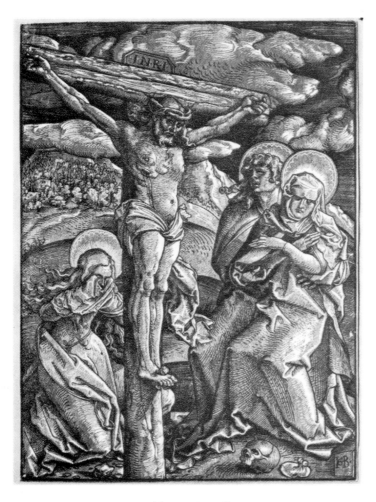

11. Hans Baldung. *Crucifixion.* c. 1511.
Chiaroscuro woodcut, 13⅝ × 10¼″

The Relief Print

As the term itself suggests, the design (whether composed of images, symbols, decorative elements, or even text) appears in relief—that is, it stands away from the lowered or carved-out background. In remote centuries, millenniums before the Christian era, relief sculpture was used to decorate the walls of tombs, palaces, or places of worship. Still to be seen in Egypt are the magnificent bas-reliefs in the Valley of the Kings, where the figures stand out against backgrounds in striking contrasts of light and shadow. Egyptian artists painted these figures in traditional colors to heighten the dramatic effect.

In the relief print, as described below, the artist approaches his task in much the same spirit as did the ancient sculptor, but he works on a wooden block or comparable material—or even linoleum (*plate 83*). His finished work is not intended to be a work of sculpture,

although he uses some of the sculptor's techniques; it is an image to be transferred to paper from the carved surface.

The oldest and most widespread application of this relief method for the making of a fine print is revealed in the story of the woodcut.

The Woodcut

Anyone who has seen a piece of printing type or a rubber stamp will understand at once the principle of the relief process. When this method was first developed in Europe during the fifteenth century, the design or image was drawn on a piece of smooth hardwood, after which the surface on both sides of the desired line was cut away, thus leaving the image or design in relief, raised and isolated from the background. This surface was then smeared with ink and a piece of paper was placed over it; the picture or image was transferred to

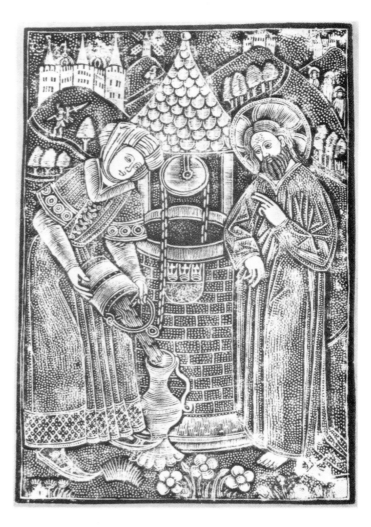

12. Master of the Cologne Arms (attributed).
Christ and the Woman of Samaria. c. 1450. Hand-colored metal cut (*manière criblée*), 7 × 4½″

the paper when pressure was exerted from above (*figs. 3, 4, 8*).

There are occasions when the creator of a woodcut handles the entire process himself, from design to printing, but this has never necessarily been the case. Some of the finest examples of this art have been produced when the artist, after drawing his picture on the block, turned it over to professional wood carvers for skillful cutting, and to capable printers for transferring the image to paper or other material (*plate 21*).

The Wood Engraving

The invention and use of this process, which is a variant of the relief method, dates from the second half of the eighteenth century. The English engraver Thomas Bewick found that if he used an *end block* (a cross section of the tree), he was rewarded with an extremely hard surface which was not subject to the splitting and splintering that comes from carving with the grain of the wood. To carve this block, he could use the same tools used for engraving on metal; the lines could be finer and closer together, and the wood block held up through larger editions. Generally, the prints give the impression of being white on a black ground (*fig. 8*), as contrasted with black on white in the earlier woodcut. The deep lines into which no ink has been permitted to seep become the white lines of the design, while the remainder of the engraved block becomes black in the printing. Bewick's own book, *History of British Birds*, published from 1794 to 1804, remains a landmark in this method of printmaking (*fig. 9*).

The Japanese Wood-Block Print

The Japanese have long been among the supreme masters of the art of printing from wood. During the period of their greatest popularity, in the late eighteenth and nineteenth centuries, the prints were produced through the combined efforts of three agents: the artist who made the design, the woodcarver, and, finally, the printer. All were experts in their respective fields, and the technique of printing from a succession of blocks, inked with different colors, was brought to a highly developed state by these Japanese masters. No book dealing with the history of Impressionism fails to acknowledge the great debt of modern art to the Japanese print.

The prints which dealt realistically with the por-

13. Albrecht Dürer. *The Penance of St. John Chrysostom.* c. 1497. Engraving, $7\frac{1}{8} \times 4\frac{1}{2}$"

trayal of contemporary life were known as *Ukiyo-e,* which means "mirror of the passing world." The designers, like the French Impressionists, chose to ignore their classic standards and limitations and dealt with what they saw around them—the changing, everyday world of the common man. These works were considered vulgar by the wealthy and sophisticated Japanese, so that recognition of their merit and value came later, just as it did for the French artists who created a similar art revolution.

The technique of the Japanese color print differs sufficiently from the method used in the West to war-

14. Albrecht Dürer. *Nativity.* 1504.
Engraving, $7\frac{1}{8} \times 4\frac{5}{8}''$

rant description here. The designers of these prints were always painters who, once they made their pictures or designs, had little to do with the process of producing the final impressions. An engraver (wood carver) transferred the image to blocks of wood (generally cherry wood) and cut the surfaces to prepare them for the printer. The printer too was a master of his craft, and it was left to him to produce the finished color print (*fig. 10; plate 48*).

The technique is described by Edward F. Strange in a handbook of the Victoria and Albert Museum, London, titled *Japanese Colour Prints:*

The process differed in almost every respect from that used in Europe. In the first place the colours in the form of a fine powder were placed dry upon the block, and there mixed for use with thin size made from rice. . . . The rice-paste not only fixes the colours, but is found to give them a peculiarly brilliant and pure quality. The paper is . . . first damped by means of a brush on the top of the block in which the colours have been carefully arranged. The actual impression is taken by rubbing the upper (and, of course, reverse) surface of the paper with a pad called the baren, *consisting of a disc of hempen cord, wound flat-wise round one of its ends, fitted into a socket of paper and cloth, and the whole enclosed in a sheath of bamboo leaf of which the ends are gathered up to form a handle. The prints are, as finished, hung up on lines to dry. Accuracy of register is secured by the simplest means, a cross cut in the wood at one corner, and a line on one side; the main reliance of the printer being on a wonderful perfection of craftsmanship.*

It has often been remarked that the period of French art that extends from the early nineteenth century to the middle of the twentieth has been a veritable golden age—a period of change and inventiveness, in which artists have constantly challenged the long-established standards and steered courses over uncharted and unexplored seas. During this period we find in the works of some painters the first clean break with traditions which had bound European art since the Renaissance. French artists went repeatedly to distant and exotic lands for ideas and inspiration. Delacroix visited Algeria and brought back new and vivid color schemes to work into his canvas. Renoir, after a similar journey, was also affected by the brilliance and novelty he found in Oriental landscapes, manners, and costumes. Matisse drew largely from Turkish and Persian mosque tiles, adapting their liquid arabesques to the background designs of his series of Odalisques (*plates 88, 89*). Modigliani, Picasso, and others took much from primitive masks and carvings brought from Africa.

But probably no foreign importation had greater effect than the Japanese wood-block print when it first made its appearance in Paris art circles. The first discovery was made by the artist-engraver Braquemond, when a small volume of prints by the master Hokusai was called to his attention. These prints, as well as others—precious objects today—were used as packing material for the protection of a shipment of porcelain imported from Japan! This was in 1856. By 1862, however, due to phenomenal demand, a rich assortment of

15. *The Virgin; Hope; St. Sebastian.*
15th century. Niello engravings, *The Virgin* 2½ × ⅝″;
Hope and *St. Sebastian* each 2⅝ × ⅝″

prints was available for examination in a shop, picturesquely named La Porte Chinoise, on the Rue de Rivoli. This establishment was managed by a Madame Soye, who, with her husband, had lived for a long time in the Orient. Their shop soon became a favored meeting place for artists and writers. Later, in 1867, there was a Japanese section at the Paris World's Fair, which offered the visitor a greater variety of native wares—prints, paintings, fans, porcelains, and lavishly embroidered costumes. In the next generation, Toulouse-Lautrec doted on a Japanese robe he acquired, and had himself photographed dressed in full Oriental regalia.

The lessons to be learned from Japanese prints were the subject of long discussions at the Café Guerbois, and several of the painters who gathered there became avid collectors. Van Gogh often traded his oils for Japanese prints with the dealer Père Tanguy. Manet, Degas, Monet, Gauguin, Lautrec, Whistler, and Mary Cassatt all became enthusiastic, and in one way or another responded to the art of the Japanese printmaker.

But the real influence of Japanese art was not on background decoration, as it occurs in Manet's portrait of Zola or Van Gogh's portrait of Père Tanguy, but on the deeper character of French art. For the works of Utamaro, Hokusai, and others had revolutionary effects; the discerning Frenchman saw that his Oriental confrere used brilliant color in large, flat, unmodeled areas, confined by sweeping but purposeful black lines. The pictures were rendered in two dimensions, the third

being merely suggested by subtle contours. The composition was generally asymmetrical, and a sense of drama was introduced by cutting the figures off at the edge of the paper, thus suggesting that the subject was caught in movement and would momentarily escape from the viewer's field of vision. The thin, sensitive, economical line in the portraits of actors, musicians, and courtesans appealed greatly to consummate draftsmen like Degas, Manet, and Lautrec.

Nowhere was the impact of Japanese art more dramatically reflected than in the striking and revolutionary posters of Toulouse-Lautrec, which were pasted on the walls and kiosks of Paris during the 1890's (*plate 82*). Modern French art owes a lasting debt to the Japanese craftsman, but it is to the great credit of the Frenchman that he never copied slavishly, or imitated in an uninspired fashion. He absorbed much that was alien to his artistic inheritance, and incorporated it purposefully and gracefully into his own language of expression.

16. Pablo Picasso. *Dance of Salomé.* 1905.
Drypoint, 15¾ × 13⅝″

The Chiaroscuro Woodcut

The term *chiaroscuro* was first used to describe the painter's method of modeling figures by strong contrasts of light and dark areas. *Chiaro*, from the Italian word for light, and *oscuro*, the word for dark, are combined to create this descriptive adjective.

Many masters of the Renaissance produced dramatic effects in their drawings by selecting a tinted paper on which they sketched the basic outlines of their subject with crayon or wash of a second color. This done, they achieved the effect of a third tone by adding touches of lime white. These brilliant drawings were perhaps the inspiration for the earliest chiaroscuro prints.

The chiaroscuro prints were produced from several wood blocks in which the major areas were printed in black and successive blocks were carefully registered to yield highlights and additional areas of color. These were the first true color prints, for hand tinting done directly, and often crudely, on the black-and-white impression was thus eliminated (*fig. 11; plate 14*).

The Metal Cut

The metal cut is a relief print carved into copper or some other metal, rather than in the more common wood block. For this reason historians have always classed it with the development of the woodcut, not with the intaglio print (*described on pages 21-23*), conventionally done on metal.

In the preparation of a metal cut the craftsman carves away or lowers the background to leave the image and printing surface in relief. When picture and text are printed simultaneously these metal plates were fastened to blocks, in order to bring them to the same height as the type face.

The metal cuts of the fifteenth century are similar to the white-line wood engravings of a later date, anticipating the efforts of Bewick and his followers (*fig. 9*). In this technique the major elements of the image are cut or incised into the metal plate, so that when it is inked and printed the surface, which is in relief, prints black, and the lowered areas remain as white as the tone of the paper.

The earliest examples, which are extremely rare, were produced by a method called *manière criblée* (dotted manner). The craftsmen, probably the same artisans who were skilled in producing nielli (*described on pages 22-23*), would often break up the forbidding black areas with a series of dots and flicks. At times they employed decorative punches with rosettes, stars, quatrefoils, or other designs to avoid monotony. Some prints have been preserved which were delicately tinted by hand directly on the black-and-white impression. The illustration here is a brilliant example of this genre in print (*fig. 12*). The term *manière criblée* requires an explanation. The overall sea of dots reminded an early French historian of a sieve, the French word for which is *crible*, and thus the term originated. Arthur M. Hind and other scholars writing in English prefer the term "dotted manner," or "dot prints."

In the eighteenth century William Blake composed his magnificent poetry, and printed and colored his own books (*plate 51*). He employed metal cuts for his publishing ventures and developed a method of etching away the background, upon which both image and text were drawn, with the aid of acids. He vividly describes his work as woodcuts on copper. With this method he was actually returning to the primitive procedure of the block books.

17. Berthe Morisot. *Young Girl with Cat.*
1889. Drypoint, 6×5"

18. Jean-Louis Forain. *Lawyer Talking with the Accused.* 1909. Etching, $9 \times 11\frac{1}{4}''$

The Intaglio Print

Of the four basic methods, intaglio has lent itself to the greatest number of variations. It has, from the time of its discovery, challenged the artist's inventiveness. The intaglio methods all have this in common: the lines are cut, scratched, or bitten into the plate, so that they all lie *below the surface* of the material on which they are drawn. Ink is forced into the lines which have been cut into some soft metal, generally copper, and when the surface of this metal is gently wiped clean, the ink remains in the furrows or cuts which form the design. To produce an intaglio print, it remains only for a piece of dampened paper to be placed on the surface and "run through" a press under considerable pressure. The absorbent nature of the porous paper will draw or pull the ink from the incisions or channels, and the

design will be transferred. Anyone who has a plate from a set of engraved visiting cards or invitations has at hand the material for making an engraving: one can cover the plate with a greasy ink, wipe the smooth part of the plate clean, place a damp piece of paper over the surface, and run them both through an old-fashioned clothes wringer. It is not expected that many readers will bother with this experiment, but it is described here to indicate how simple is this process of print-making.

All of the intaglio techniques are basically similar. They vary only in the manner in which the lines are cut into the printing surface of the plate.

The Line Engraving

The tools for making line engravings are not compli-

cated. They are called *burins* or *gravers*, and consist of a hard, slim, metal staff set in a wooden handle (a cross section of this tool is generally square or lozenge-shaped). When pushed through a soft metal, the burin produces a miniature furrow, much like that made by a farmer plowing through a field. Since the artist making a line engraving desires a clean line, he removes the metal which has been cut from the plate and polishes down the rough edges with a *scraper* or burnishing tool. The quality of the printing line is determined by the depth and width of the cut. It is obvious that the deeper the incision, the greater the amount of ink held in its hollow, and the darker and bolder the character of the printed line. The angle at which the tool is held to make the cuts will determine the nature and quality of the line (*compare plates 12, 16*).

Niello

Niello (plural: nielli) is a term which may confuse the reader, for it is used to describe two objects: an engraved metal plate, and the occasional print which was pulled from its inked surface.

A product of the goldsmith's or silversmith's shop, niello in the first sense of the word was, during the middle of the fifteenth century, a popular form of orna-mentation for small boxes, reliquaries, sword handles,

19. James Abbott McNeill Whistler. *Gretchen at Heidelberg.*
c. 1858. Etching, 8 × 6¼″

20. Francisco Goya. *Folly of Fear*
from THE PROVERBS.
c. 1810–19 (first edition issued 1850).
Aquatint, 8⅜ × 12½″

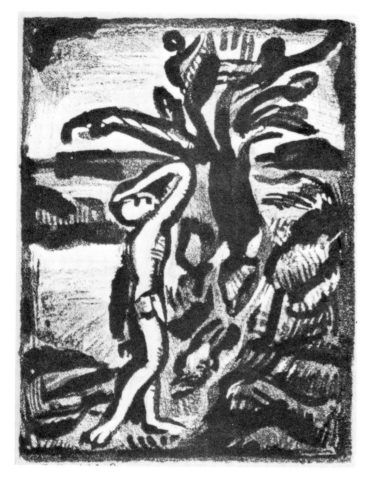

21. Georges Rouault. *Les Réincarnations du Père Ubu.*
1929. Combined technique, $11\frac{7}{8} \times 7\frac{3}{4}''$

The Drypoint

The method of making a drypoint is extremely close to that of making a line engraving. The thin, pencil-like tool is either of steel or has a tip set with a hard gem—often a diamond, sapphire, or ruby. It is held in the hand like a pencil, and the lines are scratched and dug into the plate through strong, controlled action of the wrist. If we return to the simile of the farmer plowing his field, let us imagine that in this instance the small hillocks of earth thrown up on either side of the furrow are *not* removed. In the making of the drypoint, this dug-up material, called the *burr*, will hold the ink and yield a rich, velvety line when the print is pulled. The burr is extremely fragile, and since it deteriorates rapidly as successive prints are pulled, the size of the edition of a drypoint is necessarily small. Should the artist require a line which varies in tone, he simply scrapes away the burr in the desired areas. Successful drypoints are difficult to execute; there are fewer opportunities to correct errors than in other processes, and skillful, assured draftsmanship is imperative (*figs. 16, 17; plate 77*).

mirrors, and other metal objects. When the artist had finished the relatively deep engraving of his decoration, the incised lines were filled with a powdered black substance which would melt when heated. When this substance had hardened, the surface of the plate was polished and the image revealed in clear, black lines.

It is likely that the artisans engaged in such work studied its progress by filling the lines with some greasy substance resembling ink, and that by bringing a sheet of paper into contact with this surface, they would pull an impression. This is the very basis of the intaglio method for making engravings. But the niellist was in this case using the print only as a step in the preparation of the more precious metal plaque. When it was discovered that many of these prints had a beauty of their own, the production of such miniatures became fairly popular, especially in Florence and Bologna during the mid-fifteenth and early sixteenth centuries. Those illustrated here are superb examples by an anonymous artist (*fig. 15*).

22. Pablo Picasso. *Ostrich*, illustration for
Buffon's NATURAL HISTORY. 1942.
Aquatint (lift-ground method), $14\frac{1}{2} \times 11''$

The Etching

An etching differs from the intaglio print just described only in the respect that a different method is employed to cut the lines into the metal surface of the plate. The printmaker is not required to push or drag his tool through the hard surface, for an acid will *bite* the line for him. This makes possible a freer, more fluid and calligraphic manner of drawing (*figs. 18, 19*), as well as other effects not easily obtained with engraving or drypoint.

To prepare the etching plate, the artist covers the surface with an acid-resisting material called the *ground*, its base being mainly wax. At times, he darkens the working surface with lampblack so that he may more readily draw upon it without being hindered by the light color of the surface or by reflections from the copper plate. With a sharp, needle-like instrument, he now *draws* his design with a greater freedom, made possible by the slight resistance of the surface. Thus, the ground is removed by the etching needle as it is moved over the surface, and the bare metal is exposed. With its edges and underside protected by thick varnish, the plate is now immersed in a tray containing the acid *bath*, and the acid bites into the exposed metal, leaving a series of lines incised into the surface, analogous to those of the engraving or drypoint (*plate 36*). If the artist wants to etch deeper in some areas (to produce darker, heavier lines), he removes the plate, covers the surface with the same acid-resisting medium, except for the areas he wants to deepen, and then reimmerses the plate so that the unprotected portion will be bitten more deeply. When the process is complete and the entire surface of the plate cleaned, he prints the plate in the manner previously described.

The Aquatint

The aquatint, like the etching, is prepared for printing by attacking the surface of the plate with acid, the name aquatint being suggested by the Latin term for acid, *aqua fortis*. Essentially, aquatint is a tonal rather than a purely linear process and was adopted by eighteenth-century artists when they strove to reproduce the graded, translucent effects of wash drawings and watercolors. Its invention, about 1750, is generally credited to a Frenchman, Jean-Baptiste Le Prince.

The tonal effect is achieved by using one of several possible methods for depositing a layer of fine granules of resin or similar material onto the surface of the metal plate (*fig. 20; plate 99*). The fineness or coarseness of the deposit determines the extent to which the acid will corrode the plate. The plate is heated after the particles of resin have been spread on the surface, and each particle, upon melting, becomes an acid-resisting dot. The acid bites the surface in those areas surrounding the dots; therefore, where the artist desires a highlight or a white area, he *stops out* the surface with the acid-resisting material. Where he desires the deepest tone of black, he permits the acid to work longest, thus biting more deeply. Accident plays an important role in the preparation of the aquatint plate, for the laying of the ground is not easy to control; this is especially true when the artist seeks to vary the character of the granular surface by combining fine and coarse granules,

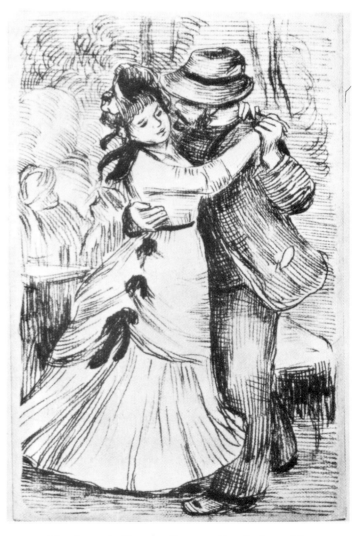

23. Auguste Renoir. *Dance at Bougival*. c. 1885. Soft-ground etching, 8¾×5⅜″

or attempts to determine the quantity of resin particles that will settle in certain sections of the plate. Because of these uncertainties in execution, aquatint is often employed in combination with etching and drypoint. This procedure is generally called the *mixed method* or *combined technique* (*fig. 21; plate 98*).

The Lift-Ground Etching

The lift-ground etching or sugar aquatint is similar to aquatint in that it produces areas of tone rather than lines. An extremely ingenious process, it was employed by Picasso in the creation of some of his finest prints (*fig. 22*).

The artist prepares a saturated solution of sugar, India ink, and generally a small quantity of liquid soap to produce the required texture. Using this mixture, he paints his image on a clean plate. After his work has dried, a liquid ground is laid over the entire plate and this, too, is permitted to dry. The plate is then immersed in a bath of warm water. The water seeps through the porous ground, and the sugar, absorbing water, swells and "lifts" the ground from the image, leaving it exposed. An aquatint ground is laid in these lifted areas and the plate is then bitten in the conventional manner. The skilled printmaker often repeats this process a number of times to achieve the desired subtlety of tone.

The Soft-Ground Etching

During the second half of the eighteenth century this process was employed to simulate in print the qualities and characteristics of crayon or pencil. The *soft-ground* (softer than the ground used for etching), a waxlike, acid-resisting substance, is laid evenly over the work area. In laying the ground, in most intaglio processes, it is necessary to warm the plate so that the resinous substance will melt slightly and form a smooth, level surface. Then this surface is covered with a piece of paper or fabric, on which a drawing is made with a pencil, pen, or other sharp instrument. The pressure of the instrument forces the resinous ground to adhere to the paper or fabric, so that when the latter is lifted away, the metal is exposed according to the drawing. In addition, the paper or fabric may be pressed onto the remaining ground, to imprint its characteristic texture on a larger area. When the plate is immersed in its acid bath and bitten, as in the other methods, the result is an uneven, broken line which, when printed, gives

24. William Ward (after John Hoppner). *Daughters of Sir Thomas Frankland.* 1797. Mezzotint, 23 × 18″

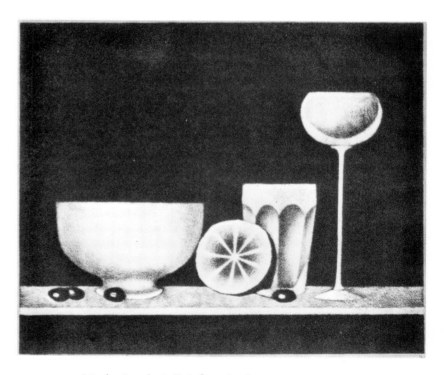

25. Mario Avati. *Still Life with Olives.* 1956. Mezzotint (*manière noire*), 10⅛ × 11⅝″

the coarser appearance of having been drawn rather than incised. Renoir favored this method (*fig. 23*).

The Mezzotint

Generally, mezzotint has been used purely for making reproductions, and there are few original works of artistic distinction in its early use. Examples of technical and mechanical excellence abound, as do impressive interpretations of oil paintings by the masters, both in black-and-white and in color (*fig. 24*). Although these were much in vogue a generation ago, today they enjoy little popularity. This process may seem ill-suited to the creation of original prints, but it can be an excellent adjunct to other methods; many artists use some mezzotint today when producing a print by the combined technique. Recently, however, a number of printmakers have adopted the mezzotint technique, which the French term so aptly the *manière noire*, to produce original prints which are not reproductions of existing works, but entirely new conceptions (*fig. 25*).

The principal tools used in preparing the mezzotint

are the *rocker*, the *roulette*, and other multitoothed implements. When the extremely sharp teeth of these instruments are literally rocked and worked over the entire metal plate, they produce a veritable sea of dots that leaves the surface completely dug up. If the plate were inked and printed at this point, it would yield a rich monotone print in velvety black. The artist creates his picture by working from black to white, from the darker tonal areas to the lighter. He does this by using a series of *scrapers* to vary the depth of the dots, and thereby determine the quantity of ink the dots will hold. Where he burnishes the surface of the plate until it is completely smooth, all the ink can be wiped off and this area will print white. His range of values, therefore, varies from the black of the ink to the white of the paper.

The Stipple Engraving and the Crayon Manner

Stipple engraving, like mezzotint, is rarely used today. Originally the technique was used for making reproductions, but it was supplanted by photography. The crayon manner, as its name implies, was invented to imitate the quality of crayon drawing. The plate is covered with the usual etching ground, and a variety of tools—the roulette, or any instrument with a serrated edge, or the *chalk roll* (commonly used for this process) —are worked over the surface. After the plate has been etched with acid, the craftsman often adds finishing touches with the drypoint or graver. With the invention of lithography, in which an actual crayon could be used, this method also became obsolete.

In both these types of prints a series of dots, cuts, and flicks is used to produce effects very similar to those obtained today in the *halftone*, a commercial photographic process. One method is to *ground* the plate as in an etching, but using a harder ground material. The artist then makes his design with one or more *stipples*, *burins*, *gravers*, or *roulettes*, or a *chalk roll*. After permitting the acid to bite the plate for the desired effect, he cleans the ground from the surface and continues working in the *dry manner*—using no acid— as in mezzotint or engraving.

Bartolozzi is the name generally called to mind when discussing the stipple engraving, and his reproductions of Holbein's drawings were highly valued (*fig. 26*). French printmakers applied the crayon manner and the

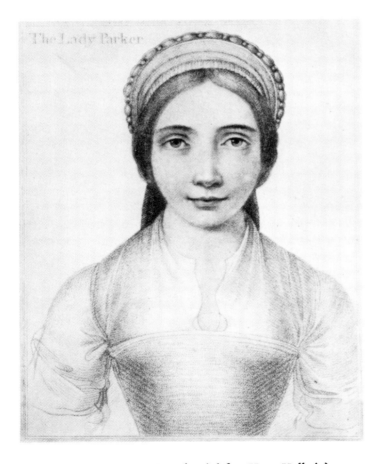

26. Francesco Bartolozzi (after Hans Holbein).
The Lady Parker. 1812. Stipple engraving, 6⅞ × 5⅛"

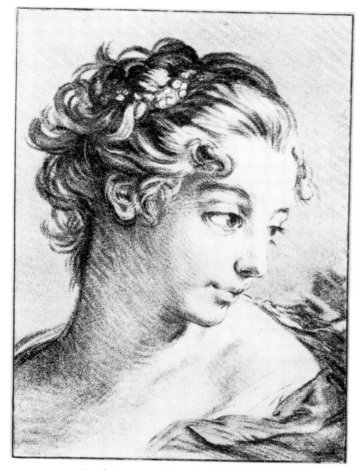

27. Louis Bonnet (after François Boucher).
Head of a Woman. 1767. Color engraving
(crayon method), 9¾×6⅞″

to print and publish his own plays. About 1796, he stumbled onto the basic principle of this method when he hastily scribbled a laundry list on a piece of stone with an ink he had been using for experiments in his workshop. The ink was his own concoction of soap, wax, and lampblack; the stone was a type of limestone found only in Solenhofen, in Bavaria. A sudden inspiration led him to treat the surface of the stone with mild acid, and he found that the surface was slightly eaten away except where his ink marks "protected" it. With the marks thus slightly in relief, he was able to ink them and print an impression. Sensing that the stone had special qualities, he continued to investigate the possibilities of using it for printing, and succeeded in anticipating almost all the variations and innovations that the efforts of others have yielded since then. Thus, at the beginning of the nineteenth century, an unsuccessful author was the unsuspecting inventor of a printing process which has immortalized his name, his literary output remaining unknown and unsung.

But at least one of Senefelder's dreams was realized, for in 1817, upon the publication of his book on lithography, *Steindruck*, he expressed his hopes for lithography in these words: "I desire that soon it shall spread over the whole world, bringing much good to humanity through many excellent productions, and that it may work toward man's greater culture. . . . "

stipple technique to imitate the *galante* drawings of Boucher, Fragonard, and Watteau (*fig. 27*).

The Planographic Print (The Surface Print)

Of all the methods used to produce an original print, none lends itself so perfectly to a direct, rapid, spontaneous statement as the planographic process. Here, the artist is afforded an opportunity to draw or paint on a smooth surface, unhindered by the need to dig into metal, carve away sections of wood, or use relatively unfamiliar tools. His working surface is hardly limited in size, and may vary from the conventional dimensions of a book or magazine illustration to the broad expanses needed for a poster. Lithography is the only planographic process that concerns us here. Essentially it is based on the simple principle of the antipathy of oil or grease for water. It is the discovery of a German, Aloys Senefelder, who was not an artist, but a writer seeking a cheap way

The Lithograph

In making a lithograph, the image is drawn with a greasy crayon or brushed with a greasy ink on the smooth, grained surface of the stone. (Today, metals are treated to duplicate the character of Bavarian limestone, and when zinc is used, the print is generally described as a *zincograph*.) The nature of the stone or metal printing surface is such that it will absorb water. After the image has been drawn, chemicals—gum arabic and nitric acid—are used to "etch" the unmarked areas of the stone or plate by increasing the water-retaining properties of the surface. The entire surface is then moistened with a sponge. The lines and areas drawn or printed with the greasy agents will repel the water, but the unmarked portions will readily absorb it. When a greasy ink is rolled over the entire surface, it will be accepted by the brushed or drawn areas and repelled by the blank, wet sections of the unmarked stone or metal. When the printing surface has been inked, a sheet of

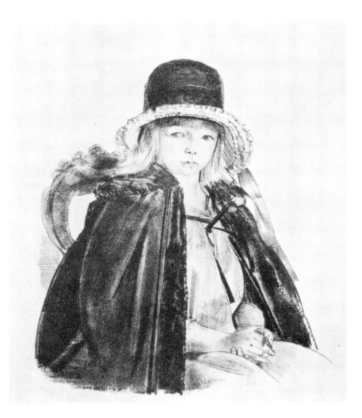

28. George Bellows. *Jean in a Black Hat.*
c. 1920. Lithograph, $10\frac{5}{8} \times 9\frac{1}{4}''$

paper placed upon it, and both run through a press as in the other processes, the image is transferred. This process is so faithful in duplicating the original drawing that it is often extremely difficult to determine the fact that the result is a print and not an original drawing (*figs. 28, 29; plates 64, 85*).

The Transfer Lithograph

One of the devices occasionally employed for making a lithograph is the use of transfer paper. In this method the artist draws his image directly with lithographic crayon on a sheet of special paper which is then placed face down on the stone or plate and run through the press. The design is thus transferred to the printing surface, which is then treated in the conventional manner for the making of a print. Picasso, Whistler, Pennell, and others employed this method. It makes it possible to execute designs rapidly at locations far removed from the printing press or studio—at a bull-fight, in a café, or out-of-doors directly from nature. Vincent van Gogh, in one of his letters to his brother Theo, writes with much excitement about this magic

29. Maurice Vlaminck.
Rue à Hesonville. c. 1925.
Lithograph, $14\frac{7}{8} \times 18\frac{1}{4}''$

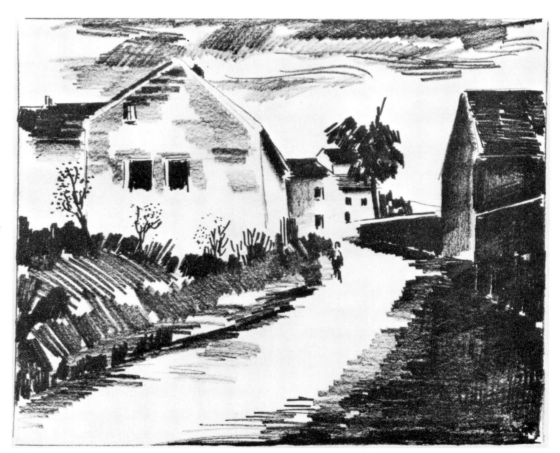

paper which has been described to him and begs his brother to secure some sheets for him.

The print which results from this modification of the lithographic method is universally considered to be an original example of graphic art (*fig. 30*).

The Stencil Print

The stencil process was used in the Orient as far back as the Middle Ages and again in Europe at the beginning of the Renaissance. It was employed primarily as a device for duplicating color, in order to enhance the appearance of black-and-white prints: examples are often found among the early playing cards and religious images mentioned above. But the astonishing possibilities of this method were neither explored nor exploited until the early twentieth century. Then, in the 1930's, the silk-screen process was developed in America. Used at first primarily to produce posters and placards, the technique was soon adopted for the creation of original prints. Carl Zigrosser, whose engaging, scholarly writings about the graphic arts are mentioned in these pages, contributed the excellent descriptive terms of *serigraphy* for the method and *serigraph* for the resulting print.

The simplest form of stencil has always been produced by cutting apertures of the desired shape in thin, nonporous materials such as paper or metal, or, more recently, plastic. When this stencil is held firmly against a blank surface, and color is brushed or rolled across it, the blank surface receives an image corresponding to that of the aperture. More elaborate effects are obtained by imposing a series of stencils over the picture area. After the print has been permitted to dry, it is possible to superimpose other stencils and colors, thereby building up a complex picture, one that can rival the effects produced by an artist working in oil, tempera, or watercolor. This technique, generally called the *pochoir* process, has been highly developed in America and France, where it has been used primarily to produce color reproductions and book illustrations.

Silk screen offers many possibilities to the adventurous artist. He is not confined to small working areas, for the screens may be stretched over very large frames; nor does he need elaborate paraphernalia. It is easier to produce color prints with silk screen than with other methods. A serigraph may be made in the home or the

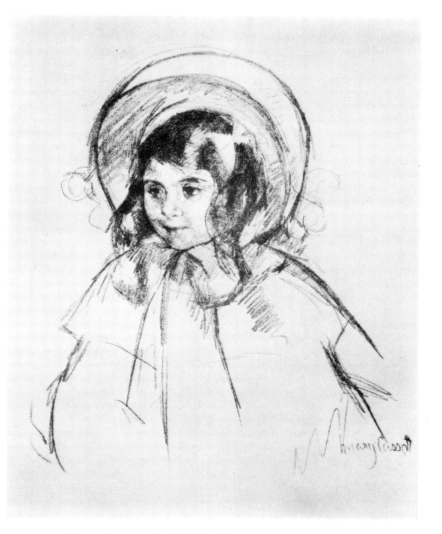

30. Mary Cassatt. *Sarah in Her Bonnet.* c. 1904. Transfer lithograph, 20 × 16⅜″

workshop, and a print involving numerous screens and colors can be executed without assistance.

The technique is described here even though the artists represented in this volume rarely employed it. In its original form it is essentially an American process, and the finest silk screens, until recently, have been produced by American artists. It is inevitable, however, that in the years ahead this method will be further developed on an international scale and will yield a rich crop of prints.

The Silk-Screen Print (Serigraph)

The silk-screen process permits the creation of a truly original print. It is based on the principle of stretching a strong fabric over a frame and forcing color through the fine mesh of the material. The image or design is controlled by making parts of the screen opaque and leaving other sections "open," or porous,

so that more or less ink is forced through the fabric. Many methods have been developed to achieve this end.

We must visualize an open wooden frame over which a finely meshed piece of silk or nylon is stretched and secured. If this screen is placed over a sheet of paper, color may be forced onto the paper through the openings between the warp and weft threads. The tool used for this purpose is a rubber instrument called a *squeegee:* it is the same as that used by a window-cleaner to work the water over the glass surface. The color, spread by the squeegee over the stretched silk, is forced onto the paper. If the silk has been left completely open, the resulting print will be a solid area of the color selected. Elaborate color prints require an expansion of this method, including knowledge of the pigments used (their qualities of opacity and transparency) and methods of keeping successive color screens in register.

To convert the silk screen into a stencil, part of the surface is made opaque and the part to be printed is left "open," the open areas of the screen corresponding to the artist's design. The following is one relatively simple and direct method: employing an inklike material called *tusche*, he draws his image on the silk surface. The entire area is then covered with a rapid-drying coating. A refined form of kerosene applied to the area of the drawing will dissolve the tusche while the coated area remains stopped out. When color is forced through the open area, the result is a silk-screen print, or serigraph (*fig. 31*).

The Monotype

Although the monotype unfortunately is rarely seen in exhibitions and collections, it is included here in the belief that it is bound to enjoy a renaissance. Perhaps this technique has been ignored because it is too simple, for almost anyone can produce a monotype—probably, without quite realizing it, everyone has. It has also been eschewed as a technique because of commercial limitations, since impressions can be produced only with the time-consuming repetition of various procedures.

Although a catalogue of seventeenth-century monotypes was compiled by an Italian, Giovanni Benedetto Castiglione, the history of the monotype is vague. Some historians insist that the method was employed occasionally by many great artists, from the Renaissance on; among those mentioned are Leonardo da Vinci,

31. Ben Shahn. *Mask.* 1962.
Color silk-screen print, $27 \times 20\frac{1}{2}''$

Michelangelo, and Rembrandt. William Blake, always an experimenter, tried his hand at it. Among the more famous nineteenth-century artists to work with this technique were Degas (*fig. 32*) and Gauguin (*plate 79*); there are recent examples by Chagall (*plate 92*).

A monotype is a print transferred from a painted plate to a sheet of paper. The plate may be of almost any smooth-surfaced material—glass, metal, or porcelain. The artist, using a fairly heavy printer's ink or oil pigment, paints an image on the smooth surface, which is in no way etched or bitten. To make the impression, a sheet of paper is placed on the plate and pressure is applied, so that the ink or paint is transferred from the printing surface to the paper. Some artists use a printing press for the required pressure; others simply place the paper on the printed image and rub or roll over the surface of the paper with a squeegee or comparable implement. The paper receiving the image is then separated from the plate; for a second impression, the process must be repeated. Changes can be made by adding to or reducing the inks or oil colors, or by increasing

or diminishing the pressure. No two impressions will be exactly alike.

Ida Ten Eyck O'Keeffe, herself a distinguished creator of monotypes, contributed a splendid article on this technique to the magazine *Prints* (June, 1937):

Who can say wherein lies the charm of the monotype—that unique print from a painted plate, which stands in the half-shadow between painting and print-making? But charm there is, and a haunting quality that more than justifies both the making of monotypes and the public response to them.

The monotype is not always taken seriously. For one thing, the process is so easy that anyone can make one, therefore it is often assumed that such "child's play" deserves little consideration. It has been called a "tricky medium"—given over to superficial effect. It has been accused of owing its successes to the fickle hand of "happy accident." But, in spite of all these derogatory reproaches, the monotype remains a source of joy to the artist and collector alike. Its spontaneity and freshness, its directness and freedom place it apart from other traditional print media as a means of artistic expression that should not be overlooked.

The Cliché-Verre

The cliché-verre is rarely encountered in the print market today, but since it is described in various texts and journals, it will be mentioned here. It is truly a bastard method, and was only practiced for a short time, principally by members of the Barbizon School in France. Corot was probably its most enthusiastic and capable proponent (*fig. 33*).

The cliché-verre is the result of the combination of some aspects of conventional printmaking and the chemistry of photography. As the French name suggests, a glass plate is employed which is completely coated on one side with an opaque material to prevent the penetration of light. The artist treats this coated surface much as he would a metal plate prepared for an etching. As his burin or other tool moves over the glass to draw the image, the covering material is removed, leaving these parts of the plate transparent.

A sheet of sensitized photographic paper is then placed under the prepared glass and both are exposed to light, much as a photographer prints from a negative. When the paper is developed, the image created by the removal of the opaque material has been translated into

black lines on the white background of the paper. This technique makes possible the creation of impressive multiple drawings, as evidenced by the efforts of Corot, Daubigny, and others. However, because of its hybrid character, the cliché-verre is relegated to a limbo between the worlds of photography and printmaking.

The Rubbing

This printmaking method may not be considered a graphic technique, in the strict sense of the word. However, in this method a contemporary generation may profit from the efforts of artists who worked centuries or millenniums ago. It is only a romantic notion to consider this a collaboration between the craftsman who prepared his "block" at some remote time and the

32. Edgar Degas. *Woman Reading*. c. 1875–85. Black-and-white monotype, $15 \times 10\frac{7}{8}$"

contemporary "printer" who transfers it to paper; this method is described here because in recent years there have appeared in the print market impressive examples of rubbings which are simultaneously things of beauty and eloquent records of the past.

Almost every child has made a rubbing: when he places a piece of paper over a coin and rubs on the paper with pencil or crayon, he is rewarded with the appearance of an American Indian, an eagle, a buffalo, or the profile of a President. The method is related to that of the woodcut, where the high or projecting portions of the surface become the picture or design. Modifications of this technique, depending on the ingenuity of the craftsman, may yield a variety of surprising results.

Archaeologists employ this technique to make records of bas-reliefs discovered in caves, on walls, on bronze sculpture, and on funerary steles. Thus, where a camera cannot be used, some of the richness of early cultures can be recorded by this method. Today, beautiful prints of carvings in India and the Orient, as well as in Europe

and America, have been made by enterprising amateurs and enthusiasts, and acquired by students and collectors (fig. 34).

A PRACTICAL GUIDE TO PRINT COLLECTING

It is natural for any writer on the subject of fine prints to encourage not only the study but also the acquisition of choice proofs of those masters he most admires. Some of the keenest and best-equipped scholars have risen from the ranks of amateurs, and some of the greatest dealers in this field were once avid students and collectors who found this art so alluring that they gave up all other work for the satisfaction and pleasure of dealing in prints.

But an admonitory note is necessary: the print collector should not fall into the error of acquiring works only because they are rare and costly. A philatelist, for example, may pay a huge sum for a prize item that was withdrawn from circulation when an error was noticed (perhaps a reversed image, or a misstated date or value): these pieces are rare, but they do no particular justice to the intent or desire of an artist.

Prints should be collected because of the genuine merit and the inherent beauty to be found in the best. Museums and outstanding collections, however, are wise to include representative prints in various states, unfinished works, or even poor impressions, to provide a comparison with mint proofs. Much, too, may be learned from fakes and copies. Careful examination of all stages and conditions of a print will prove to be a great aid to the student.

Never before has there been such daring and inventive use of material and technique as in printmaking today. This has served to make it almost impossible, even for the so-called expert, to determine exactly how prints were produced. But it should be constantly borne in mind that the basic processes remain those described earlier in these pages. Currently, for example, the intaglio, relief, and planographic methods may be combined to yield the effects desired by an artist. However, the end result alone should concern us; the printmaker has the same latitude as the composer who adds electronic sounds to his orchestra, or the painter who includes sand, beads, or other extraneous material with his pigment.

33. Jean-Baptiste-Camille Corot. *The Little Shepherd.* c. 1855. Cliché-verre, 13½ × 10¼"

34. *Forest Scene* (from a Cambodian stone bas-relief). Rubbing, 15½ × 16½″

Certain clichés are never really outworn, and, though often avoided, somehow retain their validity. The statement that "beauty is in the eye of the beholder" can mean many things, and we now suggest it as a final reward in the contemplation of a master print. The beauty of the written word, even a poem, is not by its very nature *visual* beauty, a thing actually seen. But *images* are often evoked by words as they are by sound and music. So, by contrast, the visual contemplation of a great print may carry one beyond the limitations of visual beauty, and far beyond the circumscribed confines of the picture. Just as verbal statements evoke images, so do images evoke thoughts, the very stuff of poetry, literature, and philosophy. It is in this spirit and with this attitude that we offer the information on the following pages and ask our readers to approach the works of master printmakers, past and present. The result is bound to be a keen and lasting enjoyment of this precious art form.

This book leaves many questions unanswered, as will any single book on the subject. If it encourages or provokes the reader to a study of more detailed texts, or the rewarding pursuit of the fine print, the writer will deem himself amply rewarded.

35. Pablo Picasso. *Bull*. 1945. Lithograph
(first, fifth, eighth, and eleventh states of a series of eleven),
11⅜ × 16½″

What Is Meant by the "State" of a Print?

When an artist studies the first proofs that are taken from the press, he decides whether any changes are required to improve the character of his work. If he makes corrections or additions and pulls a new series of proofs, the later impressions are described as the *second state* of the print. Many artists continue their alterations to the point where a dozen states have been produced before the final *run* of prints is authorized. There are

lithographs by Picasso which have gone through twenty states (*fig. 35*).

Occasionally a print is described as being in a *new state* due to changes not made by the artist himself. In the printing of a poster or an illustrated book, advertising matter or text may be added after the first proofs have been run (*plate 42*). A new state is created whenever any alterations are made. These states should be clearly specified in catalogues of the works of individual artists.

The Signing and Numbering of Prints

It should be emphasized that a print need not be numbered or signed to be original. Some early masters left no identifying mark on their works; others employed only monograms or symbols. When the initials or signature of an artist are printed simultaneously with the picture itself (*plates 13, 16*), we describe this as being *signed in the plate*. Some of the finest treasures of graphic art fall into this category. There are also numerous prints which bear no signature other than the unmistakable style and genius of the artist. In many splendid illustrated books the artist's name appears only on the title page. In the fifteenth century, such volumes rarely contained a title page and the artist or artists invariably remained anonymous; we have been able to identify some of them by other methods (*figs. 5, 7*).

In the late nineteenth and early twentieth centuries, a group of perceptive dealers and publishers undertook, at their own expense, the editing of portfolios of prints by the artists of the day. They also issued the classics (*fig. 6; plate 81*) and modern literary works illustrated with original prints by living artists. Most of these works were labors of love, for few were financial successes at the time (they have since become collector's items of considerable worth!). To men like Sagot, Le Garrec, Vollard, Kahnweiler, and Skira we owe the production of some of the finest graphics by Lautrec, Derain, Bonnard, Vuillard, Redon, Rouault, Chagall, Miró, and Picasso. On occasion, the artist signed only the cover of a portfolio or added his signature below that of the author or publisher on a specified page. Yet all of the prints were original, and some of the greatest works by Lautrec, Bonnard, and Vuillard were issued under these conditions.

The signing, numbering, and issuing of *artist's proofs* is a relatively modern convention. The method most commonly employed today is to indicate on the extreme left-hand side of the print the size of the edition and the number of that particular proof. Thus, the inscription 34/50 means that not more than fifty prints were issued, the one at hand being number thirty-four. This does not necessarily mean that this was the thirty-fourth print to come off the press or that it is superior or inferior in quality to higher or lower numbers. Since the artist destroyed any badly printed proofs, all that remain are of equal merit. Before the press yields the results desired by the artist, a number of test prints are pulled; these are generally marked as *trial proofs*.

Many fine examples of printmaking today are made possible by enterprising publishers or dealers who underwrite the cost of such productions. One of the methods of compensating the artist is to offer him a number of prints, generally ten, which are inscribed *artist's proof* in place of the numbering. These he may retain, give to museums, or sell to dealers. All the prints are usually signed at the extreme right by the artist. Occasionally this is done within the field of the print—that is, directly on the image, rather than in the margin below.

What Is a Restrike?

Today, the term *restrike* demands a fuller description than that generally offered in the past. It was probably first used in the study of numismatics, to describe a coin which was minted at a certain date and restruck at a later time. In large measure this also describes a restrike in the field of graphic art. A true restrike remains very close to the original production of the artist who prepared the printing surface from which the first, and original, impressions were taken (*fig. 36*). A print is not a restrike if the artist (often because he did not have the funds for paper or printing) makes the plate but has impressions pulled at a later date: such prints are the original edition. A print is a true restrike when time has elapsed between the first and subsequent printings, if no alterations have been made on the plate. When considerable time has elapsed between the original and later printings it is proper that the dates be indicated.

Many prints have been called restrikes when actually further qualifications should be made. It must be duly indicated whenever a plate is tampered with, as in the case of lines reinforced or rebitten. Prints by Hogarth, Piranesi, and Goya have been reissued many times. Although they never reveal the brilliance of the early impressions, they still have merit and afford pleasure and instruction for the owner. But all subsequent changes and alterations should be stated, insofar as feasible, with dates, names of publishers, and quantities, when these facts are known.

A restrike, then, is generally acknowledged to be an original work of art, since it is printed from the plate, block, or stone employed in the first edition. A buyer of a print has, however, every right to be informed if, as

may happen with works by Rembrandt, several centuries have elapsed between the first and last printing.

How Is a Plate Destroyed or Canceled?

The conventional practice of destroying a plate was adopted to protect the collector against misrepresentation about the number of prints issued. This does not mean that the plate or stone is literally demolished. The image on a lithographic stone is often effaced by grinding down the stone so that this valuable material may be reused. Or the artist may incise a series of lines across the surface of a metal plate, after the prescribed edition has been taken. Many of these plates have found their way into museum collections, and serve to instruct the amateur and professional alike. Some of them, still in excellent condition, have been reprinted with the *canceling* lines; the resulting prints are still considered original works (*fig. 37*).

Prints Made after the Works of Other Artists

For many centuries artists have been inspired to copy or interpret the works of other masters. Michelangelo made a faithful copy of an engraving by the German, Schongauer; Van Gogh based one of his canvases on an Italian painting by Fra Bartolommeo; and Picasso has created prints and paintings for which originals by Cranach, Delacroix, and Velázquez served as sources of inspiration. When a copy is so faithful to the original that its authorship might be mistaken, the copier should sign his own name and indicate his source; this has occasionally been done, but many collectors and museums have discovered, to their chagrin, that they were proudly displaying a copy in the belief that it was the original work.

In the 1920's, the French artist Jacques Villon produced an excellent series of free interpretations of paintings by contemporary masters. In each instance he engraved his name in the plate, the ethical method for indicating authorship. Today, these prints are treasured by collectors as fine examples of the work of Villon himself.

During the past twenty years, prints have appeared on the market that are genuine in the sense that no photomechanical aids were employed; they are copies of works by other artists. Often, the author of the original work is aware of this and has indicated his approval by supervising the work, suggesting changes, and signing a limited number of prints. This practice can be very misleading to the collector who has not been properly informed of the procedure, although the publishers of such prints generally indicate this fact in their catalogues. But this document may not be available at the time of sale, and misleading statements may have been made to the trusting purchaser; he becomes the possessor of a print which is not an original work by the artist whose name is inscribed in the lower margin.

The writer firmly believes that prints of this variety

36. Käthe Kollwitz. *Head of a Woman.* 1905 (restrike c. 1962). Soft-ground etching, $9\frac{1}{8} \times 5\frac{5}{8}$ "

should be properly labeled. The fact that they were made *after* the work of an artist by craftsman or technician should be plainly stated on every proof.

What Is a Reproduction?

It should be obvious that an original print is not to be confused with photomechanical reproductions. In the latter, the photographer and the printer combine their talents to produce a satisfactory replica of an original painting, sketch, or watercolor. The result may be a facsimile of the utmost fidelity, but it is in no way an original work of art. Often the author of the work is dead, or, if alive, he has little to say in the matter. Good reproductions fill a real need for decoration, illustration, and instruction. But the quality of the pigment, and the texture of the surface on which the artist worked, has only been simulated. We remind the reader again that reproductions are not to be confused with fine prints as described and illustrated in these pages.

Does Price Necessarily Determine Quality?

It may be categorically stated that most of the finest examples of printmaking, which today are rare and expensive, were offered to the public at very low prices when they were issued. Many excellent works by Goya, Daumier, Meryon, Whistler, and others were included in magazines, journals, and books of their time as an extra premium for the subscriber. Art books published by the Parisian firms of Floury or Vollard often included original plates by Renoir, Cézanne, Lautrec, Pissarro, and other artists.

The contemporary artist generally offers his work at very attractive prices. With judgment and taste, it is possible to select works by young unknowns, some of which will inevitably be the heirlooms of the future. This should be a most exciting challenge to the new collector. It is hoped that the printmakers of today—and many demonstrate extraordinary talent—will be encouraged by the public's support.

The Use of Catalogues
and Protection against Fraud

The student and collector has available an impressive reference library of textbooks and catalogues in which

37. Pablo Picasso. *Profile of a Woman.* 1905 (canceled 1913). Etching, 11½×9¾″

many, but not all, prints are described. Here are given sizes, descriptions of states, presence of watermarks, collectors' stamps, and many other details. Museums and libraries cheerfully make these accessible; it is most instructive and rewarding to consult this material.

When contemplating the purchase or study of an important print, careful reading of the proper catalogues is suggested. The older works, like those of the French printmaker and art historian Loys Delteil (1869–1927), are indispensable, and the newer publications with their fine reproductions make this type of research a genuine pleasure. To find works by the older masters, there are scholarly compilations and descriptions. Fine prints in good collections usually carry a catalogue title and number as a guide, and anyone purchasing a print of this sort should request that the dealer furnish all catalogue references.

The more complete catalogues will afford the reader information about dates, provenance, size of the image, and the variety of papers on which the impression was made. Since the numbering of editions of prints is a

relatively recent convention, only the newer catalogues that deal with modern artists indicate the size of the edition and inform the reader whether the plate or stone has been canceled or destroyed.

For the diligent collector, there are also catalogues of watermarks, as well as of collectors' marks (which were generally placed on the back of the print, but at times appear on the face).

The Care and Framing of Prints

There are a few elementary precautions to be mentioned about the care of prints. If kept in their unframed state, they should be placed in dustproof portfolios or solander boxes. Framers should be admonished never to mount prints—that is, paste or glue them flat against the surface of a heavier material—for this will reduce their value. Prints should simply be hinged at the edges with a material which will readily peel away from the paper on which they are printed. The margins should never be trimmed, and if, for the purpose of framing, it is expedient to reduce the size, it is preferable to fold the paper to the required dimensions rather than cut it. In framing, the fine print should be hinged to 100 per cent rag paper, to prevent inferior papers or cardboards from staining the original. Unframed prints should always be handled with care to avoid smudges and fingerprints.

The Tamarind Lithographic Workshop, Inc., in Los Angeles, in 1965 issued a bulletin titled *Mishandling and Danger to Graphic Art Due to Use of Out-of-Date Matting and Framing Techniques*. This instructive and helpful guide describes the dangers mentioned above and adds further admonitions. It stresses the important point that the variations in climatic conditions throughout the country, or the world, make certain practices reasonable in one region but quite dangerous in others. We suggest that the serious collector, anxious to preserve his prints, should consult the curator of his local museum, or an experienced, informed print dealer.

THE PLATES

Plate 1

Unknown German Artist

ARS MORIENDI ("The Art of Dying")

c. 1470. Woodcut, dimensions of page 8⅝ × 6⅜"

The block book is a picture book with both the image and the type carved into one wood block, so that the picture and inscriptions are printed simultaneously (*see plate 2*). In this instance, however, full pages were given over to the illustrations; the appropriate text was printed separately from a full-sized block and usually placed to confront the picture when the book was open.

The message or story was clear, even for those who could not read, in the same sense that the frescoes painted on church walls by Giotto and his predecessors were understood by even the unschooled viewer. Only occasionally was a book published whose text was of greater significance than its illustrations. One such example is the *Mirabilia Urbis Romae* ("Marvels of the City of Rome"), a kind of guidebook to Roman history, describing its churches and relics. It was first published as a block book, probably by a German printer in Rome, sometime before 1475. Between 1484 and 1500, over thirty editions printed in movable type were issued. This work was generally acquired by those who journeyed to Rome.

The *Ars Moriendi* was the most popular and broadly circulated of all the block books, for it dealt with a subject never far from one's thoughts—the hopes and fears of the living. During a period when successive plagues decimated cities, kings and nobles, rich and poor, worried about the hereafter and its possible rewards or punishments. The illustrations in the *Ars Moriendi* showed angels protecting the good, and demons torturing the sinner.

This book was almost a necessity, for the clergy, overworked as it was, did not always arrive in time to offer solace to the dying. Through the study of this book, man was instructed in how to meet Death and how to avoid the temptations—Impatience, Pride, Avarice, etc. The final scene is one of triumph, for at the hour of death all temptations have been resisted. The enraged demons acknowledge their impotence and fly off to try again at another bedside.

Plate 2

Unknown German Artist

BIBLIA PAUPERUM ("Poor Man's Bible")

c. 1470. Woodcut, dimensions of page 11 × 8⅜"

The *Biblia Pauperum* was another of the famous block books published in many editions in Germany and the Netherlands. It rivaled the *Ars Moriendi* (*see plate 1*) in popularity. Copies of this work were never really acquired by the poor layman, as the title of the work might suggest. In all likelihood, it was found in the hands of the poorer members of the clergy who could not afford the complete and expensive Bible.

The illustrations deal with episodes from the life of Christ, some parallels from the Old Testament, and textual comments from the Prophets. The book generally consisted of some forty to fifty leaves, and in this concise form it satisfied the needs of a poor priest who sought suggestions and material for his preaching. From an artistic point of view, the crowded pages do not have the impact of the full-page illustrations of the *Ars Moriendi*; stylistically they are linked to the traditional handling in illuminated manuscripts dating from as early as the fourteenth century.

During the late Middle Ages, the drawing of parallels between events and characters of the two Testaments had become a popular device. Each page of the *Biblia Pauperum* illustrates a subject from the life and Passion of Christ, two parallels from the Old Testament, and two witnesses from among Biblical personages. Thus, on the page dealing with the Resurrection of Christ, we also see the traditional parallels drawn from the narratives of Jonah and of Samson. On another page, depicting the Annunciation, the compartment to the left displays Eve in the Garden of Eden. In the woodcut illustrated here, we see the Temptation of Christ in the center panel, Jacob and Esau on the left, and the Temptation of Adam and Eve on the right. The preacher was thus left a broad choice as to what use to make of these pictures and text for his sermon.

Plate 3

Unknown German Artist
THE STORY OF ARACHNE

Illustration for DE CLARIS MULIERIBUS (*"Concerning Celebrated Women"*)
1487. Woodcut, 3⅛ × 4¼"

Boccaccio, the fourteenth-century writer who is also one of the great writers of all time, was a friend of Petrarch, and an able biographer. He is best known for his *Decameron*—probably the first brilliantly perceptive treatment of the Human Comedy.

De Claris Mulieribus, less well known but extremely popular with generations of readers, is a kind of biographical dictionary that bears some similarity to Chaucer's *The Legend of Good Women.* In this book Boccaccio deals with women of Classical antiquity, both real and legendary, and the great women of the Bible. This work went into many editions, one of the earliest and best being the one published by Johann Zainer in 1473 at Ulm, Germany. Zainer associated a woodcut illustration with each story; there were some eighty in this edition. The cuts in the 1487 edition were freely adapted from the Ulm publication, but are so well executed that they are considered as fine as their models.

De Claris Mulieribus combined clarity, both in text and pictures, with a frankness which was often shocking. The illustration shown here is not of such a nature, but tells the pathetic tale of Arachne, a Greek maiden who challenged the goddess Athena to a contest in weaving. She lost, of course, and for her folly was transformed by Athena into a spider. In this small cut we see the loom at the right, the swooning maiden in the center, and, at the left, the web with its tenant.

The use of empty white areas is sophisticated, and the entire design in its simple frame is executed with restraint and economical use of line.

Plate 4

Unknown Florentine Artist
HEAD OF A MAN IN A FANTASTIC HELMET

1470–80. Engraving, 5 × 2⅞"

During the early Renaissance, a number of Florentine painters produced a group of unforgettable profile portraits. Generally these were keenly observed studies of nobles or dignitaries. This engraving bears the unmistakable mark of such a Florentine craftsman. It seems to be a design for—perhaps even an example of—a fanciful helmet and a highly wrought breastplate created by some skilled silversmith or armorer. But the unknown artist also rendered a realistic portrait of a Florentine warrior; the continuous, finely engraved line from forehead to upper lip portrays a type made familiar to us by fifteenth-century frescoes and panel paintings. This small engraving is startlingly like representations of the ill-fated Giuliano de' Medici.

The most remarkable achievement in this small engraving is the incredible economy of line in the highly successful representation of the unknown warrior, which is in dramatic contrast to the intricate design above and below the profile. The viewer's attention is immediately riveted on the countenance, and only after consideration of the personality of the model does the eye wander to the costume. This portrait is a minor masterpiece of the engraver's art.

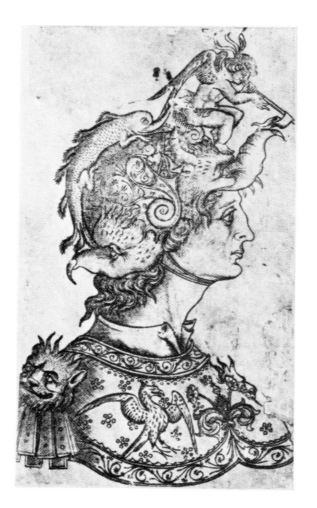

Plate 5

Unknown German Artist
SAMSON SLAYING A LION

Illustration for the Cologne Bible
c. 1479. Hand-colored woodcut, $4\frac{1}{2} \times 7\frac{1}{2}''$; dimensions of page $13\frac{1}{4} \times 8\frac{1}{4}''$

The large quantity of illustrated books issued in the latter part of the fifteenth century resulted from two factors—the development of cheap paper to replace expensive parchment, and the demands of a large buying public avid for illustrated texts. So great was the demand that the famous Nuremberg printer Anton Koberger employed as many as one hundred workers and kept some twenty-four presses active. Although two-thirds of the publications were not illustrated, at least one-third carried woodcut images—at times left in their black-and-white state, at times (for the more expensive copies) hand-colored. These books were for the people—not for the learned scholar—and the illustrations were as instructive as the text. The Bible was naturally one of the most popular works, and the Cologne Bible, one page of which is reproduced here, is perhaps the finest achievement of the period. It is believed that Dürer and Holbein took inspiration from the traditional treatment of Biblical themes as depicted in this work.

The distinguished scholar Emil H. Richter (in his essay "German Woodcuts of the Fifteenth Century," *Print Collector's Quarterly*, October, 1915) wrote that "the Cologne Bible (about 1479), one of the milestones in the progress of woodcut illustration, has caused much speculation regarding the originator of its charming illustrations, with characteristics pointing to France and the Netherlands. Presumably it is the work of a transient artist, since it stands alone of its kind among illustrative work in that town."

As a background for Samson's exploit, the artist has selected a quiet medieval town. A boatman rows his way up the river, and a few workmen are occupied in the fields on the far side of the stream. Samson, in the foreground, has his right leg perched firmly on the lion's back, and with bare hands on the upper and lower jaws of the victim seems well on his way toward destroying the "savage" beast. There is more charm than fierceness in this representation, and the semiopaque coloring suggests a fairy tale rather than a grim struggle between man and the "King of the Beasts."

herren stig auch auff in der flam. Da das hett
geschen manne vn sein haußfrawe.sy vielen mi
der geneygt an die erd vnd fürbas erschine yn
nimmer der engel des herre.vn er sprach zu sei
ner haußfrawen.Wir werdē sterben des todes
wañ wir haben gesehē den herren. Das weybe
antwurt im.Ob vns der herre wölt erschlahen
er hette nit empfangē das gätz opfer.vnd dye
opfer võ vnsern hendē.Noch hette vns gezey
get alle dise ding.noch hette vns gesagt dy dig

dye da sein kunfftig.Darumb sy gepar einē sun
vn hieß seinē name sampsō.Vñ dz kind wuchs
vnd der herre gesegent un.vñ der geyst des her
ren begund zusein in in . in den herbergen dan
zwischen saraa und esthaol.

¶ Das.XIIII.Capitel.wie
sampson ein weyb name vñ auff dem weg einē
lewen tödtet.vnd do er widerkame wie yne das
weyb betrog.

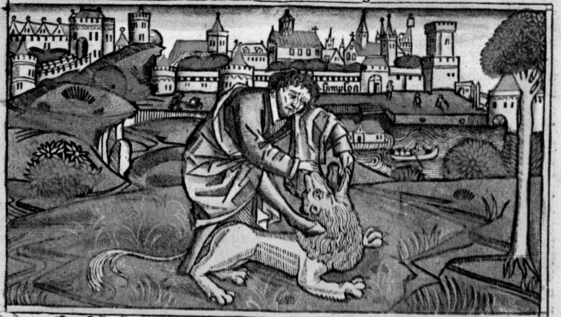

Aruß sampson gieng
ab in thammata. vnd sah da ein weyb
von den töchtern der philistiner. vnd
gieng auff.vnd verkunt es seinē vater. vnd sey
ner muter.sagend. Ich hab gesehē ein weyb in
thammata von den töchtern der philistiner.ich
bitt euch das ir mir es gebet zu einē weyb.Der
vater,vnd sein muter sprachen zu in . Ist dann
keyn weyb vnder den töchtern deyner brüder.
vnd vnder allem deinē volck.das du wölt nemen
ein weyb võ dē philistinern.Sy da sei vnbeschni
ten.Vñ sampson sprach zu seinē vater.Nyme
mir dise.wañ sy gefelt meinē augē. wañ sein va
ter vnd sein muter weßten nit.das das ding wz
von dem herrē.vnd suchet die schulde wider dy
philistiner.Wañ in der selben zeit herschetē dy
philistiner vber israhel.Darūß sampson gieng
ab mit seinē vater vnd mit der muter in tham
natha. Vnd da sy waren kumen zu dem weyn
garten der stat ein grawsamer welff des lewē
erschin im schreyend .vnd begegnet im. Vñ der

geyst des herren viel auff sampson. vnd er zer
risse dē lewē zu stücken.als zerrisse er ein kitz
lein.vnd het gantz nichts in der hande.vnd ditz
wolte er nicht sagen dem vater oder der muter
Vnd gieng ab.vnd redet zu dem weybe. Sy da
geuiel seinen augen . Vnd nach etlichen tagen
keret er wid das er sy nem.Er neygt sich.das er
seh das aß des lewen.Vnd sehe ein schwarm d
bunē.was in seynem munde. vnd ein rosen des
hōnigs.Da er es het genomen in dye hende.er
aß an dem weg.vnd kam zu seynem vater vñ zu
der muter.vnd gab in einen teyl.vnd sie aßen.
Jedoch er wolt in es mit sagen . das er hett ge
nomen das hōnig von dem mund des lewen .
Darumb sein vater gieng ab zu dem weybe.vñ
machet eyn wirtschafft mit seinē sun sampson
Als die iungen hetté gewonheit zu thun. Dar
umb da in die burger der statt hetten gesehen.
sy gaben im dreyssig gesellen die da waren mit
im.Sampson redet zu in. Ich wil euch fürlegē
eyn gleichnus eyner frag . ob ir mir dye außle

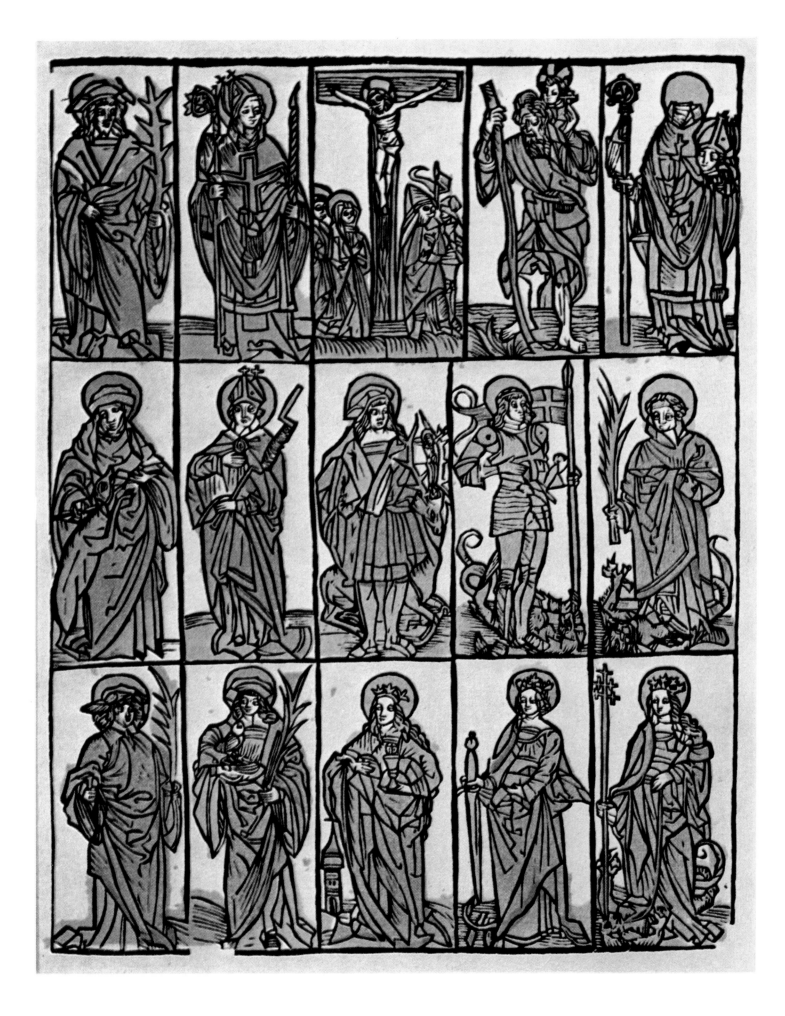

Plate 6

Unknown Swabian Artist (attributed)
CRUCIFIXION AND
FOURTEEN AUXILIARY SAINTS

c. 1500. Colored woodcut, 12⅜ × 9⅛"

In the introductory section of this book, we mentioned the small devotional cards or prints which worshipers purchased at local shrines, or during a pilgrimage. They were apt to select these prints in the same spirit in which the tourist today acquires mementos of his trip. But prints like those illustrated here served a double purpose, for the fourteen saints represented were believed to protect the faithful from disease, affliction, or catastrophe. St. Christopher, of course, protected the traveler against accidents; St. Cyriac helped to ward off "maladies of the eyes and possessions of the devil"; and St. Barbara gave protection against "lightning and sudden death."

These small images of the saints were readily identified by the faithful. They knew the stories and recognized the attributes, which often symbolized the saints' respective martyrdoms. The traveler would generally select images of the saint dearest to him, either his own patron saint or some other favorite whom he invoked for protection.

The sheet depicted here was probably intended to be cut up into fifteen separate prints, to be distributed and sold. The surviving example is extremely rare, perhaps unique, and owes its fine state of preservation to the fact that it was pasted, in its present state, in a book of larger format. The owners of the small individual prints often pasted them in prayer books or missals.

Although the drawing here is crude, it makes the artist's statement with vigor and directness. The addition of color augments the dramatic impact of these miniature woodcuts.

Plate 7

Unknown German Artist

St. Luke Painting the Virgin

Illustration for THE GOLDEN LEGEND
1488. Woodcut, 3½ × 7⅛"

The Golden Legend ("Legenda Aurea") is a collection of stories outlining the lives of the saints. Written in Latin by Jacobus de Voragine toward the end of the thirteenth century, it remained a popular work for many centuries. Depending on the whims of the publishers, some editions were made up of 177 chapters, while others went as high as 182. Essentially this was a devotional book; its purpose, like the more modest single woodcut prints, was to encourage dedication to the moral standards of the holy and saintly. This work went through countless editions and was translated into many languages. Caxton issued it in English, Chaucer borrowed subject matter from its pages; centuries later, Longfellow adopted the title for his *Golden Legend* and modeled his style somewhat on that of the original.

The illustration shown here is from an edition published by the same Anton Koberger who gave us the popular *Nuremberg Chronicle* (*plate 9; see also fig. 7*). The subject is St. Luke, shown in his studio in the act of painting a picture of the Virgin. An apprentice at the right is busily grinding color. To the left, in another room, we see the ox, the symbol of the Evangelist. A picture, or possibly a vision, of the Madonna appears on the wall. St. Luke was a physician, an author, and, according to sixth-century tradition, a painter of several representations of the Virgin.

This charming scene reminds us of some of the illustrations for the Cologne Bible (*plate 5*); but in its more subtle feeling for design and its knowledge of perspective and anatomy, it is certainly the work of a competent designer. Like other books of the period, it was offered in black-and-white, and, probably for a somewhat higher price, enlivened and enhanced by the addition of color.

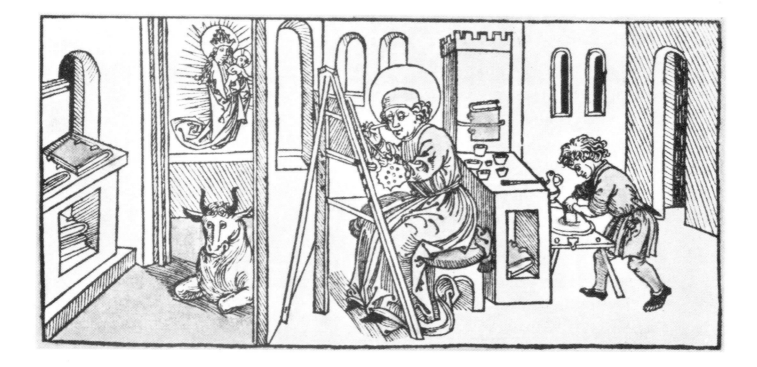

Plate 8

Unknown Italian Artist
Fior di Virtú ("Flowers of Virtue")

(a) Frontispiece; (b) Falsity; (c) Flattery
(a) 1490; (b and c) 1491. Woodcut, (a) 5½ × 4⅛"; (b) 2¾ × 4⅛"; (c) 2⅞ × 4⅛"

Fior di Virtú is a compendium of sage advice and aphorisms garnered from various sources: the Bible, philosophers through the ages, the Fathers of the Church, and medieval tales of adventure.

The book is divided into forty-one chapters that are devoted primarily to two subjects: Christian virtues, and women, the good and evil in them. Most of the chapters deal with virtues and their corresponding vices—pity and cruelty, temperance and intemperance, humility and pride. The second part of each chapter identifies the virtues and vices with some animal or bird, which is shown in the illustration for that section. At the end occurs the *example*, a short tale appropriately illustrating the vice or virtue in question. For instance, the vice of flattery (*c* at right) is based on quotations from Andronicus, Seneca, and Virgil; the animal creature chosen to represent flattery is the Siren; the example or illustrative tale is from Aesop—*The Crow and the Fox.*

The author states his purpose in the first passage of the book: "Here begins a work entitled *Flowers of Virtue*. It treats of all human vices which should be avoided by the man who wants to live according to God, and it teaches how one must acquire virtues and righteous customs according to the authority of holy theologians and many outstanding philosophers."

Fior di Virtú was the best seller of its time. It was translated into at least eleven languages and during the fifteenth century it appeared in some sixty-six different editions. It is interesting to note that in the same century only fifteen editions of Boccaccio's *Decameron* are recorded, and a similar number of Dante's *Divine Comedy.*

In 1953, a splendid edition of the Florentine *Fior di Virtú* of 1491 was published for the Library of Congress. It was translated into English by Nicholas Fersin, and contains facsimiles of all the original woodcuts; Lessing J. Rosenwald contributed a splendid introduction. I am pleased to acknowledge this scholarly essay as the source for the comments made above.

Plate 9

Unknown German Artist

TEMPTATION OF ADAM AND EVE
AND EXPULSION FROM THE GARDEN OF EDEN

Illustration for THE NUREMBERG CHRONICLE
1493. Woodcut, dimensions of illustration $10 \times 8^{3}/_{4}''$

One of the earliest professional book publishers was Anton Koberger, the godfather of Albrecht Dürer. In 1491, Koberger issued an impressive book, known as the *Schatzbehalter* ("Treasury of the True Riches of Salvation"), containing ninety-one woodcut illustrations *(see fig. 4)*, and in 1493 the more ambitious *Liber Cronicarum* of Hartmann Schedel, now known as *The Nuremberg Chronicle (see fig. 7)*. The text and pictures audaciously cover the history of the world from the Creation down to the time of the book's publication. It became another best seller in its day and was issued in two editions, one in black-and-white, the other (costing three times as much as the cheaper edition) colored by hand.

Profusely illustrated with large and small cuts, it contained some 1,809 pictures, though only 654 different blocks were employed. They tell the story of the world, relate episodes from the Old and New Testaments, describe historical events, and offer views of cities and portraits of famous men and women. Ancient and contemporary cities were depicted by the same wood blocks—only the legend or title was changed. Forty-four images representing famous men and women were used over and over again—226 times, to be exact. Thus, Thales, Paris, and Dante all have the "same look."

For this book a contract was drawn between the wealthy backers and the publisher. Nineteen months were allowed for its completion, and a large staff of artists and woodcutters was retained. This accounts for the variety of styles and skills, which results in an occasional splendid illustration (especially at the beginning) and a plethora of crudely executed blocks repeated throughout the text.

Nonetheless, this is a historic document, for it was the first great picture book offered to the middle classes. Aesthetically it does not rival books produced shortly later in Nuremberg and in other cities, but for the print lover there is much excitement to be derived from leafing through the complete work or contemplating many of the individual pages.

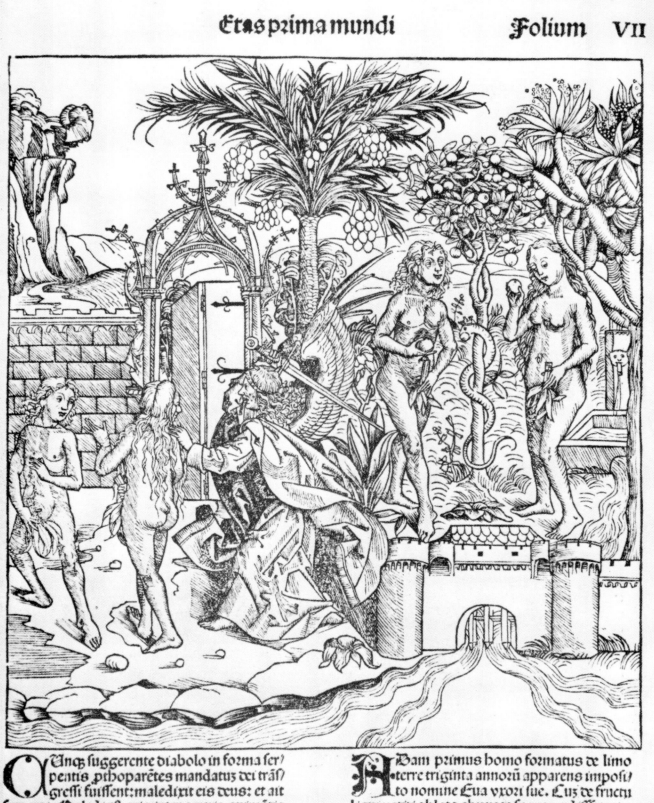

Unc suggerente diabolo in forma ser/
pentis pthoparêtes mandatuz dei trâs/
gressi fuissent: maledixit eis deus: et ait
serpenti. Maledict⁹ eris inter omnia animâtia
z bestias terre:super pectus tuum gradieris: et
terram comedes cunctis diebus vite tue. Muli/
eri quoq dixit. Multiplicabo erûnas tuas:z cô》

Dam primus homo formatus de limo
terre triginta annozu apparens imposi
to nomine Eua vxori sue. Cuz de fructu
ligni vetiti oblato ab vxoze sua comedisset: eie
cti sunt de paradiso voluptat: in terram maledi
ctionis vt iuxta imprecationez domini dei. Adâ
in sudoze vultus sui operaretur terram:et pane

Unknown German Artist
The Theater of Terence

Frontispiece for THE COMEDIES OF TERENCE
1496. Woodcut, 11¾×8″

The Humanists of the Renaissance prided themselves on their rediscovery of the Classical past. They worshiped its monuments and literature and often aped its customs and manners. Book publishers both north and south of the Alps reissued the classics in Latin and in translation, catering to the demands of their literate clients. The edition of Terence's *Comedies,* from which we reproduce this woodcut, was published in Latin in 1496 and in German in 1499.

The illustrated frontispiece depicts the theater of Terence. The design of the theater itself is fancifully decorative and architecturally is a composite of Gothic and pseudo-Classical elements. The characters of the play wear the garments of the late Middle Ages rather than authentic Classical vestments. Each play is preceded by a full-page cut; for the minor illustrations, a publisher's device of the period is employed—individual smaller cuts depicting the characters, the backgrounds, and certain properties grouped and regrouped in different combinations to fit the story.

Terence, who lived in the second century B.C., was the author of various comedies, six of which have survived. Born in Carthage, he was the slave of a Roman senator who freed him, brought him to Rome, and supervised his education. His plays were adapted from the earlier Greek comedies of Menander. The humor was broad, lusty, and popular. In fact, Shakespeare used strikingly similar plot material for some of his comedies.

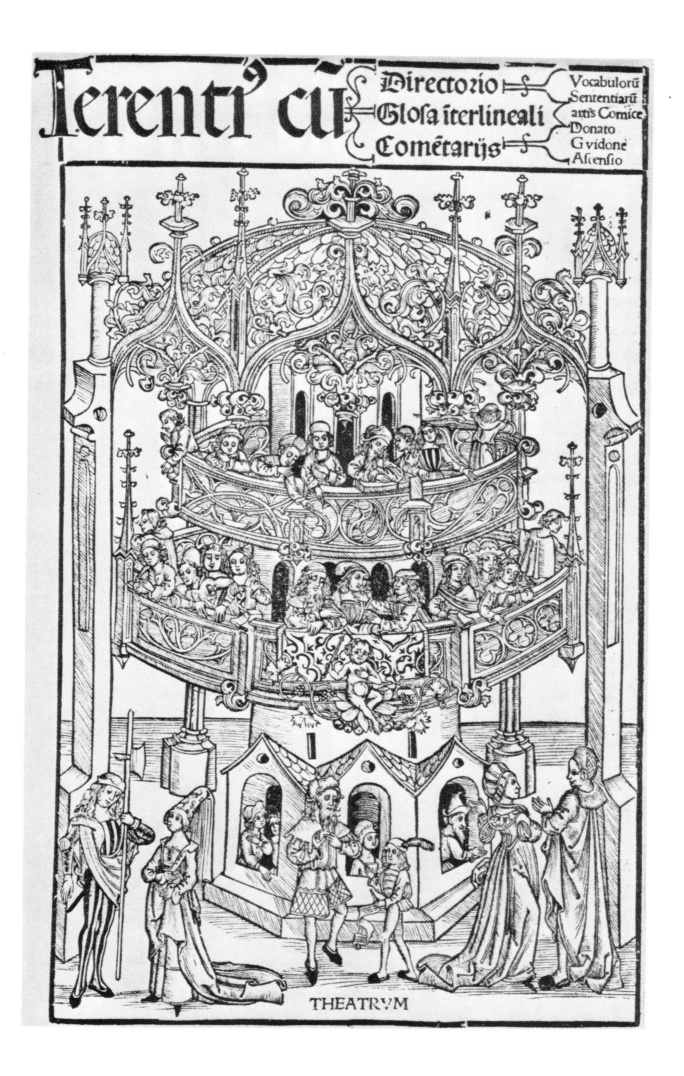

Plate 11

Unknown Italian Artist

HYPNEROTOMACHIA POLIPHILI
("The Love Dream of Poliphilus")

1499. Woodcut, 4⅛ × 5⅛"

Universally judged to be one of the most beautifully designed books of all time, the *Hypnerotomachia Poliphili* was issued in 1499 by Aldus Manutius, the great scholar-printer. A dedicated Humanist, Aldus concentrated on publishing Classical works, most of them by Greek authors. This is the only illustrated book issued by the Aldine press. Its author was the Dominican Francesco Colonna. An Elizabethan translator titled the work *The Strife of Love in a Dream.* The text, however, is far less important today than the illustrations and the design of the printed pages. It is a love story which retells many tales of amatory adventures, the escapades of love, and the various nymphs and mortals Poliphilus yearned for and won. The artist of the illustrations concentrated on the characters of the tale, often representing them provocatively nude, in Arcadia or in architectural settings inspired by Classical architecture. These stories were no doubt entertaining, but they were also educational, for they dealt with pagan tales, archaeological facts, and Classical learning—typical of the Renaissance enthusiasm for *sainte antiquité.* The identity of the artist of these woodcuts is unknown, but the style suggests knowledge of the works of Italian masters—possibly of Mantegna, Carpaccio, and even Botticelli, whose drawings for Dante's *Divine Comedy* may have been known to this designer.

One need not be a specialist or bibliophile to realize the beauty of such a page as that shown here; the type face, the magnificent initial letter "L," and the illustration work together in perfect harmony.

POLIPHILO QVIVI NARRA, CHE GLI PARVE AN-
CORA DI DORMIRE, ET ALTRONDE IN SOMNO
RITROVARSE IN VNA CONVALLE, LAQVALE NEL
FINE ERA SERATA DE VNA MIRABILE CLAVSVRA
CVM VNA PORTENTOSA PYRAMIDE, DE ADMI-
RATIONE DIGNA, ET VNO EXCELSO OBELISCO DE
SOPRA. LAQVALE CVM DILIGENTIA ET PIACERE
SVBTILMENTE LA CONSIDEROE.

A SPAVENTEVOLE SILVA, ET CONSTI-
pato Nemore euaſo, & gli primi altri lochi per el dolce
ſomno che ſe hauea per le feſſe & proſternate mẽbre dif-
fuſo relicti, me ritrouai di nouo in uno piu delectabile
ſito aſſai piu che el præcedente. Elquale non era de mon
ti horridi, & crepidinoſe rupe intorniato, ne falcato di
ſtrumoſi iugi. Ma compoſitamente de grate montagniole di non tro-
po altecia. Siluoſe di giouani quercioli, di roburi, fraxini & Carpi-
ni, & di frondoſi Eſculi, & Ilice, & di teneri Coryli, & di Alni, & di Ti-
lie, & di Opio, & de infructuoſi Oleaſtri, diſpoſiti ſecondo laſpecto de
gli arboriferi Colli. Et giu al piano erano grate ſiluule di altri ſiluatici

Plate 12

Andrea Mantegna. 1431–1506

THE BATTLE OF THE SEA GODS (left portion)

c. 1490. Engraving, dimensions of left portion 12⅞ × 17⅜"

The Italian artists of the Renaissance are among the world's greatest draftsmen, and their drawings, although generally used as preparations for frescoes or easel paintings, were even then greatly appreciated and treasured. It is likely that the engravings of such masters as Pollaiuolo and Mantegna were done "after" sketches which were considered especially admirable. The relatively new device of making multiple impressions on paper permitted the sale of such prints to other studios and other artists. Contemporary memoirs and records tell us that from the fifteenth century on, the sale of prints was a significant source of income for their creators, some of whom derived greater benefits from such work than from their painting and sculpture.

One cannot overlook the closeness of style in the techniques of Mantegna and Pollaiuolo. These artists possibly influenced one another, but the similarity may come also from their use of pen drawings as the basis for their engravings.

Only seven or eight engravings may be safely attributed to Mantegna, although a large number have come down to us which were no doubt inspired by his widely admired drawings; in 1491, Dürer made a pen-and-ink sketch after the right portion of Mantegna's *The Battle of the Sea Gods*. Mantegna's complete work, the left portion of which is shown here, was engraved on two plates to resemble a Classical frieze. For a time it was believed that the source for this double engraving was a Classical relief in Ravenna, but later scholarship revealed that the sculpture was done during the Renaissance and probably copied from Mantegna's engraving.

The exact meaning of the engraving is not known, although the insertion by the artist of a plaque with the inscription INVIDIA (Envy) suggests some literary source.

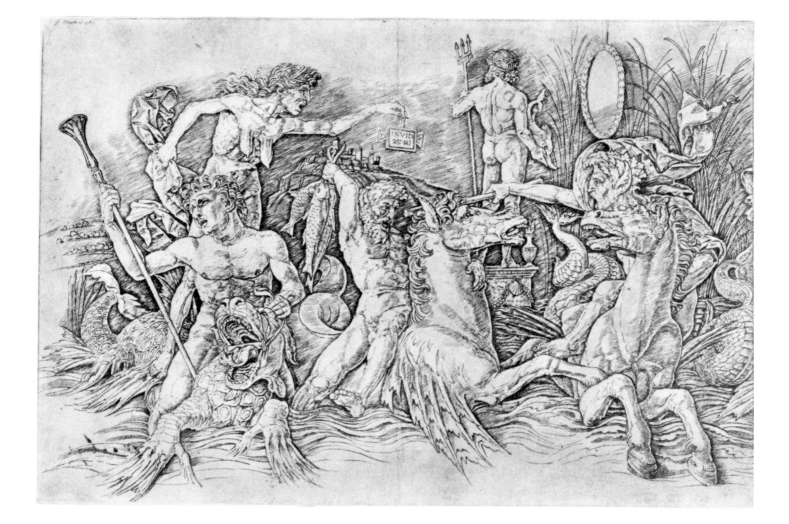

Plate 13

Antonio Pollaiuolo. 1432–1498
THE BATTLE OF TEN NAKED MEN

c. 1470. Engraving, 15¾ × 23½″

Pollaiuolo, like a number of his fellow Florentines, was a master of many arts. He practiced the goldsmith's craft, was an able engraver, and achieved fame as a painter and sculptor.

The Battle of Ten Naked Men, the only print which can definitely be attributed to him, is one of the most celebrated of all engravings, the subject of study by other artists and endless copying by students and admirers. The brilliance of this engraving derives in part from the superb conception of the drawing, which Pollaiuolo's skill as an engraver permitted him to transfer to the copper plate. His style was a personal one, based on the so-called broad manner of the Florentine school, but handled by him with incredible assurance and verve. The nudes are delineated by strong, black, sinuous outlines which establish the contours of the bodies, as well as the violent movements of the ten enraged battlers. The modeling of these figures is achieved by a series of bold parallel lines, with lighter lines laid in at an angle. The alternation of these areas of line with empty white patches produced the finest anatomical study of the fifteenth century. Vasari records that Pollaiuolo understood the anatomy of the human body better than any earlier master and that he developed his own method of studying the musculature as well as the articulation of limbs.

Against a background of trees and tall reeds, interlaced to form a tapestrylike setting, the fierce antagonists fight to the death. The beautiful, almost static character of this background suggests that Pollaiuolo was a master of the niello technique (*see page 22*). But there is nothing static in the depiction of the battle, for the warriors about to slay or be slain are filled with nervous tension. No viewer can resist the temptation to try to figure out which will survive.

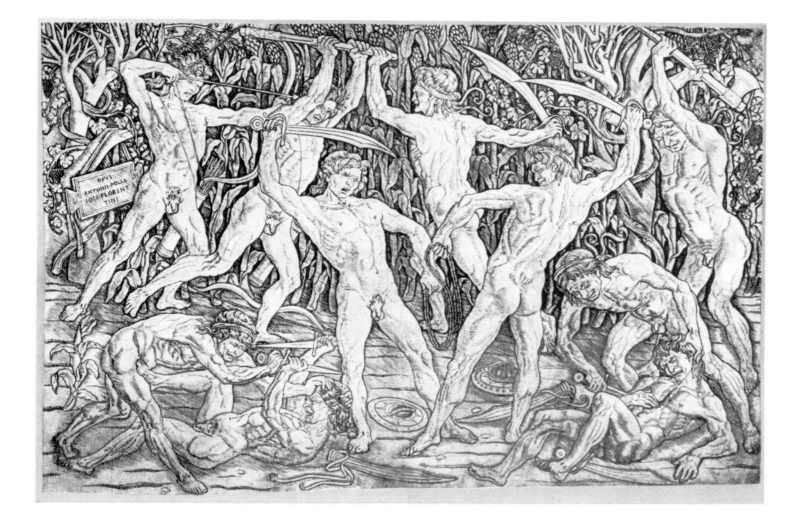

Plate **14**

Ugo da Carpi. c. 1480–c. 1523
Hero and Sibyl
(traditionally called Raphael and His Mistress)

After 1518. Chiaroscuro woodcut, 11½ × 8⅜"
Courtesy William H. Schab Gallery

In the introductory section of this book, the technique of making a chiaroscuro print is briefly described (*p. 21; fig. 11*). Here the larger format and the addition of color offer a better opportunity to appraise the character and qualities of this type of color woodcut. The finest examples of works produced by this method are generally conceded to be by Italian artists, and these prints are probably the first to be created specifically as wall decorations. Detail is reduced to a minimum and stress is placed on bold composition, large contours, and flat, subtly colored areas.

Ugo da Carpi is a somewhat controversial figure. The dates of his birth and death are not generally agreed upon. Vasari mentions him as a "mediocre painter," but nevertheless "in other flights of fancy, of the keenest genius." His chiaroscuro prints should be considered the products of these "flights of fancy." He worked in both Venice and Rome, and in the former city he probably first learned the art of woodcutting and the special technique of the chiaroscuro print. During his sojourn in Rome, many of his works were inspired by the art of Raphael, whose drawings he translated into this new medium. These sold so well that they were counterfeited by some Venetian artisans, and Ugo returned to Venice to present a petition to the Senate for a special license to protect him against this piracy.

Attributions in this medium are not readily made. The illustration of the present example in the scholarly catalogue of William H. Schab carries a question mark after the artist's name. It is, however, a splendid work and definitely in the master's style. It is discussed by Paul Poirier (*Esthétique de la gravure italienne*, 1964), who considers it "a landmark in the development of the chiaroscuro woodcut." He refers to it by its older title, *Raphael and His Mistress*. Schab's opinion, most likely the correct one, is that "the subject is probably taken from classical mythology and represents a hero consulting an oracle or sibyl."

The subject is printed from four blocks, one in black, one in gray, and two in shades of ocher.

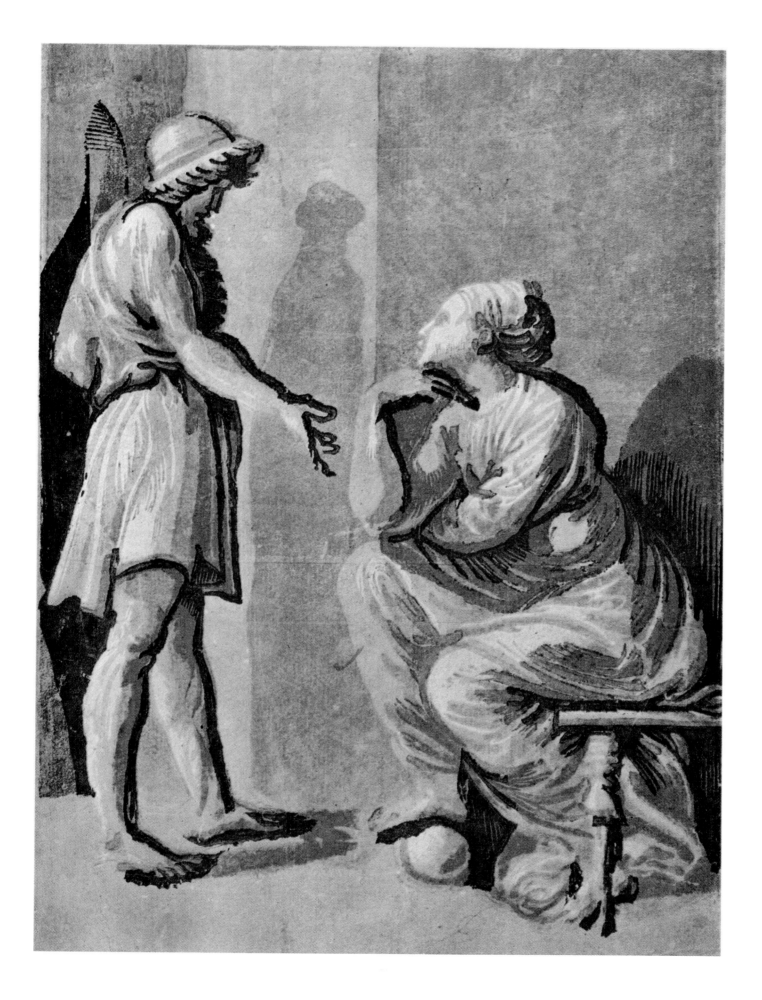

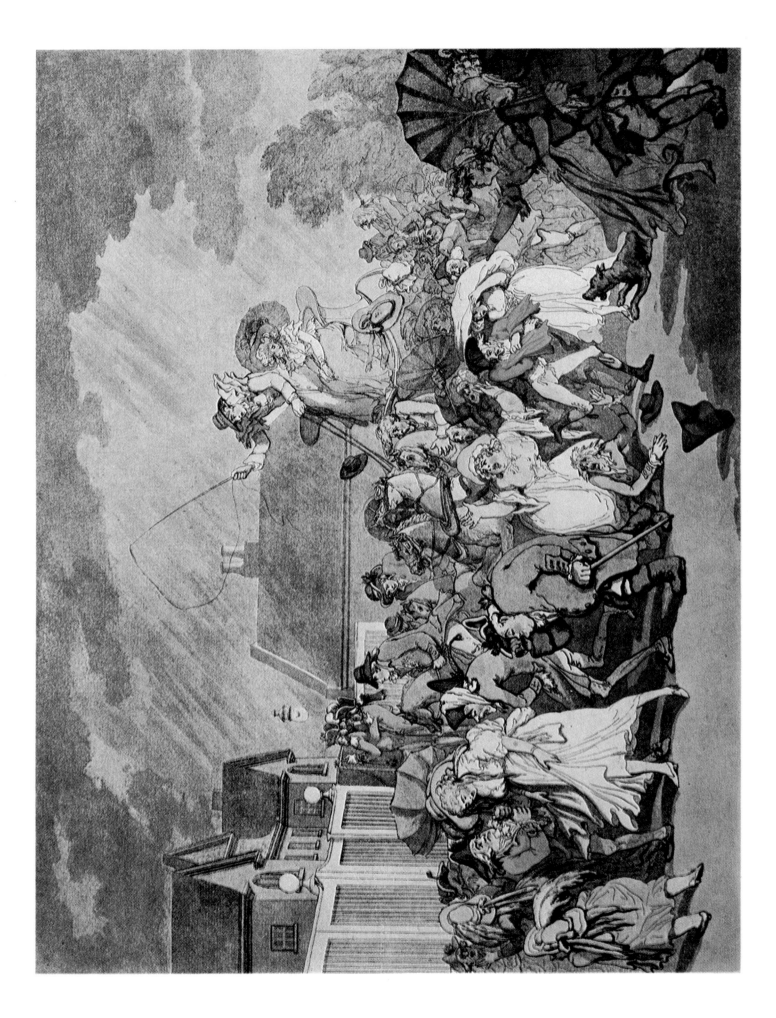

Plate 15

Thomas Rowlandson. 1756–1827

A SUDDEN SQUALL IN HYDE PARK

c. 1787. Combined technique of etching and aquatint, hand-colored, 15 × 20"

In an essay entitled "Some Drawings by Thomas Rowlandson," Frank Jewett Mather compares the work of the English artist with sketches by the brilliant Japanese master Hokusai. This is high praise: describing works by these men Mather writes that "in swiftness and economy there was virtually no choice between the two."

Accurate data on Rowlandson's life are relatively few. His legend, however, is a colorful one, and much of his autobiography is inherent in his watercolors and prints. He was a hearty drinker, "a man about town," and an inveterate gambler. He was born in 1756 in Old Jewry, London, to a well-to-do merchant family. Like many spirited young artists, he was not overdiligent at school, and filled the margins of notebooks with sketches and caricatures; at sixteen he entered the new school of the Royal Academy and won praise for his excellent "nudes." His aunt took him to Paris and later left him some seven thousand British pounds. Both Paris and London lured him with gaming tables and other attractions. Sporadically he produced portraits, which were exhibited at the Royal Academy, and a number of political caricatures. A Viennese color printer, Rudolf Ackermann, set up shop in London and found in Rowlandson a fine property. For Ackermann he produced book illustrations and a series of prints which became very popular.

Rowlandson executed his etching directly on the copper plate, after his own design. He would then "wash in" tones of gray which indicated the areas for aquatinting to be added by some other artisan; on a proof from the aquatinted copper he applied delicate transparent watercolor to serve as a guide for the "washers," who tinted the etched proof after his model.

Many of Rowlandson's prints were hastily done, suggestive of hack work. The themes were often bawdy, and the humor much broader than in works by contemporary French artists. They sold well, and pleased both buyer and print seller.

The present colored aquatint reveals Rowlandson at the height of his power in the medium of the color print. The lower left margin carries the inscription "Drawn and Etched by T. Rowlandson." In the right-hand lower margin appears the name of the aquatinter.

The subject matter of *A Sudden Squall* offers the artist an opportunity to be sly, to poke fun at his English contemporaries. Many types are depicted: thin and obese fops, and the "fair sex" in various ages and shapes. There is nothing of Hogarth's occasional viciousness. Rowlandson's satire is gentle but sufficiently barbed. The composition is superb, and the gradation of color, from the dark areas in the lower right through the lighter patches in the sky to the whites of the women's dresses, is subtly dramatic.

One of Rowlandson's favorite sayings, quoted in his obituary, was: "I have played the fool, but here" —holding up his pencils—"is my resource." Time has justified his belief in the rich resource of the tools of his craft.

Plate 16

Martin Schongauer. c. 1440–1491
THE NATIVITY

c. 1470. Engraving, 10⅛ × 6¾″

In Schongauer's art may be found a transition between the final—and possibly finest—expression of the Gothic and medieval dream, and the first tentative reaching toward Humanist ideals, soon to come to fruition in the works of Schongauer's admirer, Albrecht Dürer.

Schongauer, like Dürer and others, received his first training as a goldsmith. A man of many talents, he explored other fields and also became a painter of note. Fortunately, a number of his paintings have survived, and documents indicate that there were many more. His training as a painter is evident in his engravings, where subtle relationships of tone and "color" are suggested by the skillful gradations from black to white.

In this engraving, *The Nativity*, the Gothic storytelling element remains strong. As used in Classical times and throughout the Middle Ages, the tale is told by means of a convention called "continuous narrative." Thus, if we look through the pointed arch at the back we see the angel announcing his message to a shepherd. The Nativity takes place, not in a manger, but in the ruins of a vaulted Gothic edifice; this allows the shepherds to move forward to the next stage, and view the scene through an arched aperture.

Schongauer anticipates Dürer's love for such details as the vines overgrowing the ruin, the accurately observed plants growing between the stones in the foreground, and grasses sprouting from crevices (*see fig. 14*). The Virgin, melancholy and ideally beautiful, gazes adoringly at the Child. Joseph holds a lamp to indicate that this scene takes place at night; he has eyes only for Mary. In the upper right-hand corner three angels flutter over the arch, to herald the miracle with their singing.

Schongauer's mastery of the art of perspective and of sophisticated composition is evident in this beautiful engraving. There is superb control, too, in his handling of the burin, using crosshatching in the dark areas, and parallel lines, flicks, and broken lines to suggest the textures of soft robes, weathered stones, and human and animal flesh.

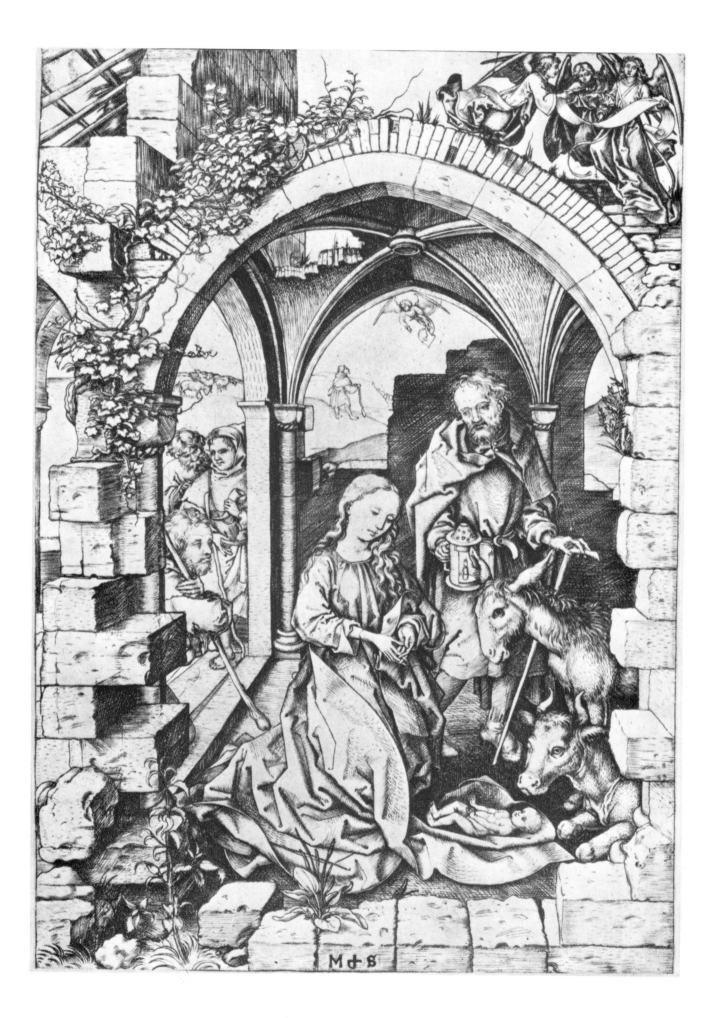

Plate 17

Martin Schongauer. c. 1440–1491
A FOOLISH VIRGIN

c. 1480–90. Engraving, $5\frac{5}{8} \times 4\frac{1}{4}''$

The name of Martin Schongauer is generally linked with that of Albrecht Dürer, who knew and admired the former's engravings (some 115 plates). Dürer was on his way to Colmar to visit the master, but was delayed on his journey and arrived only after Schongauer had died. However, he was graciously received by Schongauer's family and spent some time at Colmar. Dürer's early graphic style is patently inspired by the work of the older engraver (*see fig. 13*).

A Foolish Virgin demonstrates Schongauer's anticipation of Dürer in his desire to free himself from the prescribed iconography of religious subjects. The story of the wise and foolish virgins was popular in the Middle Ages and was often carved on the stone portals of Romanesque and Gothic churches. This subject permits Schongauer to turn from the holy and virtuous types he delineated so skillfully, and depict a more human type: a woman of the world rather than a saint. He shows a shapely female figure who exudes an aura of sex, with breasts half exposed, inviting glance, and sensual lips. There are a number of drawings by fifteenth-century Italians that depict courtesans and strongly resemble the subject of this print.

The representation here no longer seems a generalized or idealized type, but rather, like the Italian drawings, the image of a woman whom the artist found bewilderingly attractive.

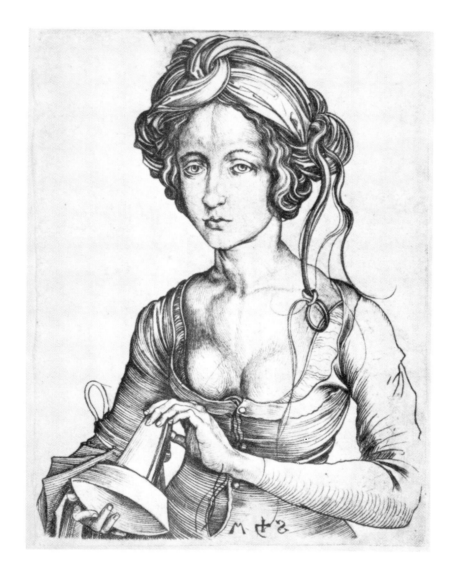

Plate 18

Israhel van Meckenem. 1450–1503
THE ARTIST AND HIS WIFE

c. 1490. Engraving, 5⅛ × 6⅞"

Israhel van Meckenem learned his trade in the shop of his father, who was a goldsmith and engraver, and his first efforts were quite naturally copies of his father's prints. His apprenticeship completed, he joined the shop of the Master E.S., an artist whom we know only through his monogram, but who was one of the finest and most successful engravers of his time (*see fig. 2*). When the latter died, Van Meckenem acquired a good many of his plates, pulled impressions from them, and sold the prints. One must realize that these early craftsmen made their livelihood from the creation, the printing, and the sale of their engravings. They often copied favorite works by other artists—prints by Schongauer, the young Dürer, and others. Thus, the success of many prints derived from their popularity as models for other artists and workshops.

Israhel van Meckenem copied many of the best works of his day. There must have been a fair amount of larceny in him (one might detect it in his face), for he added the marks and signatures of the original artists to his copies, having no ethical or legal right to do so. No other fifteenth-century engraver produced as many plates as he, and 624 are known to us today.

The print illustrated has great significance in the history of graphic art, for it is the first self-portrait of an early engraver that has survived. He represented himself here with his wife, who in all likelihood helped him run his business—and it was a business for this enterprising couple. They sold prints from their own studio, as well as those of other artists. We know that the editions were large, since over a hundred impressions of certain subjects, done some 475 years ago, have survived the ravages of time and now belong to various collections.

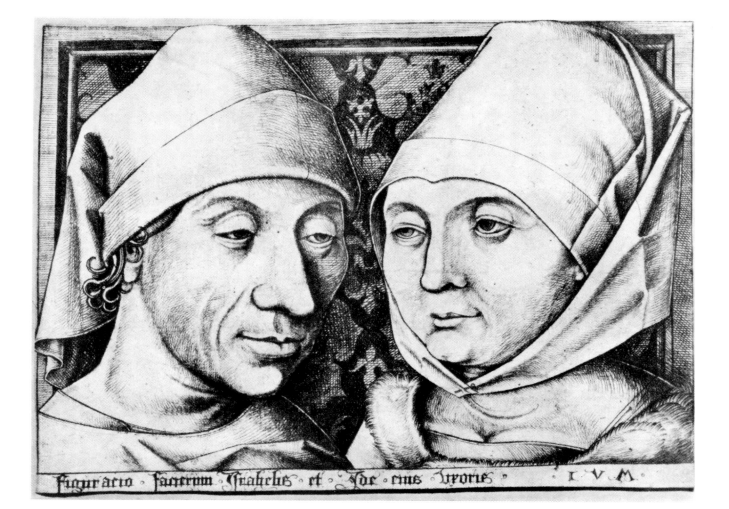

Plate 19

Israhel van Meckenem. 1450–1503
THE LUTE PLAYER AND THE HARPIST

c. 1490. Engraving, 6½ × 4⅝″

Students of architecture, of the history of costume, and of interior decoration are all indebted to Van Meckenem for the record he left us in such works as the one illustrated here. It is one of a series of twelve depicting the interiors of homes—not the castles or palaces of kings and potentates, but the houses of fairly affluent citizens. The latter are shown in various pursuits, playing the organ, lute, and harp, or preparing for bed. Thus we see the different rooms of a residence, with many of the furnishings carefully and faithfully delineated. In this engraving we may study the architecture of the room, the decorative chandelier, and a table and chair of the period. (Some prints in the series show more appurtenances than this rather sparsely furnished room.) Great care was taken with the details of costume and of musical instruments, and thus they provide excellent models for the present-day copyist. Indeed, the majority of Van Meckenem's engravings were sold to other artists as a kind of dictionary from which they might lift details; it is more than likely that our practical businessman created this series with such a use in mind. We may note here the crispness of the fine parallel lines, some crosshatching in the dark areas, and delicate flicks that model the countenances and garments—the work of a good, if uninspired, engraver. There is also a suggestion of portraiture in the expressions of the musicians, and it is quite possible that the furnishings were not the artist's only models. We have already noted in the previous illustration that Van Meckenem was capable of superb characterization.

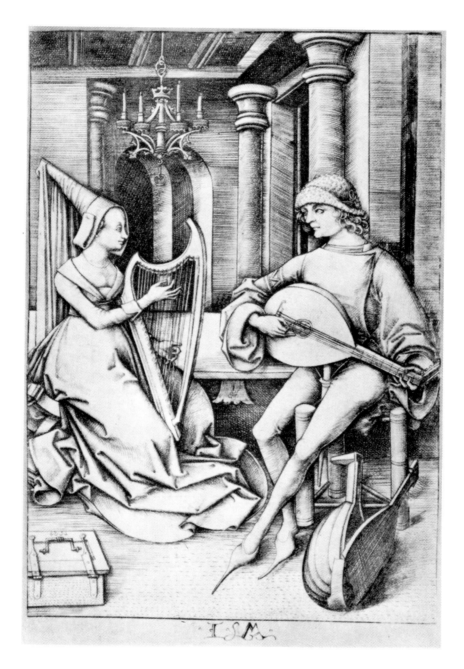

Plate 20

Albrecht Dürer. 1471–1528
THE DREAM

c. 1497–98. Engraving, 7½×4⅞"

It has been observed by every commentator on Dürer's genius that in his work is found the blending of two great traditions—the medieval, culminating in the Gothic, and the revered Classical, rediscovered and nurtured by the Renaissance, especially in Italy.

Erwin Panofsky feels that *The Dream*, sometimes called *The Dream of the Doctor*, should be titled *The Temptation of the Idler*, for here is pictured a slothful, self-indulgent individual who sleeps in front of his heated fireplace, comfortably resting his head against a soft pillow. According to medieval codes of conduct such behavior encouraged temptation, which is represented by the Devil, a demon who "blows" thoughts, presumably evil, into the sleeper's ear. Probably the dream itself is represented by the nude Venus, voluptuous and inviting. She is accompanied, no doubt to identify her, by a playful Eros. The model for the female form may well have been taken from the languorous women of the Italian Jacopo de' Barbari, whose engravings Dürer admired, or from other works by Italian masters which he knew.

Young Dürer was trained as an apprentice in his father's goldsmith shop. There he learned the use of the graver or burin for incising designs and images into metal. Practically all of the great masters of the engraved print had similar early training.

Dürer's mastery of his tools is evident in this print. Note the clean, sure flicks of the graver, suggesting modeling and volume. In the upper background, minute crosshatching is employed to project the sleeping figure forward from the rear plane. Dürer's training as a goldsmith also prepared him to render the hardware of the furniture, the texture of the tiles, and the graining of wood.

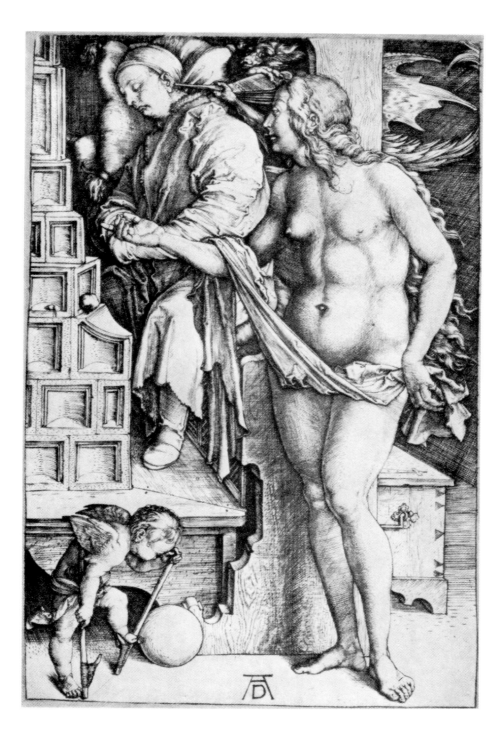

Plate 21

Albrecht Dürer. 1471–1528
The Four Horsemen

1497–98. Woodcut, 15½ × 11⅛″

Dürer, who made woodcuts, engravings, drypoints, and etchings, must be adjudged one of the greatest masters of graphic art. As Erwin Panofsky says, "His prints set a new standard of graphic perfection for more than a century, and served as models for countless other prints, as well as for paintings, sculptures, enamels, tapestries, plaques and faïences, and this not only in Germany, but also in Italy, France, in the Low Countries, in Russia, in Spain, and indirectly even in Persia."

One of Dürer's major works, his large book *The Apocalypse,* is represented here by one of the fifteen woodcuts that comprise the edition of 1498. It appeared in two parallel editions, one with German text, the other with Latin. A unique feature of this book is that the images are not encumbered by text, thus allowing the full impact of the "vision" to be experienced. (The text was printed on the reverse sides of the pictures.) This volume is also unusual in that it is the first book issued by an artist who was at once the designer of the work, the creator of the woodcuts, and the publisher.

A religious man, Dürer was deeply moved by the Revelations of St. John, and in this print he translates, if somewhat freely, the description of the devastating ride of the avenging horsemen. The four riders seem to rush out of our field of vision at a furious pace, and the sharp angle created by the movement of figures from the lower left to the upper right of the picture is as modern and sophisticated as that in many Impressionistic works of the nineteenth century. Here is not the frozen, static quality of the battle scenes of academic art, but rather a furious, tumultuous, heartless act of annihilation.

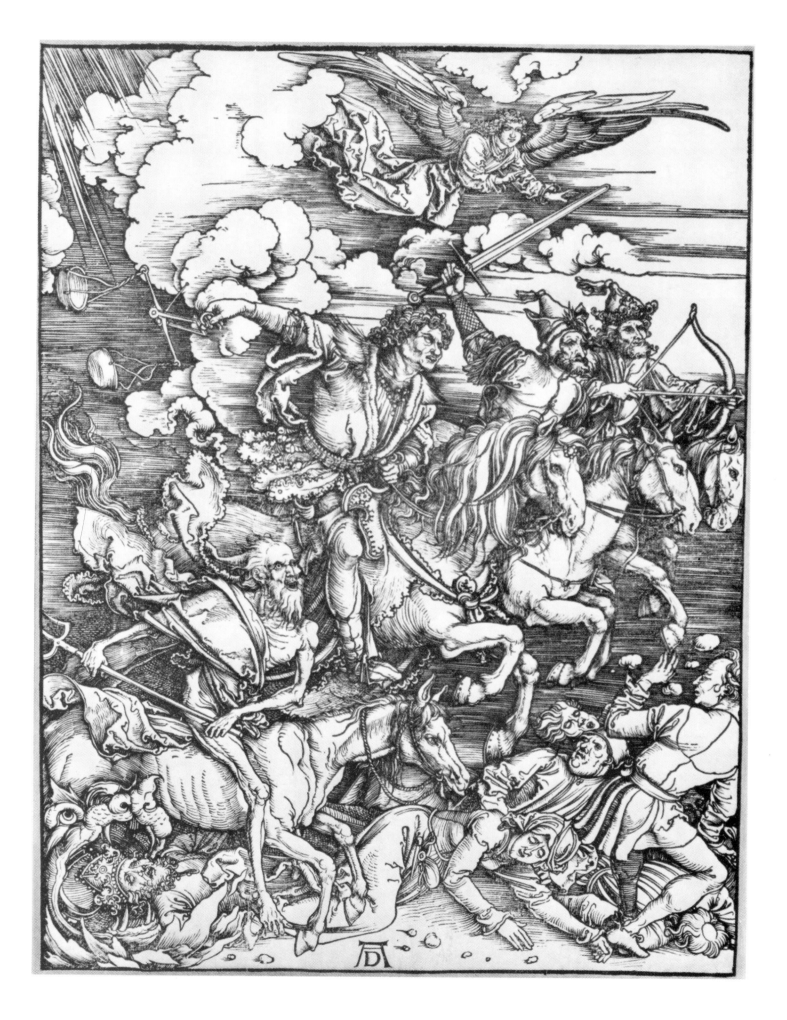

Plate 22

Albrecht Dürer. 1471–1528

THE SEA MONSTER

c. 1498 (Panofsky); c. 1501 (Dodgson). Engraving, 9⅝ × 7⅜″

Historians are in general agreement as to the high merit of this engraving. No viewer can contemplate it without being intrigued by its subject matter and awed by the competence of its execution. However, scholars have disagreed about the true meaning of the action taking place, and in their attempts to identify the story with a particular legend or myth. At first blush, many parallels suggest themselves—tales from Ovid, Lucian, or Pausanias. But the details in this representation do not agree with the Classical sources. Dürer was so knowledgeable in the field of myth and legend that at times he felt free to take liberties and improvise. But when he chose to represent an authentic antique hero he identified him properly, as in his woodcut of Hercules and Cacus, done about the same time as this one.

Dürer mentioned this work in his records as *Das Meerwunder* ("The Sea Monster"). He loved a good tale, especially if it included weird elements. It has been suggested that Dürer heard some current story about the rape of a young girl by a monster who came out of the sea. Fascinated by various elements suggested by ancient tales, he mingled them in this scene.

The magnificent, shapely young woman who had apparently been bathing with her friends (who now seek shelter on the far bank) is being carried off by a strange, bearded creature, half human, half fish. She does not seem too reluctant to leave family and friends; nor does the sea monster appear evil—in fact, he hardly seems to notice his voluptuous cargo. The rest of the scene shows nature at its most serene. Elaborate buildings nestle on the hillside or are perched on the heights. In the foreground Dürer creates an arabesque of small waves, and completes it with a charming rendering of grasses growing on the shore. Like so many of Dürer's works, this picture, once viewed, is not readily forgotten.

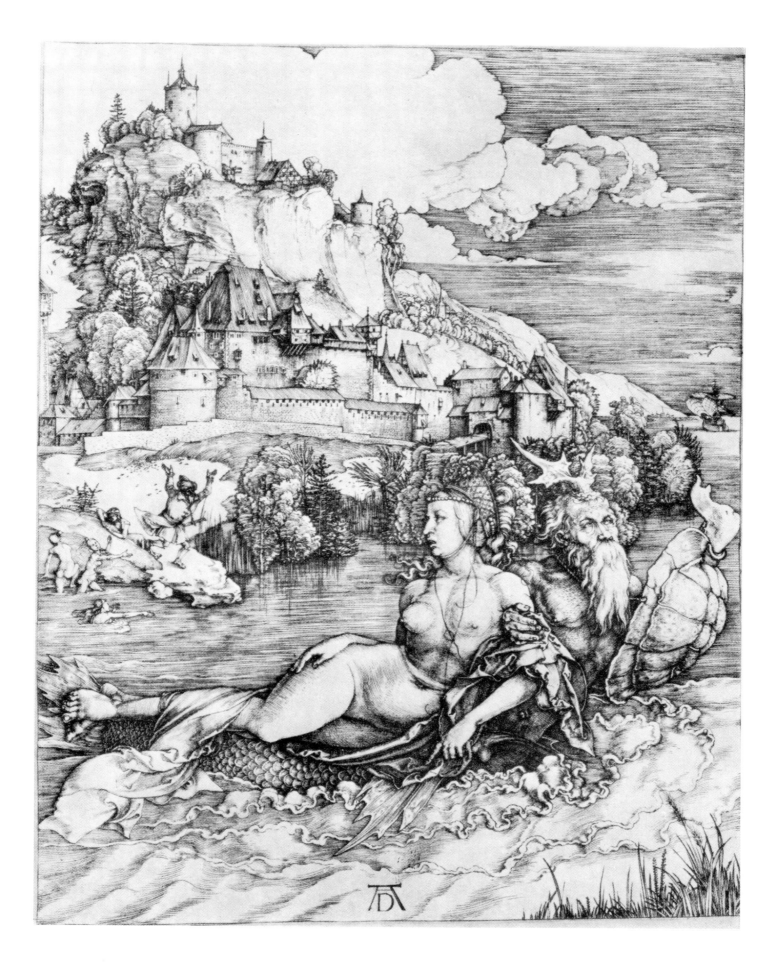

Plate 23

Albrecht Dürer. 1471–1528
Adam and Eve

1504. Engraving, 10 × 7⅝"

This engraving is considered by many to be one of Dürer's most brilliant achievements. Obviously the artist himself considered it a major effort; for the first time, he engraved his name in Latin and added the date. Five states of the print are known, of which our illustration is the fourth or fifth, and it is interesting to discover the use of a technique adopted by Rembrandt for some of his etchings (*see plate 40*). In the earliest state the figures are only outlined, except for Adam's right leg. As Dürer progressed, he "worked up" Adam's other limbs and transformed the simple outlines of Eve's form into a fully modeled body.

By 1504, the artist was acquainted with much of the art of the Italian masters, and had seen famous Classical statues of Apollo, Venus, and Mercury. He studied the poses, measurements, and proportions of ancient marbles, and felt a challenge to reproduce this antique beauty. From ugly reality he sought to create the ideal. He studied Vitruvius and worked out geometric proportions, using the compass and the ruler. Just as he had once been challenged by the laws of perspective, he now sought to master the perfect canon for rendering the human figure in all its proportional beauty.

This exquisite print also boasts a degree of the symbolism so dear to the medieval and early Renaissance mind. Erwin Panofsky, in his definitive work on Dürer, points out that the cat and mouse at the feet of the figures possibly suggest woman's predatory feline quality and man's weak susceptibility. He goes on to mention the wise parrot contrasted with the evil snake, and the four animals—elk, cat, rabbit, and ox—who represented respectively melancholic gloom, choleric cruelty, sanguine sensuality, and phlegmatic sluggishness to the sixteenth-century viewer. But for most of us today this scene shows an episode from the Old Testament, rendered with a superb feeling for the human form—surely sufficient a message.

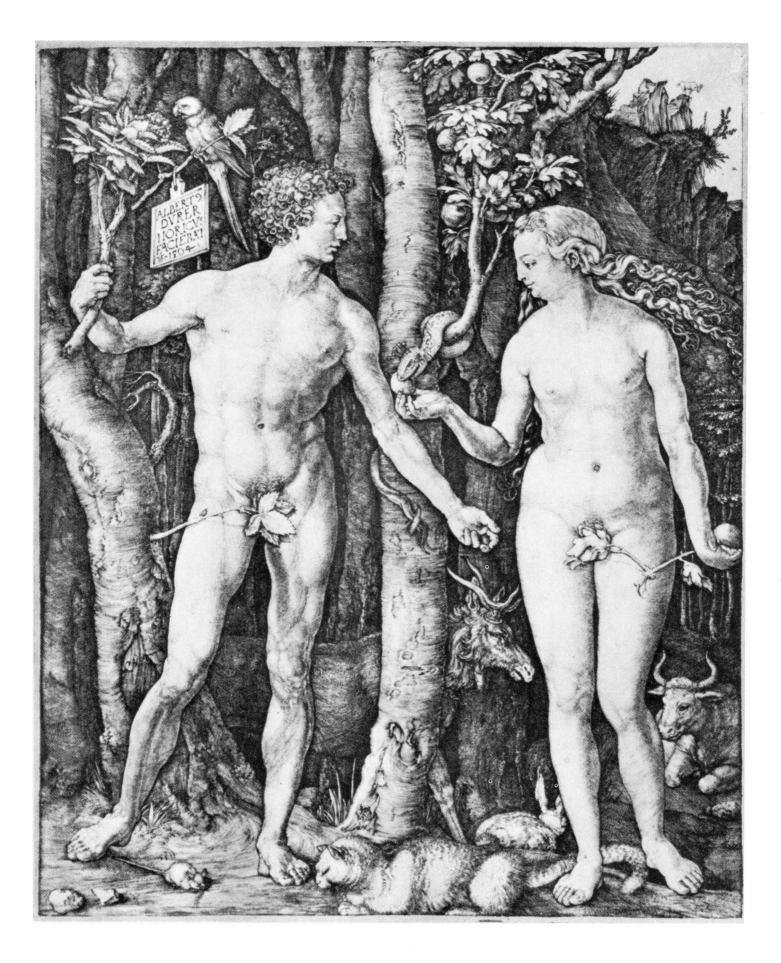

Plate 24

Albrecht Dürer. 1471–1528

MELENCOLIA I

1514. Engraving, 9⅜ × 7½″

Campbell Dodgson, Keeper of Prints and Drawings at the British Museum, has written: "The literature on the *Melencolia* is more extensive than that on any other engraving by Dürer: the statement would probably remain true if the last two words were omitted." Panofsky, after dedicating numerous pages to this print, states: "Thus Dürer's most perplexing engraving is, at the same time, the objective statement of a general philosophy and the subjective confession of an individual man." The influence of this astonishing work has endured for more than three centuries and has reached into many areas—the works of other artists, and the verses of such poets as James Thomson in his *City of Dreadful Night*.

Let us, however, examine this print without attempting to follow the reasoning of scholars or to interpret the symbols scattered throughout the composition. An impressive, moody figure, with attributes of a celestial being in its wings and wreathed crown, is surrounded by paraphernalia of various trades, as well as a winged *putto*, a sleeping hound, a rainbow, a flash of light from the heavens, and a bat on whose wings is inscribed the title *Melencolia I*. This print is reminiscent of no work by any other master—it is not derived or borrowed from any works which predate it. Let us then be moved by it, dream our own dreams, and interpret them as we wish, for this work of art offers us a keen aesthetic experience.

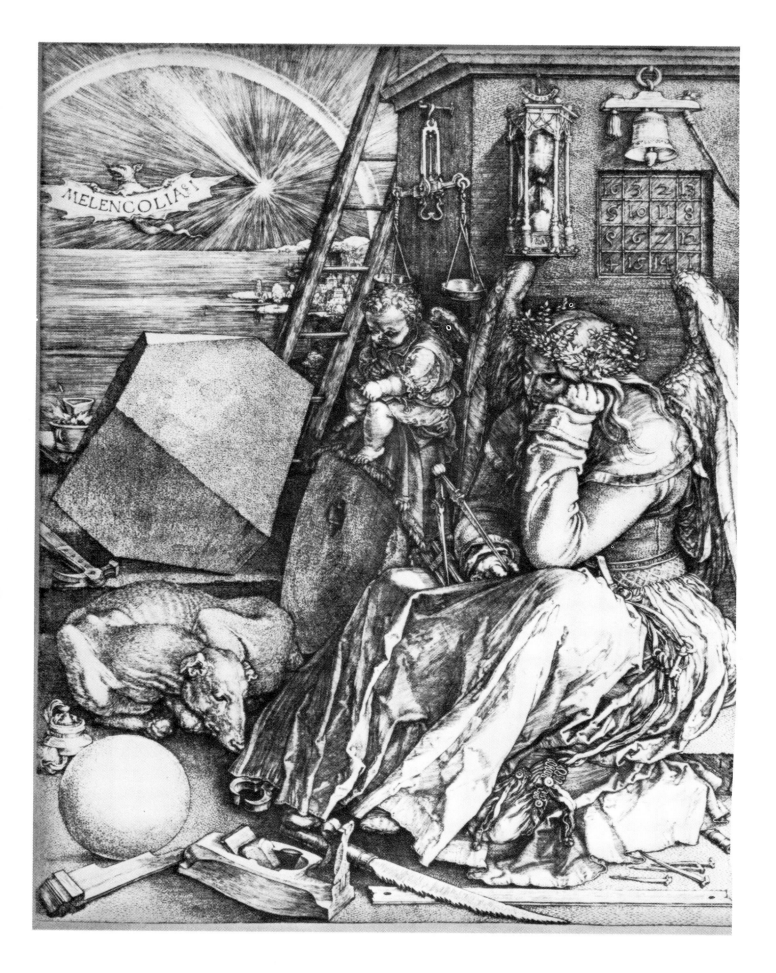

Plate 25

Lucas Cranach the Elder. 1472–1553
ADAM AND EVE

1509. Woodcut, 15¼×9⅛″

Lucas Cranach, who was to become court painter to the Elector of Saxony, performed other tasks for a livelihood before this honor was bestowed upon him. He was for a time a pharmacist, a burgomaster of Wittenberg, and the director of a factory for the production of pictures. He may have turned to designing woodcuts for the monetary rewards involved, for they were much in demand in Germany at the beginning of the sixteenth century. Even the greatest painters of the period contributed to the illustration of books, and made single-sheet prints and series of pictures of a religious character—often with imperial sponsorship. Dürer, Holbein, and Lucas van Leyden were among the more famous painters who engaged in the production of prints.

Cranach was more competent as a painter than as a printmaker. Apparently he did not find the medium a congenial one; perhaps he used it to satisfy financial needs, or because it was considered a worthy and lucrative profession by the best artists of his country.

This scene of Adam and Eve in the Garden is typical of his style—of its virtues and defects. He had a tendency to overcrowd his compositions, to overstress secondary details, and to fail to concentrate on the main theme. The central figures stand before a huge tree (Cranach did not omit the arms of the Elector of Saxony, hanging on one of the limbs). Adam, a somewhat emaciated type, is seated next to a standing Eve, similar in proportion and sexuality to Venus and other comely goddesses who often appear in Cranach's paintings.

Cranach gave equal attention to the various animals surrounding the figures. They are drawn with incredible dexterity based on a sound knowledge of their respective anatomies. Though hardly equal to Dürer's accomplishment in the art of the woodcut (*see plate 21*), this print by Cranach has an intriguing quality of its own.

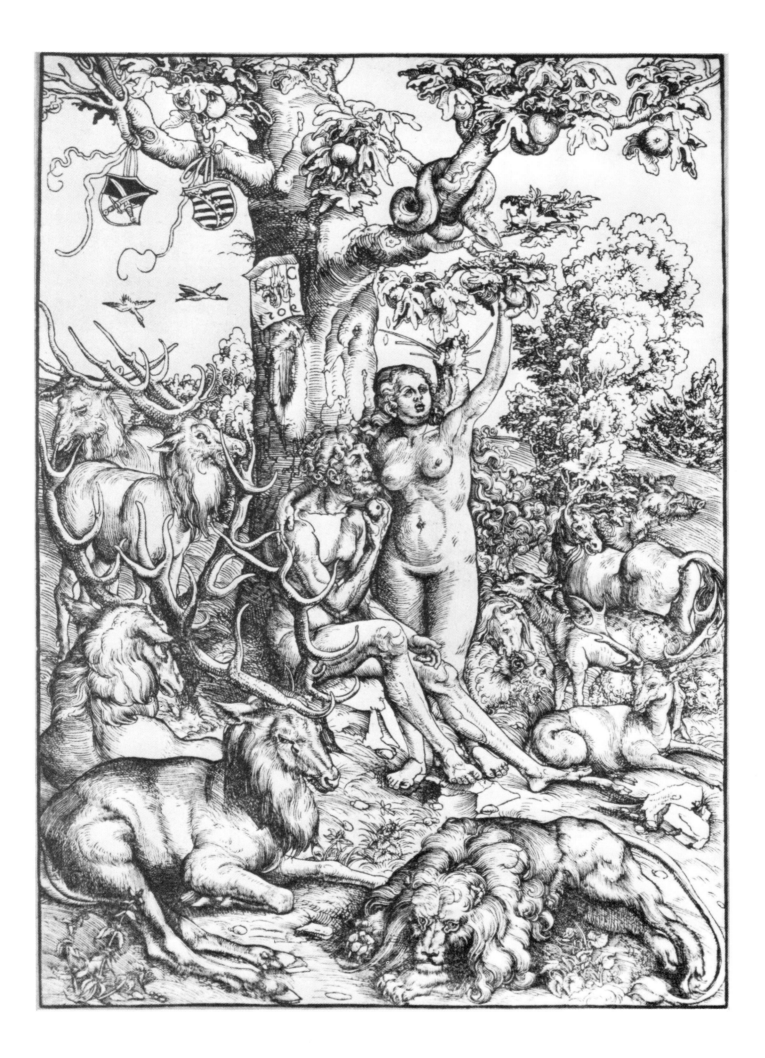

Plate 26

Hans Baldung. 1484/5–1545
The Groom Bewitched

c. 1544. Woodcut, 13 × 7¾"

Hans Baldung was a powerful designer of woodcuts (*see fig. 11*), second only to Dürer in his ability to create an atmosphere in which the familiar becomes strange and eerie. He, like some of his Flemish contemporaries, favored weird tales of demons and witches, so that many of his scenes deal with diablerie and magic. One of his masterpieces of this genre represents malevolent witches riding goats in an atmosphere as ominous as that described by Goethe in *Faust*.

We have selected here the startling representation of a bewitched groom, not only because it is typical of Baldung's favorite subject matter, but because it is so original and inventive. One senses in this artist the same desire to probe the laws and principles of perspective that we find in the earlier Italian masters Paolo Uccello and Piero della Francesca. The fallen groom, daringly foreshortened, with feet extended almost out of the picture and head reaching to the entrance of a second room, recalls a similar experiment of Andrea Mantegna's, the dead Christ in his painting of *The Lamentation*.

The unlucky groom had been caring for his horse when the evil creature appeared at the window on the right and leveled her curse at him. He lies prostrate in a trance. The horse turns his head, obviously sensing something strange.

The viewer realizes at once that the artist was as much concerned with the design of his picture as with its literary content. On his flat sheet of paper he has succeeded in suggesting deep space: a view that extends from one room into another, and continues through an opening in the back to the open air outside. This print is fairly large and was probably intended as a decoration. The engraved lines are set wide apart except in the back stall, where they are worked into a screenlike effect to suggest a darker area. This is a memorable print, and, for the period, a veritable tour de force.

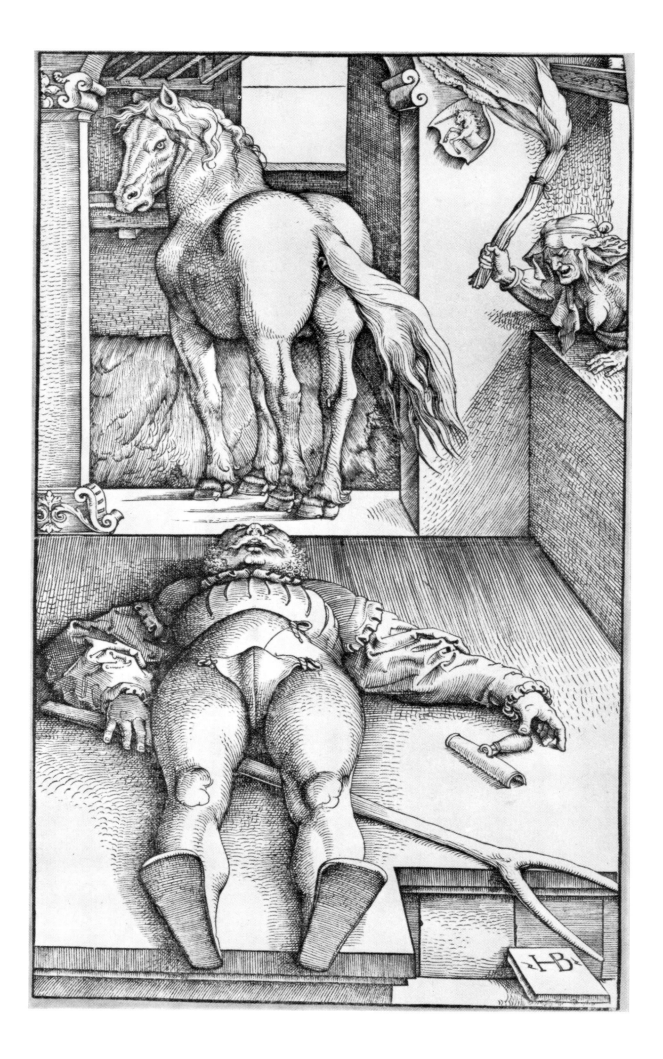

Plate 27

Lucas van Leyden. 1494–1533
DAVID BEFORE SAUL

1508. Engraving, 9⁷⁄₈ × 7³⁄₄″

Lucas van Leyden was considered a child prodigy; it is believed that he executed some fine engravings when he was only fourteen years old. One of these, *Mahomet and the Dead Monk Sergius,* is so competent in workmanship that it was certainly made after his works from a more tender age. When he died in 1533, after a relatively short life, he was famous both in the Netherlands and in Italy. Dürer went to visit him in Antwerp and recorded the meeting in his diary. The German master honored him by making a sensitive silverpoint portrait.

We have no records of any engraver of stature in Leyden before Lucas, and it is likely that the works of the German engravers—the Master E. S., Schongauer, and Israhel van Meckenem—were his sources of study. Lucas, however, was not a slavish copyist, and his style bears little resemblance to that of other masters.

The print shown here, *David before Saul,* is a product of the artist's youth, and it demonstrates his competence as a technician, as well as his amazing skill at delineating character through gestures and physiognomy. Here are real people, not stereotypes. Clearly, they are portraits of individuals seen and studied, not only for superficial facial characteristics, but for the inner man. They are among the first psychological studies in art, and the viewer is tempted to gaze long at David and Saul, and at the figures in their entourage as well. Lucas anticipated certain compositional devices employed in the nineteenth century: note the profile of the soldier at the extreme left, half of whose figure is cut off by the edge of the plate to suggest the movement from outside our field of vision into the crowded room. Sophisticated, too, is the use of lances and spears in the upper section of the print to indicate the presence of other men.

The engraving technique is exceedingly fine, with lines extremely close to one another. Such mastery indicates early training as a goldsmith.

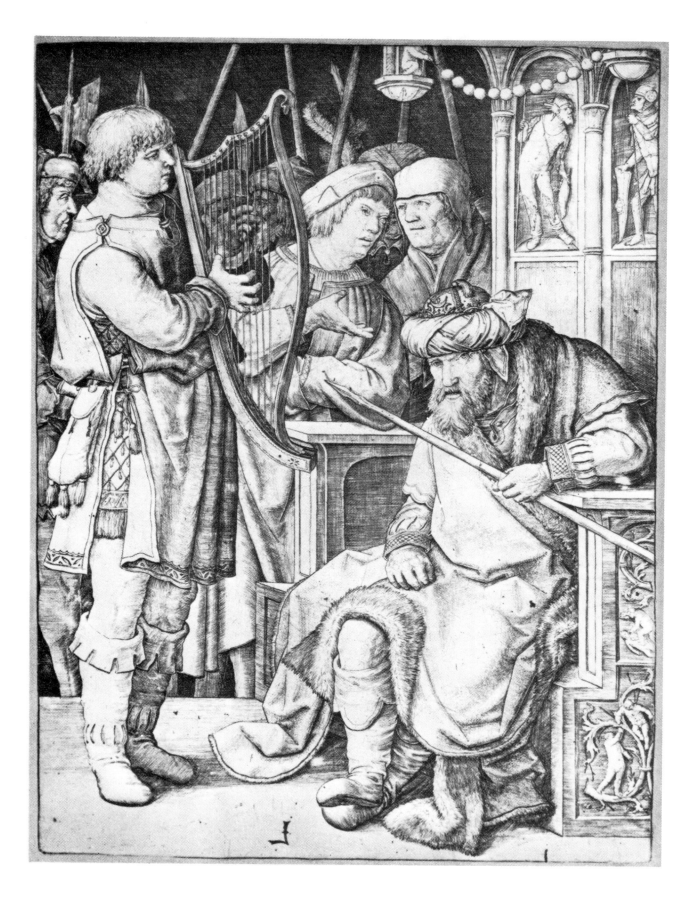

Plate 28

Hans Holbein the Younger. 1497–1543
The Rich Man; The Queen

Illustration for THE DANCE OF DEATH. *1523–26*
Woodcut, each 2¹⁄₂ × 1⁷⁄₈"

The Dance of Death was a recurrent theme in the literature, art, and drama of the Middle Ages. In one form or another, it continued well into the Renaissance, finding expression in frightening and macabre imagery that is only occasionally lightened by touches of humor (*plate 1*). The approach of Death, almost always personified by the skeleton, was anticipated by the masses, for they had seen recurring plagues carry off family and friends. Thus, the poor found consolation only in the fact that Death was the great equalizer who spared no one. The message of most of the illustrations emphasizes this point: kings and queens, laymen and clergy, good folk and evil, wise men and fools are all approached by Death.

It remained for Holbein to bring to this theme a lightness of touch, an elegance that extends to the very engraving of the wood blocks. The prints are miniature in format, and though each one tells its story dramatically, there are also charming details of a decorative nature—the interiors of rooms in private homes, convents, or castles. Holbein drew the designs, and a brilliant craftsman, Hans Lützelburger, is credited with the cutting of the blocks.

Holbein's subtle sense of humor is revealed in the episode of Death and the rich man. Since for the rich the loss of wealth is a "fate worse than death," Holbein shows the bewildered owner left untouched by the skeleton—who makes off with his gold, not his soul.

In the other episode, Death is coming for the Queen. All her soldiers and courtiers cannot protect the terrified young woman, healthy and in the prime of life, from her doom. The encounter takes place in the open, before a background that includes a pseudo-Classical building, a view of trees, sky, and a distant town.

Plate 29

Hans Sebald Beham. 1500–1550
THE PRODIGAL SON WASTING HIS PATRIMONY

1540. Engraving, 2×3⅝"

The Little Masters among printmakers were so called not because the group included masters of lesser artistic stature, but because the majority of their engravings were small, close to the dimensions of miniatures. Within the limits of a tiny format, however, Albrecht Altdorfer, Georg Pencz, and the Beham brothers, the most famous of the Little Masters, made large statements. Their fascinating, excellently engraved prints have been avidly collected from the time of issue to the present.

Hans Sebald Beham and his brother Barthel Beham came from Nuremberg, a major center for the engraver's and woodcutter's art. The two brothers and their friend Georg Pencz managed to enrage the authorities by their frivolous attitude toward religion at a time when freethinkers were not welcome in Nuremberg, a town steeped in the tenets of the Reformation. In 1525, they were banished from their native city.

The present scene, one of a series dealing with the story of the Prodigal Son, is larger in format than the majority of Beham's prints. It is a work of the artist's maturity, and it reveals those characteristics which made his work popular with the public and unpopular with the authorities. The wastrel and his cronies, surprisingly mature and worldly, are sporting with their female companions in the secluded corner of an outdoor enclosure. Beham, who later succumbed to producing prints on Classical themes, here depicts the people and costumes of his own day. If no title were given, this print might be another of the genre scenes upon which Beham's fame rests, for no moralizing spirit is implicit in this illustration of pleasure-seeking and the overture to sin. Only the Latin inscription identifies the subject.

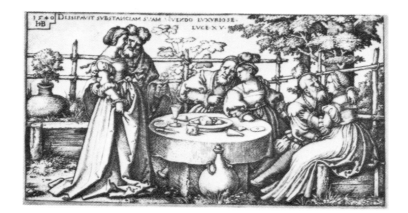

Plate 30

Augustin Hirschvogel. 1503–1553

A CASTLE YARD

1546. Etching, 5½ × 8⅜"

Augustin Hirschvogel was a true man of the Renaissance, a multitalented, restless inquirer in the tradition of Dürer and Leonardo. He produced maps for Ferdinand II, wrote and illustrated books on such disparate subjects as mathematics and travel, and created a pictorial concordance for the Bible. He was an engineer and architect, a surveyor, and a designer of medals, enamels, and coats of arms.

Hirschvogel's reputation rests today on his splendid landscape etchings—sensitive, poetic representations of countrysides with gentle hills, mountains, and sky. Human beings rarely appear in his compositions, for he concentrates on landscape and buildings. Here, as in most of his works, a simple device is employed to suggest movement far into space: a tree is seen in the right foreground, buildings fill the middle plane, and far away in the vast landscape are minuscule trees on a distant mountain top.

With rare economy of means, the artist suggests an atmosphere as well as a linear perspective. The lines are darker and more deeply etched in the foreground, and thinner and fainter in the distant regions. In his knowledge of the laws of optics and of the diminution of contrasts (contrasts of tone that gradually fade and become lighter as the objects recede into the distance), Hirschvogel was ahead of his time. Prints such as this one certainly anticipate the delicately worked plates of Rembrandt.

It is possible that the sensitive variations in the etched lines were obtained by using etching needles that varied from coarse to fine. The delicate nature of the biting suggests that this may be so. But such speculation is academic in view of the end result, as seen here.

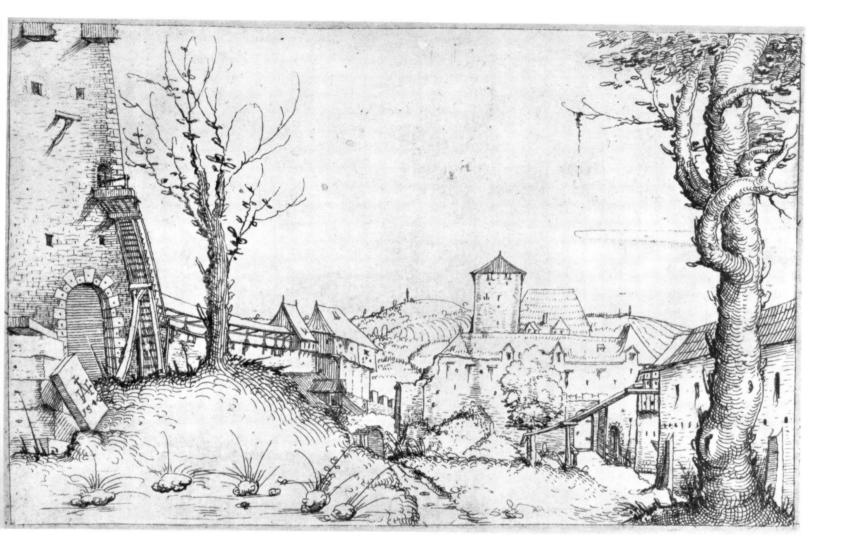

Plate 31

Pieter Bruegel the Elder. c. 1529–1569

RESTING SOLDIERS (MILITES REQUIESCENTES)

1555–58. Etching, 12⅝ × 16⅞"

The fame of Bruegel rests firmly on his achievement as a painter. His haunting pictures, many of which anticipate the spirit of Surrealism in their concern for dreams and fantasy, are well known. The cryptic, fanciful representations of his people's customs—their games, legends, and aphorisms—intrigue us today as they must have intrigued Bruegel's contemporaries. But few of his graphic productions may be attributed entirely to his own hand. To derive greater monetary return from his art, he collaborated with Hieronimus Cock of Antwerp, an astute and successful publisher and print dealer who was also a capable craftsman; Cock maintained a shop at Antwerp called Aux Quatre Vents. There he sold the pictures of the best artists he could induce to work for him, as well as the miscellaneous prints he acquired. Bruegel worked for him from 1553 to 1569.

Bruegel supplied this entrepreneur with drawings in pen-and-ink, mostly based on the subject matter of his paintings. Among Bruegel's finest compositions is the suite known as the *Grands Paysages,* a series of splendid landscapes which echo his major paintings. These drawings were then copied onto plates which were etched by workers in Cock's employ. (On occasion, the proprietor himself etched a plate.) The imprint of the publisher was then added, and most of the existing impressions carry his name.

The present print is typical of these, and the subject matter of soldiers resting is secondary to the landscape itself. Like Hirschvogel *(plate 30),* Bruegel used the device of placing a large tree in the foreground, a river or lake in the middle distance, and mountains far off. The lines are more deeply etched than those of the Nuremberg artist, and the picture field is more cluttered with detail. The viewer will find it rewarding to compare the works of these two contemporaries, one trained in the German tradition, the other in the school of Flanders.

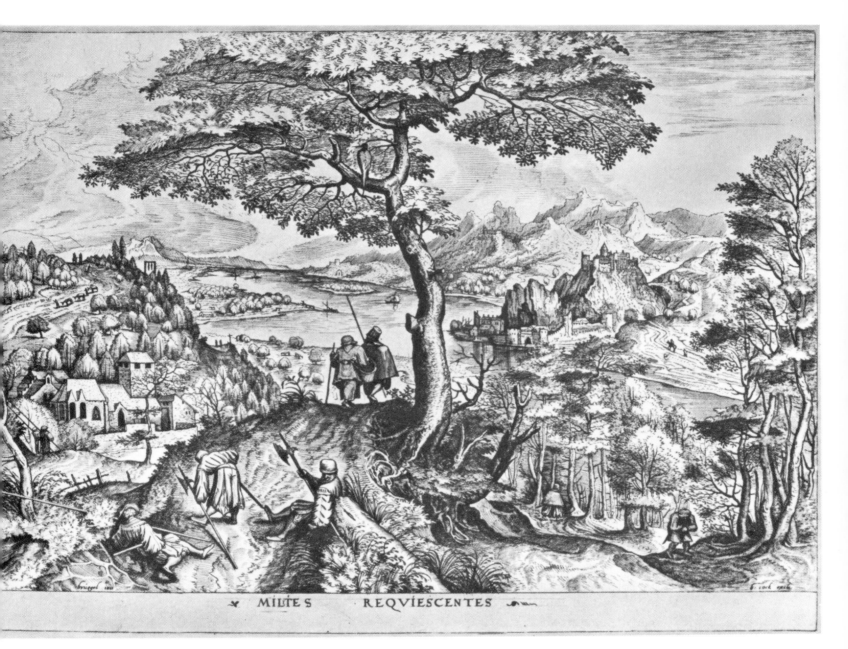

MILITES REQVIESCENTES

Plate 32

Jacques Callot. 1592–1635
THE HOLY FAMILY AT TABLE

1628. Etching, 7½ × 6½"

The subject matter of Callot's etchings was extremely varied; in a host of tiny compositions, he represented vagabonds and dwarfs, and characters from the *commedia dell' arte*. He did two series of the *Miseries of War*, one large and one small, as well as views of cities and representations of elaborate pageants and fêtes. His *Caprices* have a spirit more like that of Tiepolo, unlike the moody aquatints of Goya. In the preparation of this series of fifty plates, Callot used a hard-ground varnish in place of the softer variety. He also mastered the technique of immersing the plate in acid a second time to create more deeply bitten lines. Callot visited France, worked on a series of plates illustrating the siege of La Rochelle for Louis XIII, and in 1629 created *View of the Louvre, View of the Pont-Neuf,* and *Tour de Nesle*, memorable records of seventeenth-century Paris.

The Holy Family at Table is not typical of Callot's general style or subject matter; rather, it indicates his desire to experiment with new effects. The composition here is circular; in another print executed the same year (*The Card Players*) he employs an oval format. The nocturnal scene is made dramatic by the lighting, the table illuminated by a candle and the heads of the three figures brightened by the radiant halos of the Christ Child and the Madonna. It has been suggested that the inspiration for this handling of the subject came from the impressive night scenes of Georges de La Tour.

Iac. Callot In.

et fec. Nancy.

EIA AGE CARE PVER, CALICEM BIBE, TE MANET ALTER
QVI TENSIS MANIBVS° NON NISI MORTE CADET.

Israel Siluestre ex. cum priuil. Regis.

Plate 33

Jacques Callot. 1592–1635

The Battle of Avigliana

After 1631. Etching, 13⅞ × 20¾"

Callot, adventurous from his youth, carried his daring and curiosity into his craft and is responsible for inventive brilliance in the preparation of his etched plates. He was born in Nancy, France; his family planned a life for him in the Church. However, he ran away from home on two occasions while still a youth. The first time (1604) he met a band of gypsies and traveled with them to Florence. His memory of this escapade resulted in a group of etchings done in later years. From Florence he traveled to Rome, where he was recognized by merchants from his home town, and compelled to return to Nancy. A second attempt to escape was successful only as far as Turin, where an older brother found him. About 1608, the family finally accepted defeat and permitted him to leave for Rome to study art.

Callot studied in both Rome and Florence under various masters, and learned the craft of etching. But he soon outstripped his teachers and in the course of his lifetime produced some thousand plates, along with over fourteen hundred drawings, which have influenced and inspired many artists since his day. There were many imitators, but Callot's prodigious accomplishment remains unequaled.

Typical of Callot's genius is this view of a battle, in which the vantage point of the artist seems far removed from the field of action. The horsemen in the left foreground are clearly depicted, and as the action recedes into the distance, mere scratches on the plate become, by some miracle of craftsmanship, footmen and cavalry engaged in fierce action. With incredible patience Callot draws a walled town at the right, delineates other small towns perched on huge rocks, and creates plains, mountains, and rivers that move into the far distance. It has been estimated that Callot crowded a thousand figures into compositions of this size. In this magic of suggestion he remains unsurpassed.

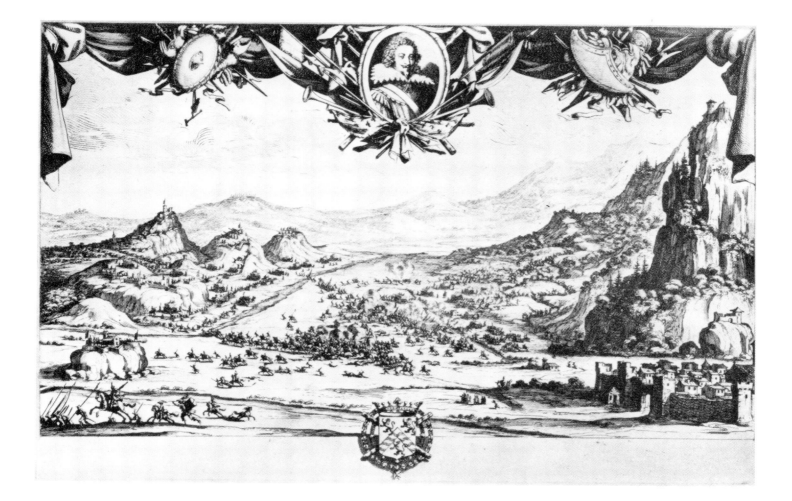

Plate 34

Rembrandt. 1606–1669

THE ANGEL APPEARING TO THE SHEPHERDS

1634. Etching, 10¼ × 8½"

Rembrandt holds an almost unique position in the roster of great printmakers. The craft of etching, which for many of his contemporaries meant no more than the transferal of a drawing to copper, became a new method in his hands. Although all his prints are classed as etchings, he also attacked many plates with the burin and the tools employed for drypoint. (Unfortunately, the burr, which produces the rich, black line in drypoint, becomes worn down with the pressure of repeated printings: thus only a few of these combined–technique prints are of mint quality.) He is the first great artist who used a combined technique. Not only did Rembrandt work on his own plates, he also supervised the printing of them; during his mature period he experimented with leaving a film of ink on the copper to achieve various tonal effects. Unfortunately, these innovations have contributed to the great confusion in judging the authenticity as well as the quality of the impressions attributed to him. The methods adopted by Rembrandt and the fate of many of his plates, which continued to yield up "ghosts" long after his death, will be discussed as we consider his later works.

The present subject, *The Angel Appearing to the Shepherds,* was done in 1634. Rembrandt was already producing superb paintings, and there is something of the painter's approach in this richly etched plate with its dramatic effects of light and dark. The episode of the Angel descending from the heavens to appear before the terrified shepherds and frightened animals seems almost staged.

It is evident that Rembrandt labored long over the making of this print. The darkest areas are deeply etched; in the light portions he probably used his burin for delicate retouching. The subject concerns a miracle, and the awe-inspiring nature of the event is majestically stated. It is interesting to note that in later years Rembrandt produced other masterpieces, but these were achieved with few lines, minimal crosshatching, and great understatement—that special economy of means which is the mark of genius.

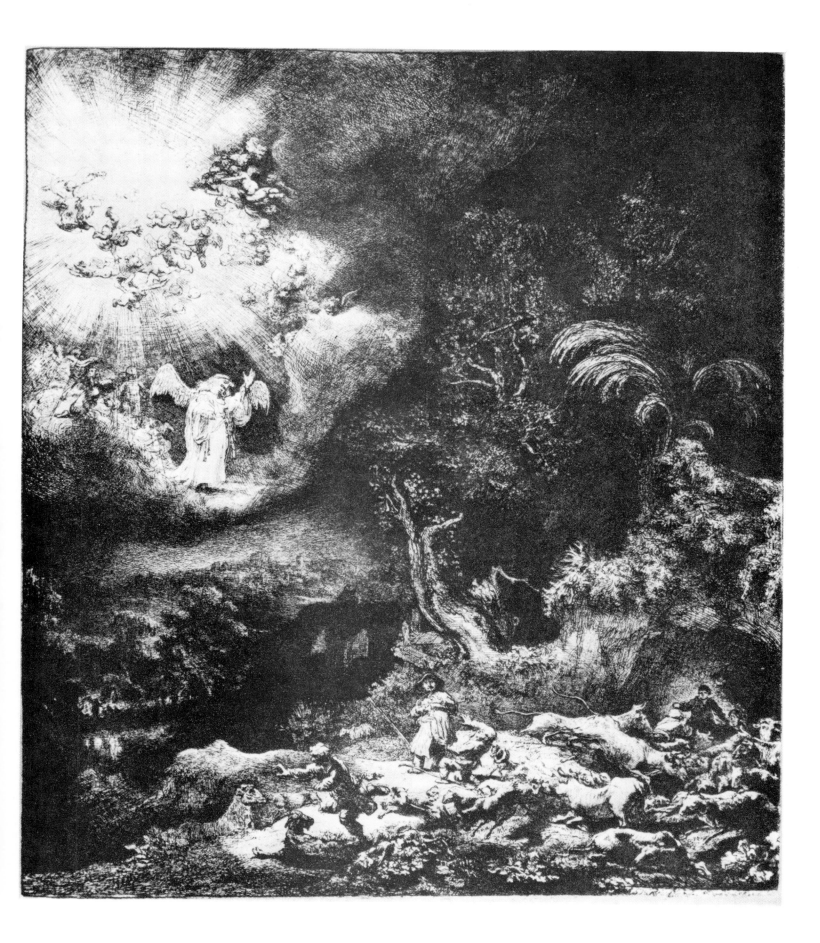

Plate 35

Rembrandt. 1606–1669
REMBRANDT LEANING ON A STONE SILL

1639. Etching, 8½×6¼"

The people in Rembrandt's works are always taken from life. He was not prone to idealize them or to invent nymphs and goddesses for his paintings and prints. He was a learned man and well aware of what the Humanists had revived of Classical lore and legend. He was impressed with the contributions of Leonardo, Michelangelo, and Raphael. The present subject, a self-portrait, shows the artist in the pose of the great courtier Baldassare Castiglione as painted by Raphael. Yet Rembrandt was never tempted, like Dürer and most northern artists, to visit Rome, Florence, and other sites of the Classical past. The faces and figures of his family, friends, and strangers, and quite often his own, sufficed for his needs. Nor did he require antique ruins or crumbling monuments as settings. As a lover of nature, particularly his own Dutch countryside, he found his inspiration in its fields, streams, and thatched huts.

But even more than to natural views, Rembrandt turned to the human form for his subject matter. Early in his career he made endless drawings and many etchings, usually small in format, of beggars, street vendors, relatives, friends, and, of course, himself.

It is doubtful that any other artist has left such a complete visual autobiography. His moods, his state of affluence or poverty, the approach of old age and ill health, all these have been recorded. Here, at the age of thirty-three, Rembrandt is at the height of physical well-being; there is almost a touch of arrogance as he gazes straight out of the picture. Earlier portraits show him posed in a variety of costumes enriched by props: sabers, plumed hats, embroidered robes. The robe here was rendered with skillful crosshatching, the face and elegantly groomed hair produced with the aid of drypoint.

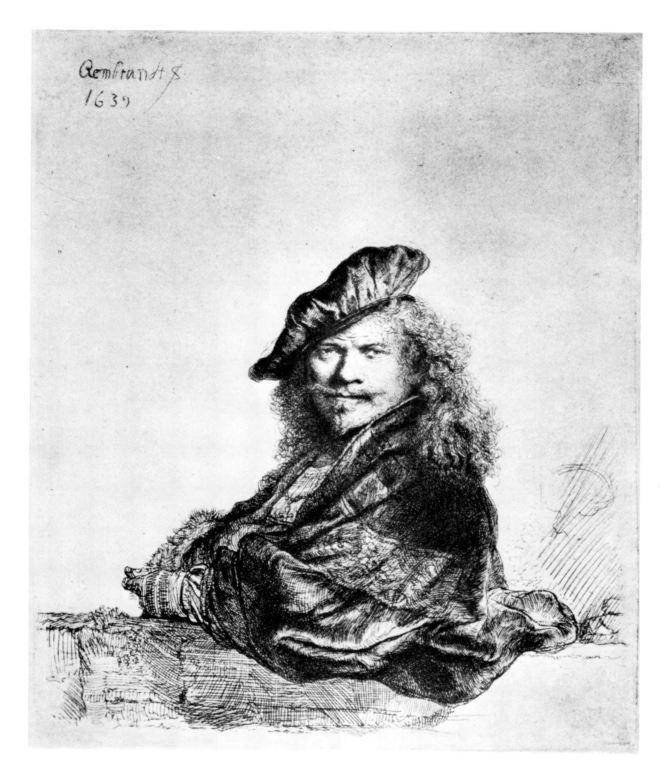

Plate 36

Rembrandt. 1606–1669

THE ARTIST DRAWING FROM A MODEL

1639. Etching (unfinished plate), 9 × 7⅛"

This print has always fascinated students and collectors alike. It affords an opportunity to understand the artist's method, his approach to a work in progress. We will recall Dürer's engraving *Adam and Eve* (*plate 23*). The first state of that engraving bears a startling resemblance to the present print. But whereas Dürer continued his effort and brought his representation of Adam and Eve to completion, this print, to the best of our knowledge, was left in its present state. It is worth noting that Picasso seems to have been impressed by the quality inherent in such "unfinished" works as the present one: we know that he was enormously impressed and inspired by Rembrandt. In his famous series of prints known as the *Suite Vollard* (*plates 98 and 99*), Picasso adopted this device of finishing some areas while leaving other sections merely suggested by outlines. With Picasso there is no accident; his prints are not states, nor are they unfinished. He simply capitalizes on the effectiveness of an unelaborated area to stimulate the viewer's imagination.

Here we have the opportunity to appraise Rembrandt's incredible skill as a draftsman. It is possible that he first made a pen drawing which he translated, by means of drypoint, into a suggestive outline on the copper plate. (After the year 1639, Rembrandt made greater use of combined techniques, and usually employed drypoint.) It is also possible that like other skilled craftsmen—Segonzac is a good example today—he worked directly on the plate. Once the outline was indicated, a craftsman as brilliant as Rembrandt was free to elaborate his concept as he has done in the upper portion of this picture.

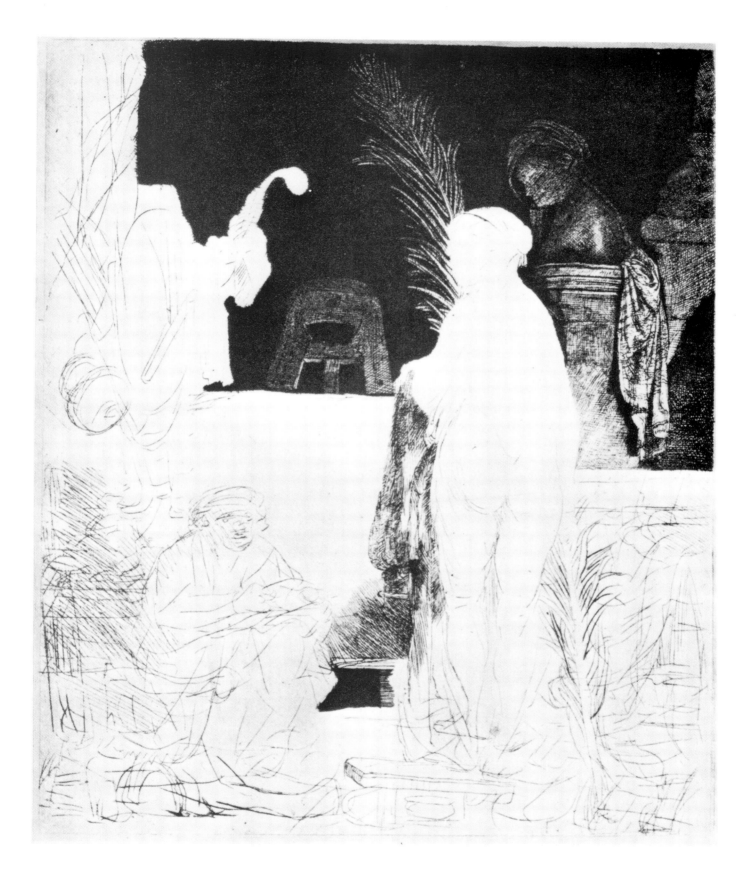

Plate *37*

Rembrandt. 1606–1669
THE THREE TREES

1643. Etching, 8¼ × 11″

Among the best known and most widely admired of Rembrandt's graphic works is *The Three Trees*. It is strange that although his reputation as a master printmaker is based in great measure on his poetic treatment of the Dutch countryside, he produced most of his landscape works within a relatively short period—between 1640 and 1653. Religious themes, portraits, an occasional nude, and genre studies constitute the rest of his production.

Perhaps the universal appeal of this landscape comes from a special quality that is immediately *sensed* rather than *perceived* by the viewer. Only with prolonged study and exposure to this print does its mood and dramatic character become apparent. (Rembrandt generally reserved such dramatic handling for his religious subjects.) This print might well be called "Summer Storm," for an exciting event of nature is what the artist sought to portray. The scene here is really of the end of the storm; the sky is clearing on the right, behind the majestic, silhouetted trees. However, high winds still seem to be blowing, and ominous storm clouds hang over the village in the distance to the left. The strong diagonal lines which cut across the upper left corner of the composition have been interpreted as the last sheets of driving rain before the final passing of the storm. We do not know whether Rembrandt intended this to represent rain, but certainly the powerful diagonal strokes across the corner were essential for the composition, and essential for the mood of "nature aroused." When compared with this majestic print, the two landscapes still to be considered (*plates 38 and 39*) are quiet indeed.

It has been said that Rembrandt's landscapes are Dutch Arcadias. If this is so, one must search for the details which make it so. Here we can see, if we look sharply, some grazing cattle, a couple fishing, a pair of lovers hidden in the bushes, and a party of hayriders far off on the hillock behind the trees. This is truly one of the world's great prints.

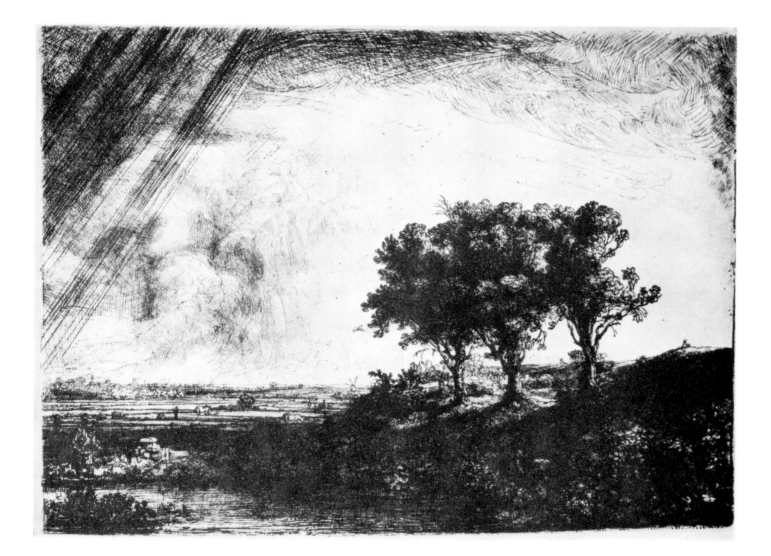

Plate 38

Rembrandt. 1606–1669

COTTAGES BESIDE A CANAL: A VIEW OF DIEMEN

1645. Etching, 6 × 8¾″

More typical of Rembrandt's usual landscape treatment than *The Three Trees* is this view of some cottages on the edge of a quiet canal. The eye is carried diagonally into the composition, from the stronger forms of the huts and trees at the left to the sailboat on the canal, then back to a church spire and small buildings in the distance. The etching is naturally stronger in the left foreground, and it diminishes gradually to flicks of drypoint in the distance. To be noted also in this impression is the faint tint of gray in the sky: here, perhaps, is an example of the effect that Rembrandt produced by the wiping of his plate. Generally, when a plate has been bitten, and retouched with drypoint, it is completely inked so that all the incisions in the copper are filled with ink; then the surface is wiped clean, and the flat, unmarked areas remain white when going through the press. Artists who do their own printing are privileged to make experiments, and one of these is to leave a slight film of ink on the flat areas. When the impression is pulled, this film registers as a tone—an effect similar to that produced by the aquatint process.

Rembrandt made hosts of drawings, but he rarely copied them carefully in his etchings. Rather, he would adapt some details of a sketch to the needs of a print.

In the Rosenwald Collection there is a small masterpiece, *Landscape with Cottage and Hay Barn*. Elizabeth Mongan, formerly Curator of Prints at the National Gallery of Art in Washington, has written sensitively about this drawing in *Selections from the Rosenwald Collection* (1943). Her comments may well be applied to most of Rembrandt's landscape etchings:

> What is it that gives such a drawing as the *Landscape with Cottage and Hay Barn* its absolutely unmistakable character of a master drawing by Rembrandt? The tools he used are simple and common enough to any would-be dabbler. Yet, under Rembrandt's unerring hand, guided by his receptive and understanding eye, the pen, charged with rich brown ink, moved across the paper, sometimes heavily burdened, then lightly touching the surface for accents, created the essential economy of shapes; the light grey-brown washes miraculously bring out alternately the warmth of the sun and shadows, while the paper, carefully selected and often treated, encloses this essence of his native Dutch world. Many other artists have tried to imitate or recapture the effect of Rembrandt's drawings, for his easy naturalism, a balance of heart and mind, or his craftsmanship, tempered by human warmth, is universal and timeless in its appeal.

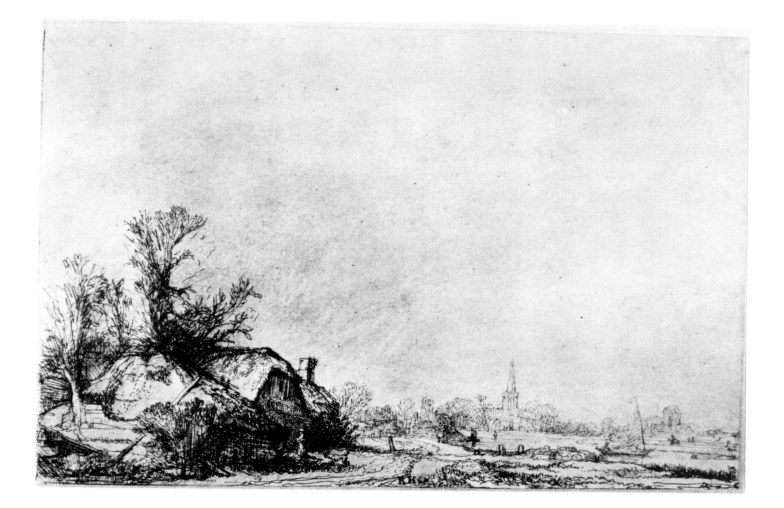

Plate 39

Rembrandt. 1606–1669

LANDSCAPE WITH SPORTSMAN AND DOGS

1653. Etching, 5 × 6⅛″

This small etching is truly a masterpiece in miniature, a work of Rembrandt's maturity, with all his formidable skill and knowledge as artist and craftsman in evidence. Like all great talents, he makes the difficult seem easy, but though he had many students and imitators, none could rival the majestic simplicity of this beautiful print. If not Arcadian, this is certainly an idyllic scene. The countryside is quiet, few residents are awake: two ducks are in the left foreground, and some small figures in the field beyond. Along the winding country road a huntsman approaches, accompanied by his dogs. In the middle distance is a village, and far behind are rolling hills, their solidity and massiveness magically suggested by a few light strokes.

At this point, it might be well to call attention to the various disputes about the authenticity of some Rembrandt etchings. The argument has continued for many years, and much ink has been spilled to prove or disprove a thesis. One critic accepts only seventy-one plates as genuine. Other writers vary the number, accepting from 293 to 375 plates. But the reader, should he desire to become a collector, is admonished to be both careful and dubious. Rembrandt's technique of etching his plate delicately, and using the rich but perishable burr of drypoint, made it impossible to produce more than a few mint prints. Since the graphic work of the master has remained popular from his own day to the present, many impressions that are a far cry from the original have appeared on the market. When the noted scholar Arthur M. Hind published his book *A History of Engraving and Etching* in 1908, he pointed out that plates by Rembrandt were then still in existence (and, unfortunately, prints were still being pulled from them). He states that in 1785 the dealer and engraver P. F. Basan had acquired eighty-five plates which were then reworked for new editions; at the end of the nineteenth century, Michel Bernard used the same badly worn plates for further printings. And a portfolio of impressions was again issued in 1906 by Alvin-Beaumont and Bernard. Therefore, *caveat emptor*—rather, "reader beware!"—satisfy your desire for Rembrandt by studying his prints in museums or private collections, and buy one only from a reputable print dealer.

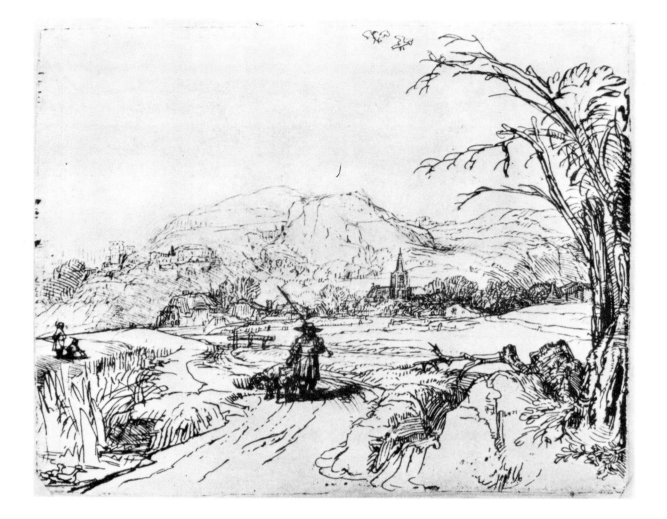

Plate 40

Rembrandt. 1606–1669

THE WOMAN WITH THE ARROW

1661. Etching, 7⅞ × 4⅞″

Rembrandt, who was fully capable of rendering the nude human form, brought to his representations little of the worshipful attitude that characterized the Italian Renaissance masters or the northern painters who followed them in their rediscovery of the antique. When, in 1638, he made an etching of Adam and Eve, he depicted two most "naked" people: middle-class citizens caught with their clothes off. Only the presence of a serpent—not the conventional snake, but a prehistoric monster—and an apple in the hand of the woman let us know that this is the story of the Fall.

Toward the end of his life, however, he did produce, between 1658 and 1661, a group of studies in which the female figure is, if not in the Classical tradition, certainly shapely and reasonably attractive. For one of these etchings he borrowed from mythology and depicted an aged, anxious Jupiter drawing back the covers from the seductive sleeping figure of Antiope.

His last dated etching, *The Woman with the Arrow*, may possibly be another concession to Classical myth. In any case, Rembrandt handles the etching needle with all the assurance permitted by his mastery of the craft. The powerful contrasts of dark and light, which he favored throughout his career, are employed brilliantly, and the gracefully posed body of the woman seems to be lighted from a source in front of the picture. Only after the viewer's eye has followed the sinuous lines of the nude figure does he peruse further the interior of the huge, canopied bed, to discern the shape of a male companion.

The ability to depict the lusty tales of nymphs, gods, and goddesses was plainly within Rembrandt's grasp. But after giving the world this masterpiece he turned from graphic art to dedicate himself to the painting of other subjects.

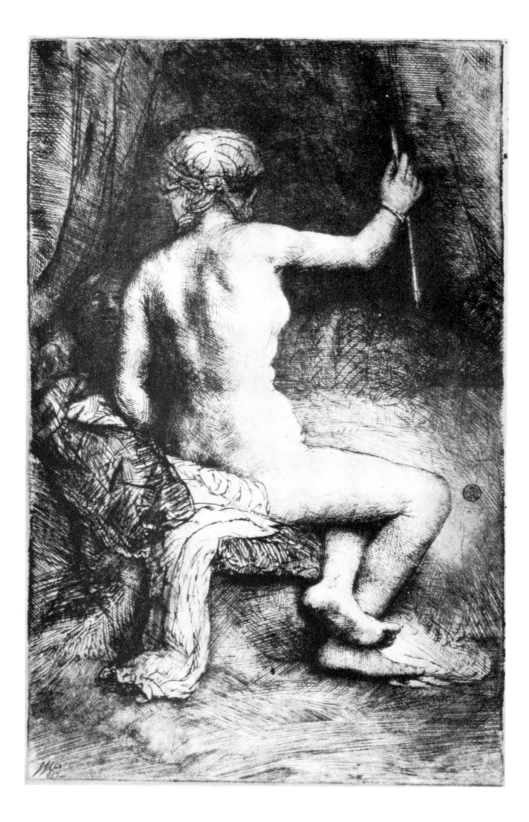

Plate 41

Adriaen van Ostade. 1610–1685

THE ANGLERS

1653. Etching, 4¼ × 6⅜″

Although not typical of most of Van Ostade's etchings, this charming scene of an angler and his companion fishing from a bridge has been selected because it represents the artist at the height of his power. He was an admirer of Rembrandt, and this print is worthy of that great master.

Van Ostade was a genre painter, and, unlike Ter Borch and Pieter de Hooch, who supplied elegant portraits and views of the homes of the well-to-do, he painted or etched scenes of everyday happenings, indoors and out. Like Rembrandt's, his models were street vendors, roving musicians, peasants, and middle-class families. His motifs ranged from tavern scenes and family groups to other homely pursuits, producing an occasional minor masterpiece like the one illustrated here.

Van Ostade seemed never to realize his great ability as a printmaker. When his etchings became popular he was compelled to rework them in order to reissue the editions. Unfortunately, some of his plates were reworked and offered for sale after his death, a circumstance which creates difficulties for critic and collector alike.

Like Rembrandt, Van Ostade etched his plates in the conventional manner of biting the lines with acid, then augmenting the design with drypoint to obtain desired effects. But whereas Rembrandt was capable of using this device for delicate or subtle additions, Van Ostade generally made coarse incisions in the plate to strengthen dark areas.

But technique is not the major issue in appraising this print. Here is a simple scene, so dear to the painters of Holland and the people who purchased their pictures. Within the restrictions imposed by the copper plate, Van Ostade has managed to "paint" a memorable commentary on the life of his time.

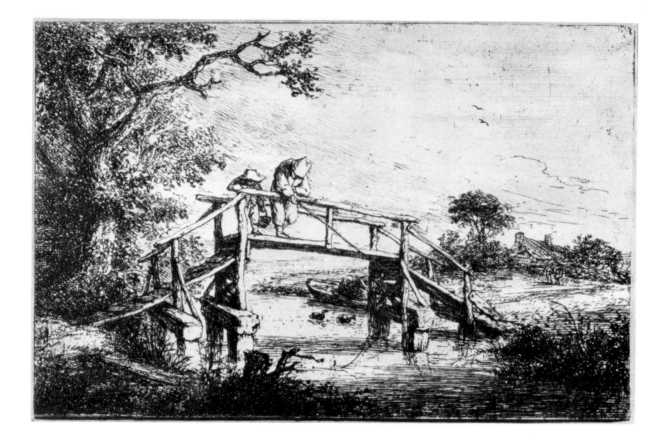

Plate *42*

Giovanni Battista Tiepolo. 1696–1770
THE CAPRICES (title page)

1749. Etching (proof before letters), 8¾×7″

Giovanni Battista Tiepolo produced only about fifty etchings, yet these are sufficient to establish his reputation as one of the great printmakers of the eighteenth century. Like many of his countrymen, he was a superb draftsman, and his etching technique simulated that of his pen-and-ink drawings.

Tiepolo had gained international fame as a painter of huge, decorative, and fanciful frescoes, and he was commissioned to do major works in Würzburg, Madrid, and Genoa. The paintings in Madrid inspired Goya, influencing his early style. It is interesting to note that Tiepolo, like Goya, titled a series of his etchings *Caprices*. The present illustration reproduces one from his set of ten *Caprices*. It is the title page for the series and is a rare and beautiful impression. It was taken from the press before the printed titles were inserted. In the parlance of the print collector, this is known as a "proof before letters."

The *Caprices* of Tiepolo may be enjoyed for their fantasy, for their brilliant representations of birds and animals, real and imaginary, and the idyllic landscape settings. Unlike Goya's *Caprices* (*plate 46*), they offer no hidden meaning, no allegory, no social satire. It is curious that what was intended to be the first page of the Goya work shows a sleeping figure (probably the artist) surrounded by owls; but Goya's owls are somewhat monstrous, quite different from the amusing, quizzical birds seen here.

Plate 43

Canaletto (Giovanni Antonio Canal). 1697–1768

THE PORTO DEL DOLO

c. 1740–45. Etching, 11¾×17"

Canaletto, painter of Venice, dedicated himself to representing its canals, streets, and incredible architecture. He also immortalized, in paintings and a series of etchings, such nearby places as Mestre and Murano.

Canaletto's early training was with his father, who painted scenery for the pageants and entertainments of his lively city. From Luca Carlevaris he learned the technique of etching, as well as the principles of perspective and human anatomy. Canaletto loved his city and wandered from one quarter to another making endless pen-and-ink sketches. These became the basis for a set of thirty-one etchings, which he described as "views, some taken from actual spots, others fanciful." Although Canaletto is known to have used the camera obscura as a means to record some views mechanically, his finished impressions are far from photographic. Like a later great delineator of architecture, Charles Meryon (*plate 63*), Canaletto changed the positions of buildings and added and subtracted details to enhance his compositions. Along with the more important monuments and structures, he represented the simple two-story houses with their chimney pots, shuttered windows, and weathered façades. Handsomely costumed citizens, workmen and vendors, playful cats and dogs mingle in the streets.

Canaletto suggests atmosphere and the sun-drenched landscape with sinuous, undulating etched lines. Where the sun shines brightest on a building, he leaves the white of the paper unmarked.

This series of plates was dedicated about 1741 to Joseph Smith, the English consul to Venice, who purchased many of the artist's paintings and drawings. It was he who induced Canaletto to travel to England, where he decorated the interiors of wealthy homes with souvenirs of Venice.

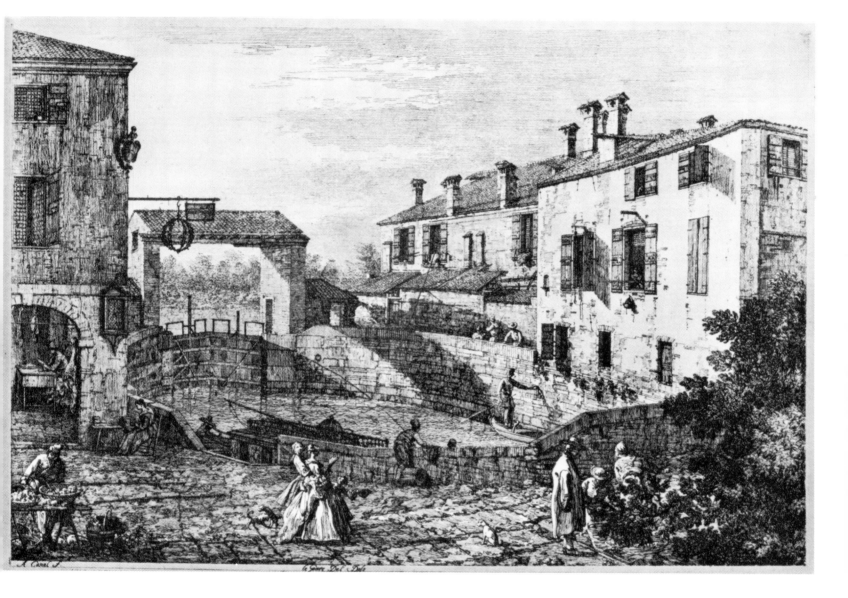

A. Canal f. Le Porte Del Dolo

Plate 44

William Hogarth. 1697–1764

Gin Lane

1750–51. Etching and line engraving, 14⅛ × 12"

Among the strong didactic pieces by Hogarth is *Gin Lane,* his graphic lecture on the evils of drinking gin. "Idleness, poverty, misery and distress, which drives even to madness and death"—this is the price one pays for indulgence in this poison. The companion print, *Beer Street,* encourages the use of this beverage, for, as Hogarth said, it is an "invigorating liquor" and on this street "all is joyous and thriving. Industry and jollity go hand in hand." No modern copywriter could produce a more persuasive argument.

In most of Hogarth's plates one does not look for expert handling, for he used his craft to tell a story rather than to demonstrate a technical skill—which he did not, in fact, possess. We "read" his pictures. We must examine every section of the plate, as we would read every page of a book to know everything that happens.

In the lower left-hand corner is the notorious gin cellar. Over the entrance is an inscription: *Drunk for a Penny/Dead-Drunk for Two Pence/Clean Straw for Nothing.* On the lower right is a cadaverous itinerant ballad seller who also retails gin and obviously has imbibed more than he has sold. In the background, the buildings are empty or toppling—the area is rapidly becoming a slum. In one exposed room a man has hanged himself. In the right middle section there is some gaiety, some fighting, and much drinking.

In front of a pawnshop on the other side of the square, a carpenter is trying to pledge his tools, a housewife her pots. Their receipts will, of course, go for gin. The most horrible scene is in the foreground, where a woman, breasts exposed and a drunken grin on her face, reaches for a pinch of snuff. She has lost her grip on her child, who falls over the railing to the pavement below. Hogarth's point is well made.

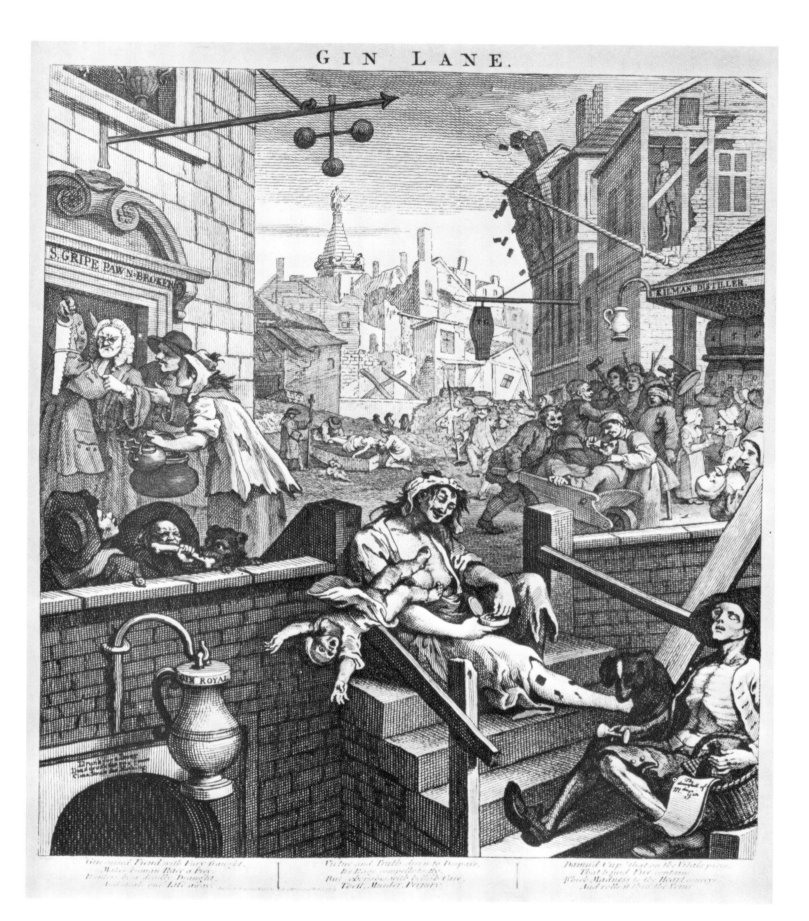

GIN LANE.

Plate 45

Giovanni Battista Piranesi. 1720–1778
The Prisons (plate IV)

c. 1760. Etching, 21½×16¼"

Giovanni Battista Piranesi not only produced an incredible number of etchings and engravings, but is known to have written an autobiography which was reputedly as full of swashbuckling incidents as that of Benvenuto Cellini. His two sons knew this manuscript and, with additions based on their recollections, prepared their own version, which was submitted to an English publisher. Both versions are lost. In 1831 Francesco Piranesi did, however, publish an account of his father's career, part of which reads: "In an age of frivolities, he boldly and singlehanded dared to strike out for himself on a new road to fame: and in dedicating his talent to the recording and illustrating from ancient writers the records of former times, he met with a success as great as it deserved, combining, as he did, all that was beautiful in art with all that was interesting in the remains of antiquity."

Born in Venice, Piranesi yearned for Rome, and there he lived and worked most of his lifetime, dedicating himself to studying, measuring, and drawing its architectural treasures. From Giuseppe Vasi he had learned etching and engraving, and most of his plates are a mixture of these two techniques. It is believed that during his residence in Venice he also knew and studied the etchings of Tiepolo(*plate 42*).

Certainly Piranesi's most often discussed prints are in his etched Prison series, the *Carceri d'Invenzione*. A famous description comes from De Quincey's *Confessions of an English Opium-Eater*. De Quincey never saw Piranesi's plates, but obviously was very moved by the verbal description of them given by his friend, the poet and essayist Coleridge.

Piranesi was twenty-two when he composed his sixteen fantasies. They were reissued about sixteen years later. They may be seen in two states: the first more freely drawn and lightly etched, the final one (to which this illustration belongs) reworked with deep, dark lines and more ominous interiors. These etchings were destined to influence countless scenic designers in preparing their sets of dungeons and torture chambers.

Piranesi produced several thousand prints, and it seems inadequate to represent him here with a single example. The reader who wishes to pursue the career of this astonishing man is urged to read A. Hyatt Mayor's brilliant and scholarly monograph, *Giovanni Battista Piranesi* (1952).

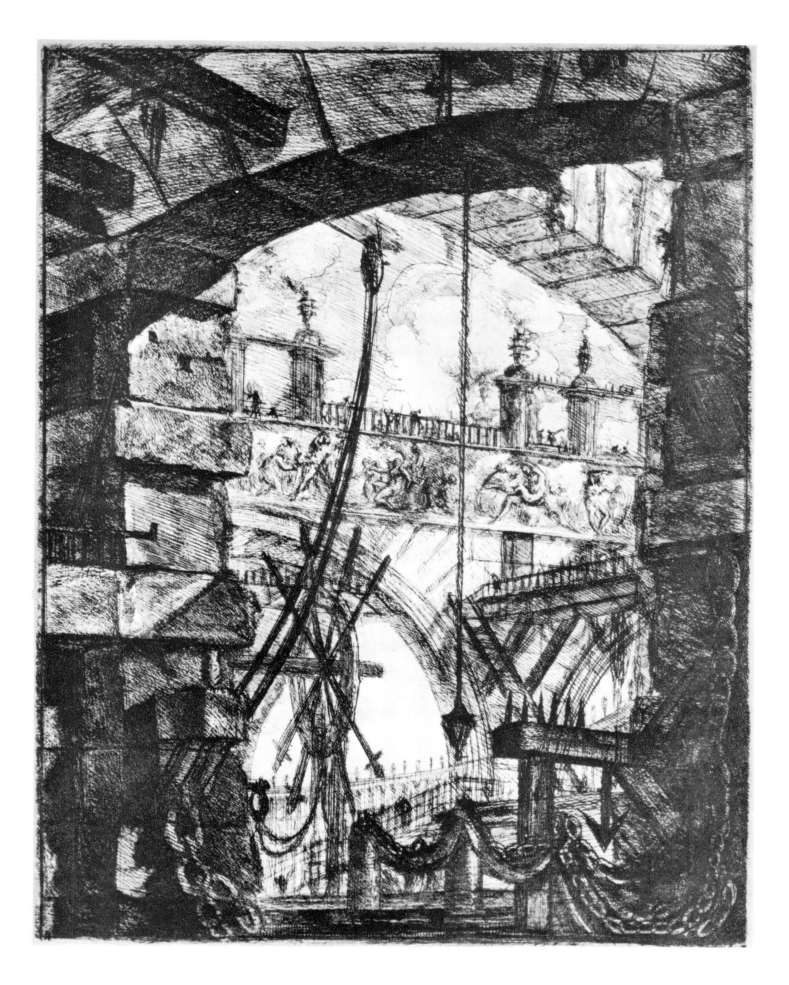

Plate 46

Francisco Goya. 1746–1828

Tantalus

From the series THE CAPRICES. *1793–98*
Etching and aquatint, $7\frac{1}{4} \times 5''$

In the work of Goya we approach one of the greatest printmakers of all time. The legend of his life and art is such that novelists, playwrights, and biographers have produced a vast literature, repeating tales of his physical prowess, his youthful escapades (which possibly resulted in homicide), his lustiness, and his incredible success with women, which culminated in his celebrated affair with the powerful and beautiful Duchess of Alba. Many works are dedicated solely to Goya's *vie intime*.

Goya's early inspiration came from the paintings, and possibly the prints, of Giovanni Battista Tiepolo (*plate 21*). He found little to borrow, however, and quickly attained an independence of vision and technique.

The most bitter of satirists, Goya was compelled to conceal his message in strange images, so that monsters in various forms, quadrupeds and birds, as well as men and women, are the protagonists in dreamlike engagements. Detesting the clergy, he castigated it in many of his prints, and had he not been protected in high places, the Inquisition would certainly have downed him. He loathed pretense of every variety, all prejudices and hypocrisies, the ignorant physician, the pompous scholar.

The *Caprices*, his first major series of prints, were begun as early as 1793, but were not issued as an edition until 1803, when they were acquired by the king of Spain for the government print studio, the Calcografia Nacional. The present print is a superb example of Goya's combination of etching and aquatint. Only a master could silhouette so dramatically the etched figures against areas of tone.

The significance of this plate is not completely clear. A young man is distraught over the death, probably the murder, of his mistress. Material for speculation, however, stems from the extraordinary resemblance of the girl's features to those of the Duchess of Alba. And the countenance of the youth is remarkably like the self-portraits which Goya introduced into many of his works.

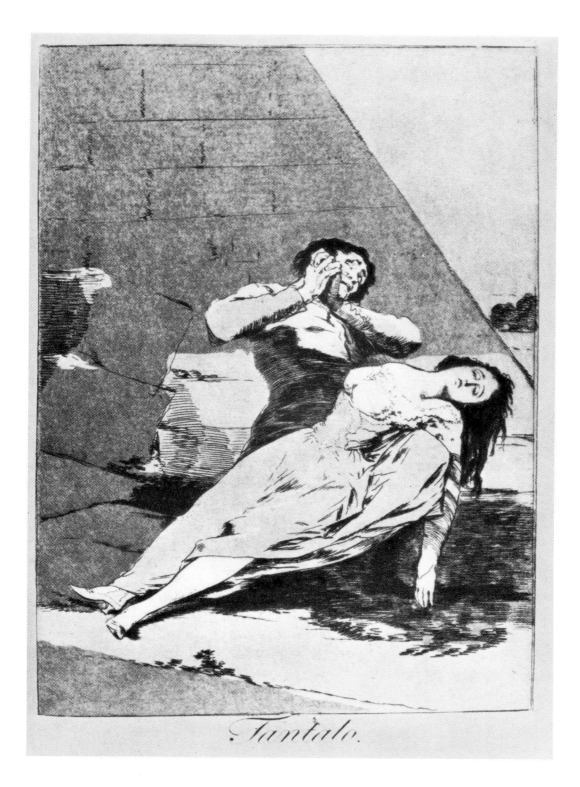

Tantalo.

Plate 47

Charles-Melchior Descourtis. 1753–1820
VILLAGE FAIR

c. 1788. Color aquatint, 12×9¼″

The general category of color prints is often termed *estampe galante*, and it enjoyed great popularity during the eighteenth century. French artists and craftsmen combined their talents to produce the most noteworthy examples. George S. Hellman, in his appreciation of this special group of prints (*Print Collector's Quarterly*, February, 1913), stated that "these eighteenth-century engravings do not constitute great art. They lack the lyric impulse of individual emotion, they are without national purpose or ideal, they touch humanity only at very few points. Their interest is seldom in character, almost invariably in situation. They are repeatedly telling a story whose theme is so often frivolous or sensual."

This very story-telling character is what has proved so attractive to the viewer or collector of such prints. Religious themes, and the grim aspects of life, such as often appeared in the works of Hogarth (*plate 44*)—indeed, serious commentary of any type—were avoided. Romantic tales and legends furnished much of the subject matter, and the indiscreet behavior of the maid and lover amused and titillated the public.

Some of the prints in this group were pulled from single plates. The color was worked into the copper surface by use of the "dolly" or "poupée," a stump of rags dipped into colored ink and applied to the appropriate section of the plate. When the etched copper was completely covered with the desired tones, the plate was run through the press. This tedious process was repeated to produce each successive print.

The finest examples, however, were produced through the use of several plates, each carrying a separate color. These required careful registry, as in present-day methods of printing in color. The scene reproduced here is a superb example of this type of workmanship.

In the truest sense such works were "reproductive" in nature. One artist generally furnished the original gouache, watercolor, or painting which was translated into a color print by another craftsman.

In *French Color Prints and Line Engravings of the XVIII Century* (a catalogue published by the Knoedler Gallery in 1930), Ralph Nevill remarked: "The beautiful *estampe galante*, it may confidently be affirmed, will maintain its position. Exhaling the very spirit of the *ancien régime*, its charms must ever appeal to all lovers of daintiness and grace; whilst at the same time, owing to its accurate delineation of architecture and costume, it is certain to retain an undying interest for the student of the vanished age."

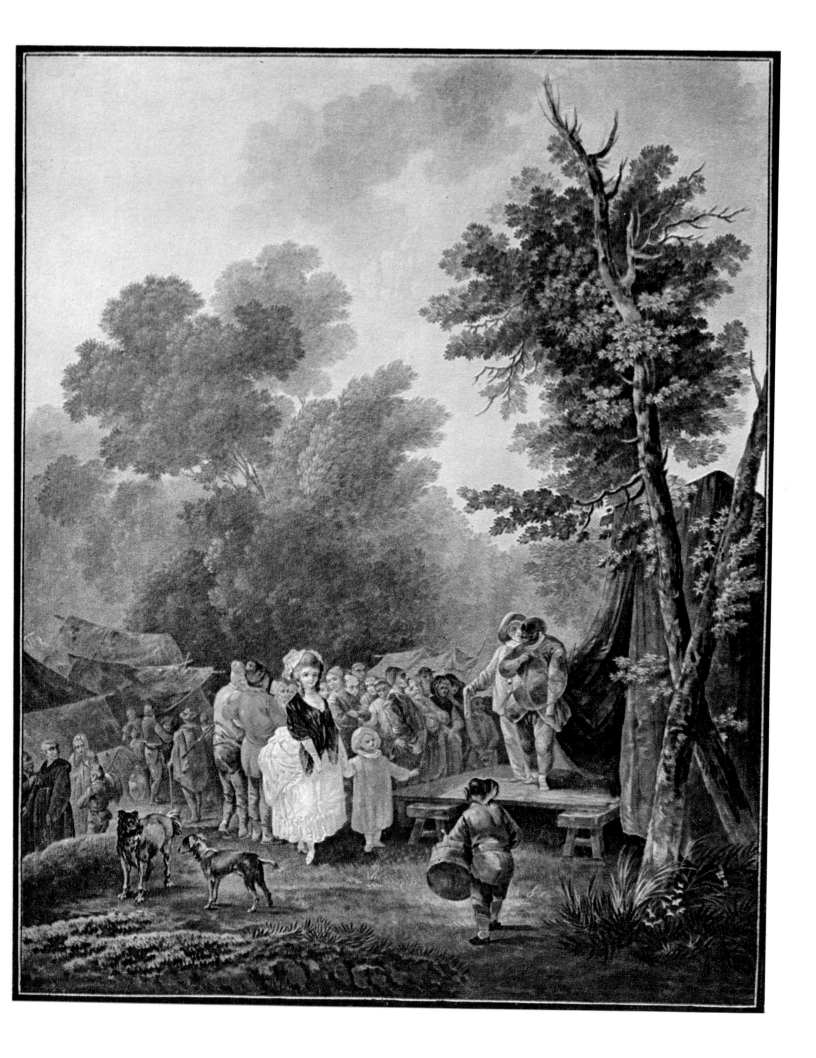

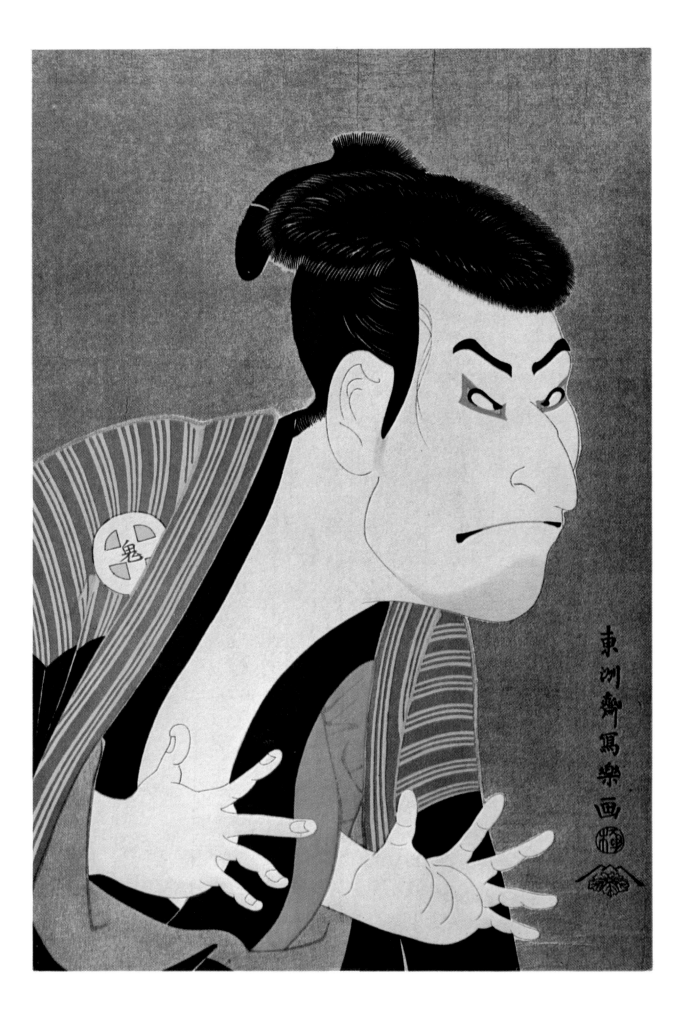

Plate *48*

Tōshūsai Sharaku. Active 1790–95; died 1801

The Actor Otani Oniji as Edohei

1794. Color woodcut, 15½ × 10¼"

Earlier in this book (*see p. 17, and fig. 10*) we mentioned the influence of the Japanese wood-block print on artists of the Western world. French artists were especially enthusiastic in their reception of the examples which appeared on the print market after 1854, and soon these were avidly collected. In Japan they sold for a very few yen; they were rarely valued as collector's items, but were used as advertising throwaways, and often ruined through exposure to the elements. The themes were varied, and the *Ukiyo-e,* as they were called, depicted the transient world; there were pretty girls, landscapes, and the flora and fauna of the country. Courtesans were seductively represented, to attract the citizens to their teahouses or other places of assignation. These courtesans, who held a dignified position in Japanese society, often set the fashion for costume and behavior. As the *Noh* drama grew increasingly popular, the more famous actors were represented, either singly or in their performance of a well-liked play.

Tōshūsai Sharaku owes his fame to his many prints of famous actors of the day. His personality remains dim, and little is known about him beyond the fact that he himself was briefly a *Noh* dancer. Over 125 portraits by him have survived, and are now part of the best collections. Most of these were done in the single year 1794.

His characterizations were bolder than in most works of this class, and he often employed the effective mica backgrounds which enhance the appearance of the print. Carl Zigrosser, in his *Book of Fine Prints* (1956), comments on Sharaku's art. He compares him to Goya and to the bitter satirist George Grosz, and notes "a savage irony directed against a whole class or even the human race. His prints, perhaps for this reason, were not well received, and after a brief productive period he seems to have given up this art form. But the originality, the vigor and forcefulness of his portraiture place him in the ranks of the foremost masters." The present woodcut, a superb example, reveals him at his very best. It is little wonder that artists like Whistler, Degas, Lautrec, Mary Cassatt, Pissarro, Van Gogh, and others took inspiration from the art of Sharaku and his school.

Plate 49

Francisco Goya. 1746–1828

FEMININE FOLLY

From the series THE PROVERBS. *c. 1810–19*
Etching and aquatint, 8⅝ × 12⅝"

In this series, Goya bitingly explores the follies of mankind. The prints were probably executed between 1810 and 1819, but were published only in 1864, by the Academy of San Fernando in Madrid.

More obscure in their meaning and message than the earlier *Caprices,* the *Proverbs* (*Disparates*) consisted of eighteen plates (*see fig 20*). A memorable addition was made in 1877, when four rediscovered aquatints were published in the French magazine *L'Art.* The plates of Goya's masterpieces were acquired by various publishers, and ultimately by the Spanish government. There were innumerable printings, each successive one requiring reworking and rebiting of the copper plates. However, even with the loss of the pristine quality of the first proofs, these restrikes retain their message.

The exact meaning of these prints is not clear and the artist has left us no commentary, yet they evoke a very disquieting mood. Animals and humans behave strangely, and there is a disturbing, nightmarish quality which may also be seen in a number of his paintings. Goya joins Bruegel, Bosch, Ensor, and Redon in seeming to anticipate the Surrealists.

The meaning of the present print is perhaps less obscure, and we can attempt to interpret it. Goya often saw man as a puppet and woman as the malicious instrument of his downfall. Here, a group of six females are tossing two helpless male figures in a blanket. Perhaps the artist was commenting on some current abuse or some contretemps in his own career. Perhaps he was speaking for all dominated and misused males.

In this plate Goya used aquatint only for the background. The foreground, the blanket, and the figures are deeply etched. The harsh contrasts of black and white contribute to the eerie atmosphere of the performance.

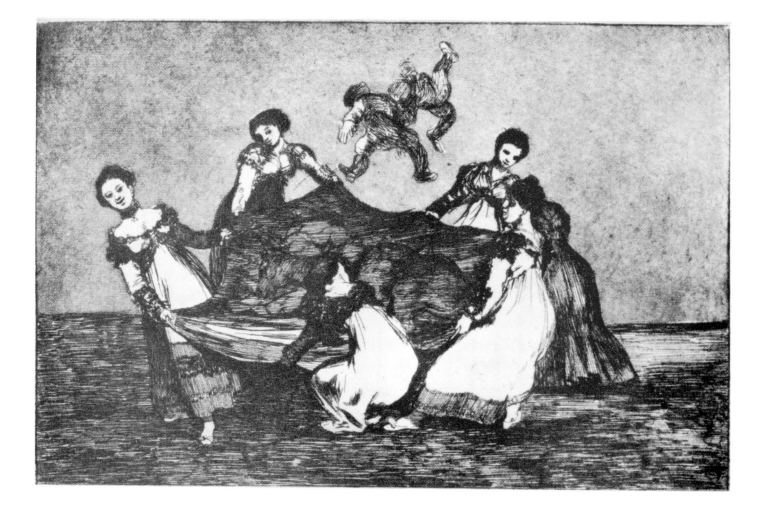

Plate 50

Francisco Goya. 1746–1828

SPANISH DIVERSION

1825. Lithograph, 11⅞ × 16¼"

Goya created four incredible lithographs of bullfights while in exile in Bordeaux. He was seventy-nine, an invalid, and almost completely deaf. Some years before, he had produced his *Disasters of War,* etched during the French occupation of Spain (1808–14) but not issued until 1863. Probably no more powerful graphic document exists to demonstrate the horrors of war: Callot's miniatures are mild in comparison.

Goya had issued thirty-three prints (later expanded to forty-four) in 1816 under the title *Bullfights* (*Tauromaquia*). These illustrate the history of bullfighting in his native land. Drawing on his memory of this suite, he now turned to lithography to create a series of prints which have never been surpassed. Picasso is only one of the many who have known and studied them diligently.

Goya had experimented with lithography as early as 1819. A Bordeaux printer, Gaulon, probably helped the Spanish artist and supervised the printing of this memorable set of lithographs. It is reported that Goya set up the heavy lithographic stones on easels and approached the drawing on them, all from memory, as though he were sketching from life. One must turn to Goya's oil paintings to find a similar excitement—the suggestion of hysteria engendered by the action in the ring. Goya also anticipated the Impressionists in the devices he used to suggest the crowds.

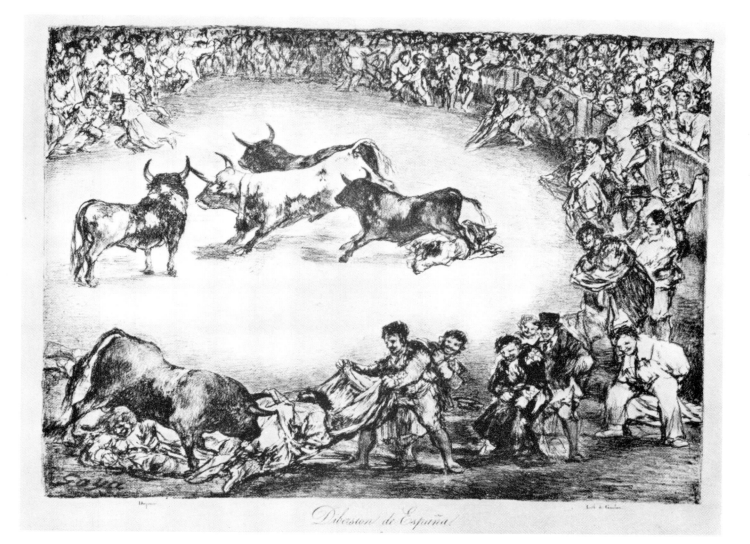

Dibersion de España

Plate 51

William Blake. 1757–1827

GLAD DAY or MORNING

1780. Engraving, 10 × 7½"

William Blake was another of those "madmen" who failed to convince his contemporaries (save very few) that there was any merit in his work, or anything but sheer lunacy in his behavior. At eight he began to report his "visions"—"visits," he often termed them to his parents. Yet today he is acknowledged as one of the great poets of his time, who with his haunting verses anticipated the Romantic movement in English poetry.

As an artist, his unique achievement has attracted enthusiastic admirers and avid collectors, especially in the field of engraving, a medium which he rescued from the limbo into which it had fallen in the eighteenth century. There has been a constant stream of writing about his poetry, his philosophy and mysticism, and, of course, his art. His earliest devoted biographer, Alexander Gilchrist, in 1863 published his *Life of William Blake;* under the name of the artist, in quotation marks, one reads "Pictor Ignotus." Blake is no longer an unknown painter. The Tate Gallery in London has on permanent exhibition one of the greatest collections of Blake in the world.

What concerns us here primarily is Blake as a printmaker. Many of his engravings were done to illustrate the works of others, such as Edward Young's *Night Thoughts,* Robert Blair's *The Grave,* a series for Dante's *Divine Comedy,* and, from the Bible, the Book of Job.

Many of Blake's most imaginative prints were made to illustrate his own writings. Finding no publisher, he wrote, printed, and published his own works. Some of these were done to order, after he found a client. Many plates, printed in one tone, were hand-colored by the author. He devised special techniques which he thought were his own inventions. He would leave the writing and the image in relief (as in a woodcut) and cut or etch away the surrounding areas; for this technique he used the expression "woodcut to copper." His two literary masterpieces, *Songs of Innocence* and *Songs of Experience,* were produced completely by the author.

Glad Day or *Morning* bears the date 1780. The young male figure became an important symbol for Blake. He sometimes called it Albion and identified it with mankind. Glad Day or Morning alights from the heavens above and joyfully places one foot on the earth. This is a print which reflects the directness, simplicity, and optimism of Blake's early verses.

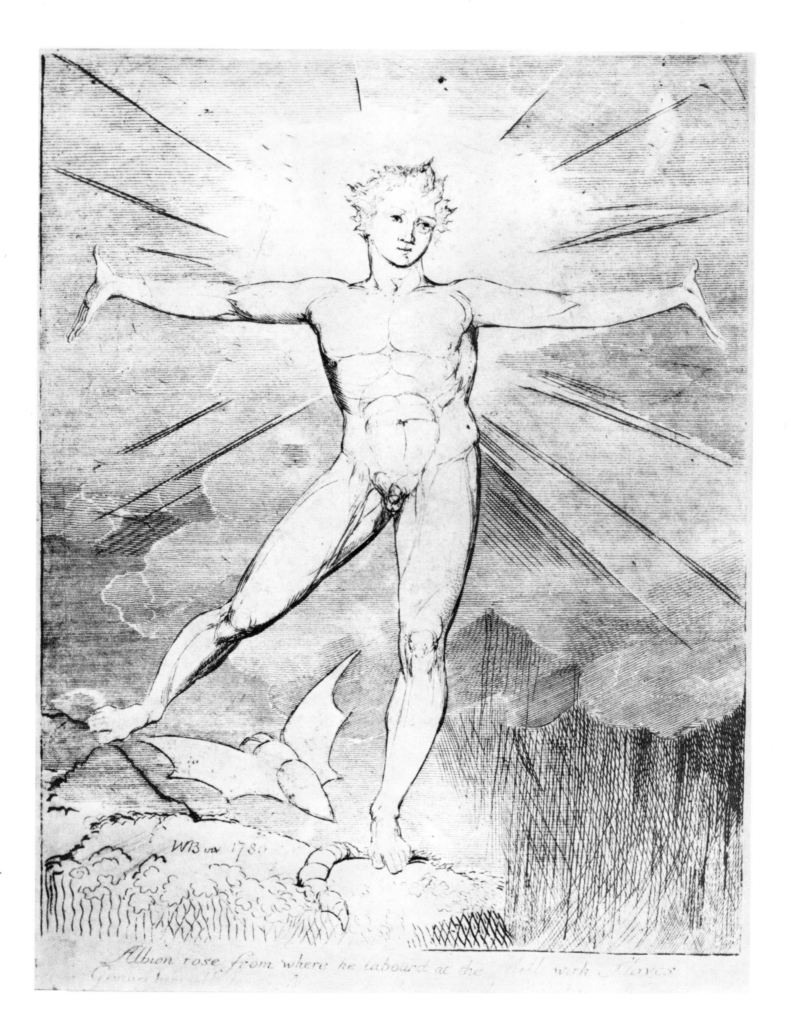

Albion rose from where he laboured at the Mill with Slaves

Plate 52

Jean-Baptiste-Camille Corot. 1796–1875

SOUVENIR D'ITALIE

1871. Lithograph, 5¼ × 7⅛″

Corot, like so many of his contemporaries, began his artistic career only after he had disappointed first his schoolmasters, then his employers. While employed by a clothing manufacturer in Paris, he was sent around the city with bundles of samples but lost himself in admiration of the window displays of art dealers. And whenever he could, he tramped the long magic corridors of the Louvre. His family finally supplied him with a yearly allowance of 1,500 francs to study art.

Corot loved the country, the forests, and the woodlands. He had been inspired, like other French artists, by the work of the British painter John Constable. After his journey to Italy in 1825, he drew constantly on his recollection of its treasures of Classical art; he also made two later visits (*see fig. 33*).

Corot came to lithography after he had produced numerous etchings. He disliked using the dangerous acids required to bite the copper plates, and usually retained others to do this job. A friend, Alfred Robaut, induced him to try his hand at lithography, for which only lithographic crayon, ink, and some transfer paper were needed. Corot was delighted by the freedom of this medium and did about sixteen subjects. Unfortunately, the editions were small, and today good proofs, such as the two reproduced here, are extremely rare.

Corot succeeded in making his black-and-white lithographs almost as eloquent as his paintings. The subject matter is similar, and even without the use of pigment he manages to suggest the colors of trees, land, and sky.

All the qualities of a superb drawing are to be found in this lithograph. No print in the pages of this book demonstrates more convincingly the statement that the graphic technique makes possible the production of multiple originals.

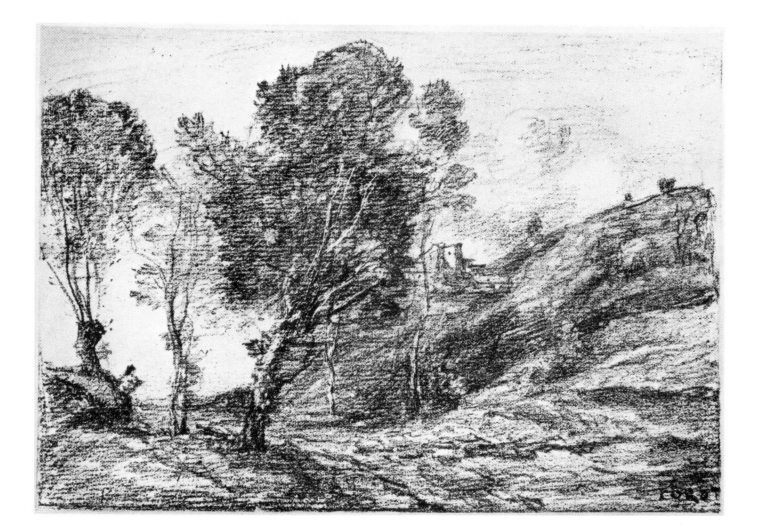

Plate 53

Jean-Baptiste-Camille Corot. 1796–1875
The Cuincy Mill near Douai

1871. Lithograph, 8⅜ × 10¼″

Corot was tall, had a ruddy complexion, and looked like a man of the outdoors. Apart from his magnificent portraits and the subjects he painted in the studio, his concern was always with outdoor subjects. Much of his sketching was done in the environs of Ville d'Avray, where his father had a country house. But he enjoyed traveling, often north to Arras and Douai. The present lithograph represents a scene in the vicinity of Douai.

Artists of the Barbizon School, as well as the Impressionists later in the century, preferred to make sketches directly from nature. These artists often carried scribbled notations to remind themselves of the tone and color of objects as first seen. Such sketches became the basis for the landscapes which were completed later—often far from the original site. This view of a mill, set on the edge of a stream, is just such a sketch. All the ingredients are here: the nervous, sinuous trunks of trees; the suggestion of foliage, which seems always windblown; the dramatic diagonal of the branches of the fallen tree cutting across the center of the composition. It is again our good fortune that lithography made possible the duplication of this splendid drawing.

If we compare this print with the preceding one, it may be noted that the drawing is more sketchy—suggestive rather than explicit. The blacks have been grayed down to the silvery tones which characterize many of Corot's most poetic landscapes.

Gustave Geffroy, his friend and loyal biographer, wrote the following description of Corot's paintings; it may well be applied to his lithographs, which are indeed paintings in black-and-white:

"I gaze at the fields, the forests, the skies and waters—all those wonderful places of refuge where Corot spent his life, and which he offered to those who, like himself, were ready to love and understand the eternal beauty of the universe."

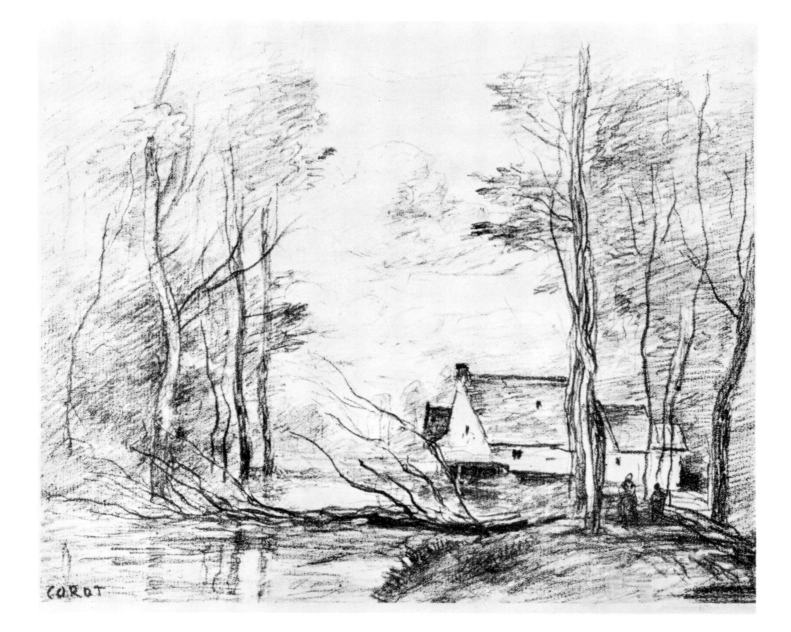

Plate 54

Eugène Delacroix. 1798–1863

FAUST: MY BEAUTIFUL YOUNG LADY, DARE I OFFER YOU MY ARM AND ESCORT YOU HOME?

Illustration for Goethe's FAUST. 1828
Lithograph, 11 × 8"

In the frail, tireless person of Eugène Delacroix there was imprisoned an obstinate will to realize big dreams; imbued with the spirit of his artistic ancestors in the Renaissance, he wished to cover vast walls and ceilings with his own, Romantic, conceits. Delacroix belongs with the poets, for from them, rather than from his fellow artists, he received his inspiration. He was a lonely man, had few close friends, and confided in almost no one. Even in his journals and correspondence he was more reticent about himself than were Van Gogh, Pissarro, or Gauguin in their respective autobiographical outpourings. The end of his life was that of a recluse—reading, dreaming, and still planning for the future. Ever the aristocrat, he once wrote: "As it is my imagination that peoples my solitude, I choose my company." And this company was mostly drawn from literature—Hamlet, Faust, Romeo. It has been remarked that there was something of Hamlet in the melancholy character of Delacroix. In fact, in an early painting, dated 1821, he has represented himself garbed in the dark raiment of the Prince of Denmark.

This print is one of his series of lithographs illustrating Goethe's *Faust*. Though not appreciated by everyone, the series won high praise from Goethe himself, and when it was issued in Paris in 1828 by the publisher Motte, this work brought Delacroix his first acclaim.

Delacroix takes a thoroughly Romantic approach to his subject, and might well have been designing the costumes and sets for this classic. In the scene reproduced, Faust makes his first gesture toward seduction: "*My beautiful young lady, dare I offer you my arm and escort you home?*" is the title below the illustration. Marguerite's willingness to comply is plainly indicated in the lithograph.

Delacroix has created the atmosphere of a medieval town, with details of Gothic architecture and carving in the buildings in the foreground. The figures are about to disappear down a street obscured by a murkiness which suggests perhaps nightfall, perhaps mystery. This is a picture to be "read," for the storytelling quality is all-important.

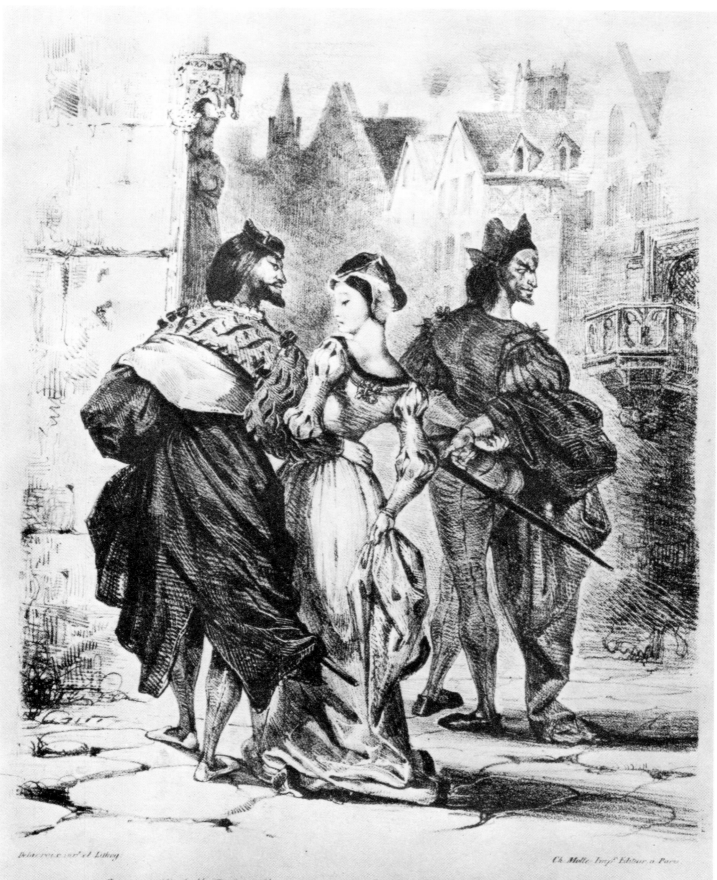

Faust — Ma belle Demoiselle, oserai-je vous offrir mon bras et vous reconduire chez vous?

Plate 55

Honoré Daumier. 1808–1879

THE LEGISLATIVE BODY

1834. Lithograph, 11⅛ × 17″

Honoré Daumier was born in Marseilles. His father was a glazier who dreamed of a different career, and having published a poem locally, he moved to Paris to the wider audience he was sure awaited him. Needless to say, his success was not great, and his glazing business suffered from his literary endeavors. Young Honoré was called upon to bring in whatever humble earnings he could. His first position was as a bailiff's clerk, so that he came into early contact with law courts and with the judges, lawyers, and ordinary people who may be seen in this milieu. Having convinced his parents that he was not suited to a business career, he entered art school. But he tired of the endless drawing exercises and often failed to appear in class, spending the stolen hours in the galleries of the Louvre or wandering through the streets of Paris.

Daumier learned lithography from his friend Ramelet, and he earned small sums for the commercial jobs entrusted to him. At the age of twenty-one several of his political caricatures were published and were brought to the attention of Charles Philipon, then actively opposing the hated government of Charles X. When Louis Philippe came to power in 1830, Philipon set about fighting all that Louis, the "citizen king," stood for. In this struggle Daumier was a willing and useful tool.

Two newspapers carried Daumier's graphic observations and messages to the public: *La Caricature* was a weekly, and *Le Charivari* a daily publication. An early cartoon entitled *Gargantua* so infuriated the government that Daumier was fined and sentenced to six months in prison.

For *The Legislative Body*, subtitled *View of the ministers' benches of the nonprostituted Chamber of 1834*, Daumier relied on his own observation of the chamber in action. He modeled small busts of the distinguished members in clay (these have all since been cast in bronze), and from them he composed this memorable print. There is little kindness in his portrayal of the venerable gentlemen. This, like *Rue Transnonain* (*plate 58*), is one of Daumier's major lithographs.

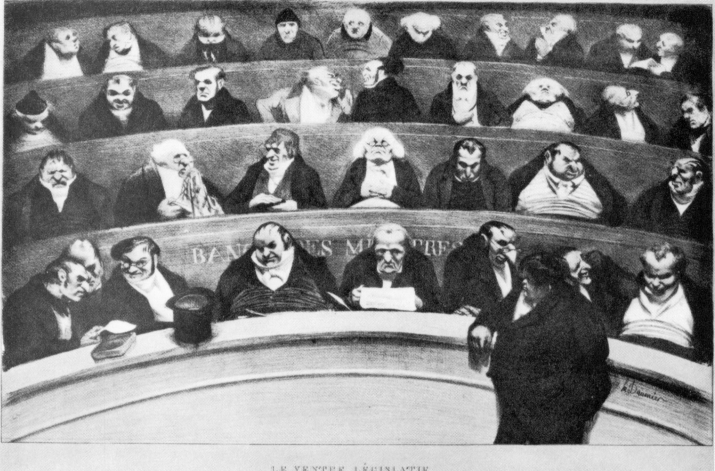

LE VENTRE LÉGISLATIF.

Aspect des bancs ministériels de la chambre improstituée de 1834

Plate 56

Camille Pissarro. 1830–1903

THE PLOW

1901. Color lithograph, 8¾ × 6″

In 1952 this author wrote the following: "Camille Pissarro, whose name is regularly associated with those of Renoir, Monet, and Degas, never seems to have received the recognition to which he was entitled; to this day, I doubt whether his true worth as an artist, or his important role as a teacher, has been evaluated properly." Happily, in the intervening time, his great stature has come to be recognized.

Pissarro revealed a love and talent for painting from early youth, but it was not until he was twenty-five that he was able to convince his family that this had to be his life's work. He arrived in Paris in time for the World's Fair of 1855 and attended its international exhibition of paintings. Of all the pictures he saw, those of Corot impressed him most. He went to visit the painter and was received kindly.

Like Corot, Pissarro in his black-and-white prints produced many "impressions" of nature. But Pissarro carried the art of printmaking further than Corot had done. He understood etching and lithography, and used aquatint to add tone and richness to his etched impressions. He occasionally produced a lithograph in color, as in the present example.

The Plow successfully simulates the character of a drawing executed with color crayons. Pissarro and Cézanne often went on painting jaunts together, and the latter actually made several copies of Pissarro's landscapes. Cézanne once paid his friend a great tribute when he listed himself in a catalogue as "pupil of Pissarro."

During his lifetime Pissarro received few official honors. Even at the end, when some success had come, he remained doubtful of it. In one of the last letters he sent to his son Lucien, he wrote: "I sold two pictures to the Museum and two to collectors, but I am hardly besieged by demands! I see that we are far from being understood—quite far—even by our friends."

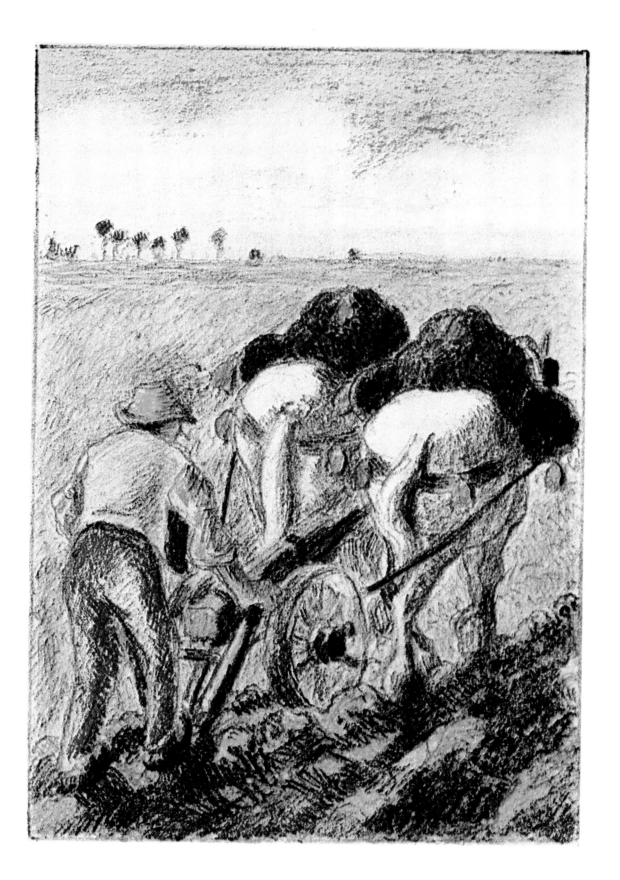

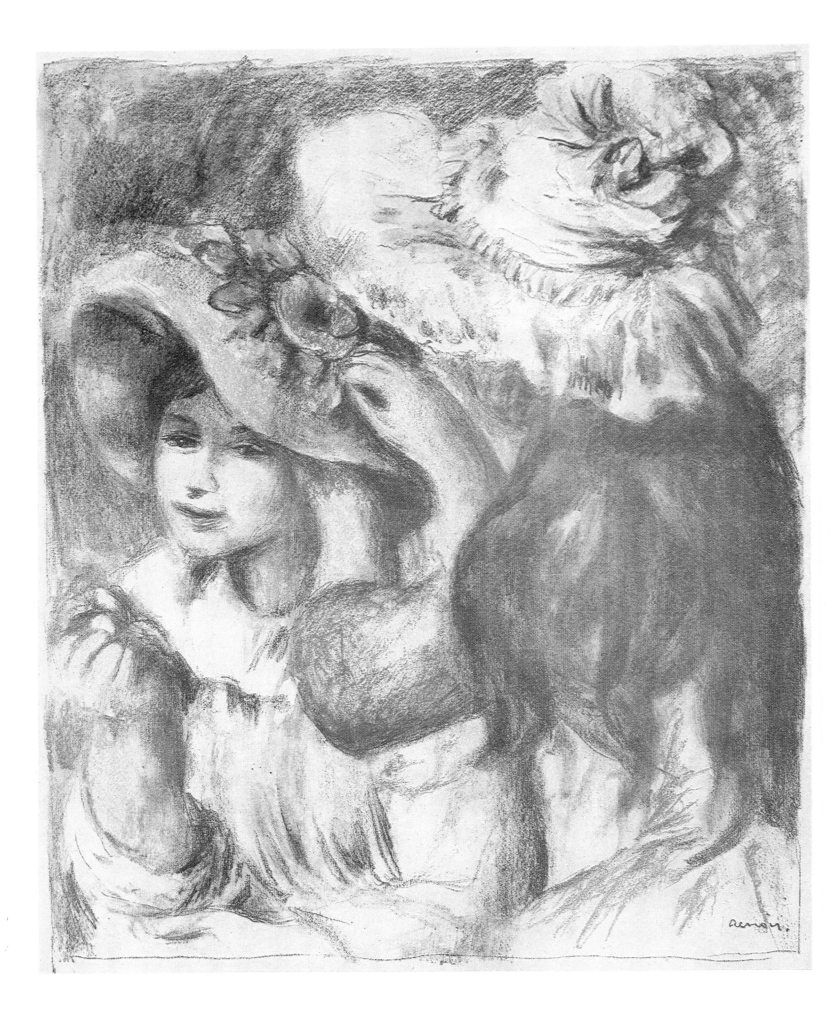

Plate 57

Auguste Renoir. 1841–1919

PINNING THE HAT

1897. Color lithograph, 24 × 19½″

In Renoir's circle, a number of artists delighted in painting, drawing, or producing prints of family and friends—especially when children were involved. For Berthe Morisot and Mary Cassatt this was a favorite theme, as it was for Renoir, too. The lithograph illustrated here was inspired by the incident of Berthe Morisot's daughter pinning on her cousin's hat. Renoir did an oil and a pastel in 1893 based on this theme, and several small etchings in 1894. The dealer and publisher Ambroise Vollard, foreseeing their use as framed pictures for wall decoration, suggested that he make some oversize prints of the subject. The artist executed two versions in black-and-white, and some fifty proofs of each were printed in sanguine and bister inks. For the printing of the color lithograph here reproduced, Renoir hand-colored a black-and-white impression with watercolor and pastel, to serve as a model for himself and the printer. It required eleven stones to print the finished version.

The lithographic stone offered the artist great latitude: he could draw with a crayon, wash tones in with a brush, and scratch with a pen or other materials, making such effects possible as those we see here. It is little wonder that the French artists, when they learned how congenial lithography was as a medium for their talents, consented to make editions of prints. Renoir produced a goodly number of etchings and black-and-white lithographs, but at the time of his death he had completed only four in color. He had in preparation several color prints for publication by Vollard, but these were not carried beyond the black-and-white stage.

Plate 58

Honoré Daumier. 1808–1879

RUE TRANSNONAIN

1834. Lithograph, 11½ × 17⅝"

Rue Transnonain is considered by many to be Daumier's greatest lithograph, though it was done early in his career. It is said that he deliberated for six months in working out this treatment. This is no caricature in the usual sense of the word. The drawing is powerful, worthy of any master; the composition is brilliant; and the dramatic handling of black and white indicates how much "color" can be suggested when the lithographic crayon is held by a master hand.

The scene represents the horrible events of April 15, 1834, when the police repressed what they termed a rebellion in the Rue Transnonain. A family is shown exterminated: what more ghastly spectacle than this, the dead father fallen upon the pitifully tiny body of his son. The head of another victim intrudes into the right of the picture, and the fourth victim lies in the deep gloom at the far side of the blood-drenched room. The reader needs no written commentary to this tale of horror.

Daumier never made another lithograph quite like this one. He continued to castigate oppressors and to mock the pompous. He was keenly observant of the *bourgeoisie*, but kinder in his satire of their middle-class manners and foibles. *Rue Transnonain* remains his grimmest and perhaps most memorable masterpiece in this medium.

Daumier painted and sketched the society which he knew, but his art is as timeless as any that has come down to us. Just change the costumes of his characters and you will have observations on human behavior which apply to generations before and after his own. Study his political cartoons and lampoons and you will find in them a relevance to events of yesterday, today, and surely tomorrow. For Daumier saw in humanity (the only thing with which he was concerned) those qualities which are everlasting, or at least eternally recurrent.

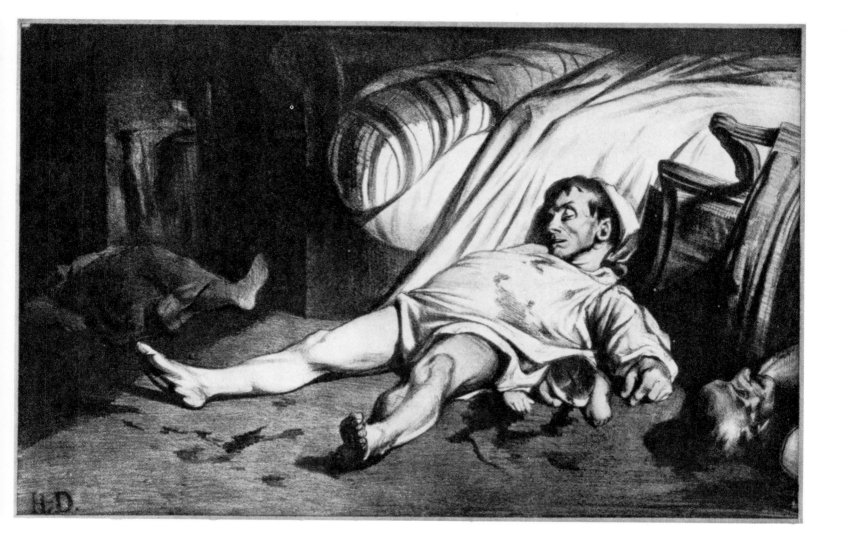

Plate 59

Honoré Daumier. 1808–1879

PYGMALION

From the series STORIES OF ANCIENT TIMES. *1842*
Lithograph, 9⅛ × 7½″

For about thirteen years, from 1835 to 1848, when revolutionary mobs again tramped the streets of Paris, Daumier produced thousands of lithographs for *Le Charivari*. The range of subject matter was varied, and covered events both current and remote. Nothing seemed to please the artist as much as retelling in his own style the legendary tales of heroes, heroines, and other famous characters from the Classical past.

Daumier's humor is at its broadest in this series, which deals with ancient history. Pygmalion and Galatea have long been a popular theme in literature, music, and the fine arts. But where do we encounter a version that offers so outrageously exaggerated an image of the sculptor and his statue as this one? The reader may recall other treatments of the theme, but he will definitely never forget this one. And the more conventional treatments are apt to suffer through comparison with Daumier's, for here he has indeed reduced the love story to an absurdity.

Our Pygmalion is a long-haired artist who is bewildered at what he has wrought: with mallet and chisel he has released this goddess from the cold marble, and is a bit shocked at having done so. The lower part of her torso is still white and without life, but the upper portion has become flesh and blood, and her features already carry an invitation to seduction. Daumier did not copy figures such as these from the casts of antique sculpture in the Louvre: they are the bodies he saw exposed in the public bathhouses of Paris, and immortalized in his famous set of *Bathers*. Galatea, just coming to life, might well be one of the bathers about to plunge into the pool. It is said that Delacroix constantly copied Daumier's prints as a cure for the vagueness of his own drawing.

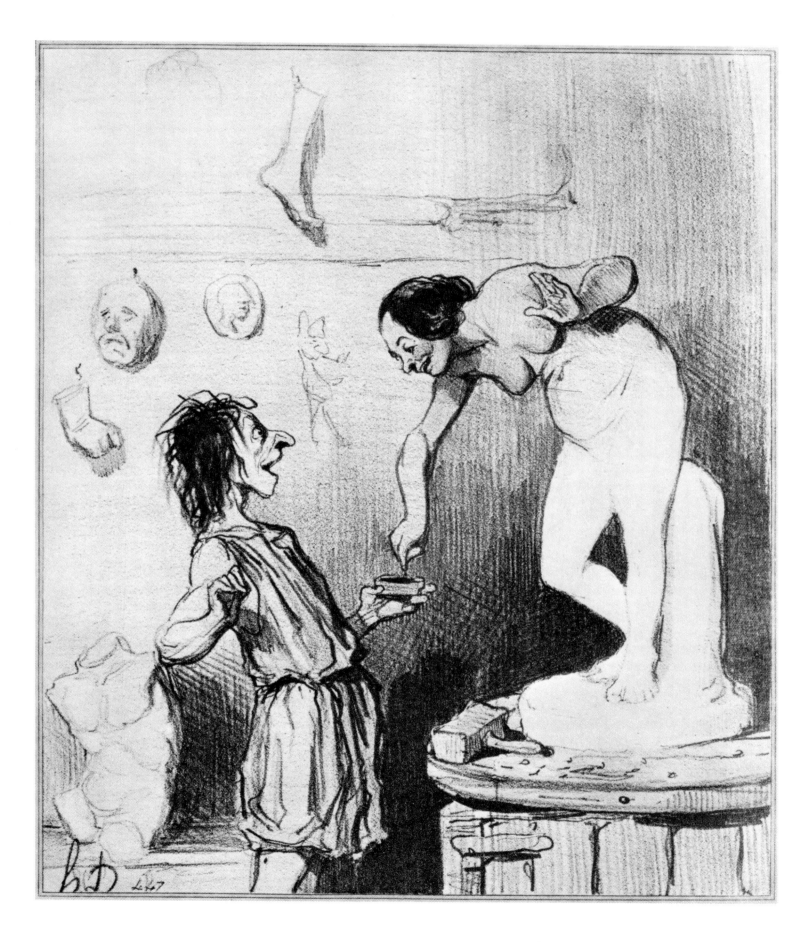

Plate 60

Honoré Daumier. 1808–1879

PARDON ME, SIR, IF I DISTURB YOU A LITTLE....

From the series THE BLUESTOCKINGS. *1844*
Lithograph, 8¾ × 7¾"

The biographical material on Daumier is vast, and it is a tribute to him that so much has been written about a man whose daily life was actually very pedestrian. In fact, there are hardly any anecdotes to relate which make Daumier out to be a colorful character. When not producing lithographs, he painted with his artist friends during the day and joined them at night in their café gatherings. He was a good listener, but rarely held the floor. Yet in his art Daumier was a giant—incisive, bold, and controversial.

Today there is no question of Daumier's greatness, but this recognition did not come easily during his lifetime. It was left to the amazingly perceptive Charles Baudelaire to write of Daumier, as he did of other unrecognized talents. In his *Aesthetic Curiosities* he makes the following statement:

> I am going to speak of one of the most important men, I will not say merely in caricature, but in modern art, a man who amuses the population of Paris every morning, and daily satisfies the need of public gaiety by giving it something to feed on. The bourgeois, the businessman, the urchin, and the housewife often laugh and pass on, ungrateful creatures, without noticing the artist's name. Up to now only artists have grasped that there is something serious about him, something that would really supply material for a treatise. As you may guess, it is about Daumier. . . .

Woman's fight for independence and equality is recorded in a series of lithographs titled *The Blue-stockings*. Was Daumier sympathetic to the cause? We need only examine the type of evangelist portrayed and her effect on the men around her for our answer.

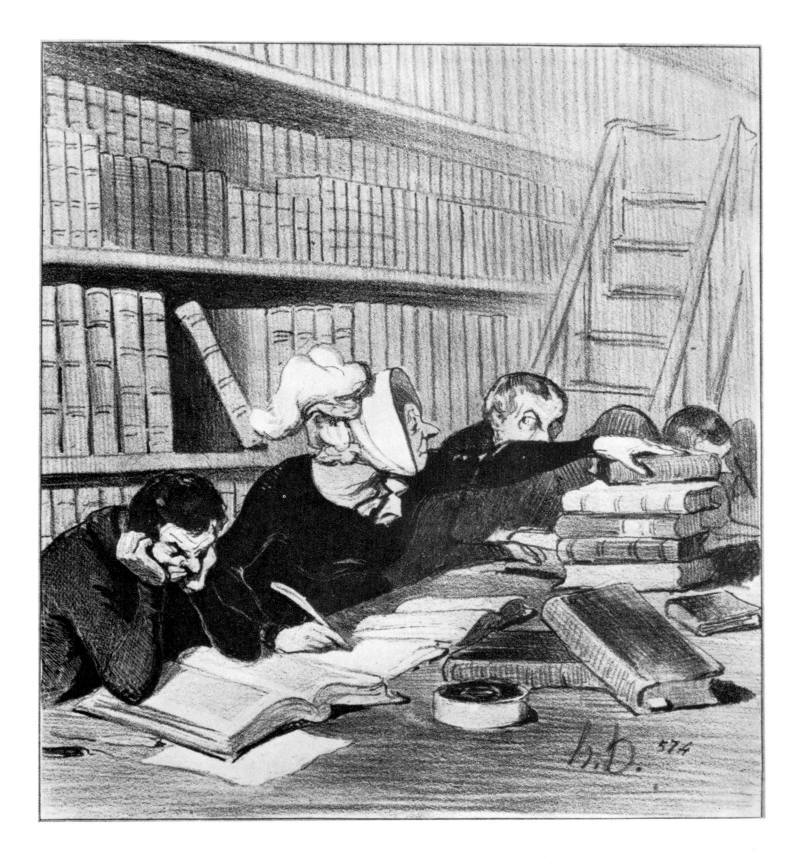

Plate 61

Honoré Daumier. 1808–1879

NOW THEN, THE PUBLIC PROSECUTOR IS SAYING
SOME VERY NASTY THINGS TO YOU...
TRY TO CRY A LITTLE, AT LEAST FROM ONE EYE...
THAT ALWAYS HELPS!...

From the series THE LEGAL PROFESSION
1846. Lithograph, 9⅜ × 7¾"

In the course of his career Daumier produced close to 4,000 lithographs; 3,958 are illustrated in the moumental catalogue by Loys Delteil. The subject matter of these lithographs, apart from the political cartoons, is the life of Paris and its environs. It is Balzac's Human Comedy, and Daumier's crayon observations would make apt and telling illustrations for the novels. Every aspect of life is touched upon—the theater, the law courts, the print dealers, family life, and bourgeois excursions. Daumier's representations of Classical and mythological characters in the costumes and settings of his own day are the most extraordinary satires of this sort ever made. Here is his answer to the followers of David, who aped the Greeks and Romans and deified them to an absurd degree. Daumier, following his own dictum, made Diana, Ulysses, and Jupiter belong to his own time.

The Legal Profession is a magnificent suite of prints dealing with events at the Palais de Justice, where Daumier had spent so many hours on his first job. He has a strong dislike for the lawyers and judges; for those on trial, even the occasional scoundrel, he shows much sympathy. Generally, Daumier brought his lithographs to the editors of the journals without any written comment; all that he had to say was revealed in his incisive drawings. Members of the editorial staff added the legends, such as we see appended to the present subject—and it seems most appropriate.

It is ironic that today the most avid collectors of this group of prints are lawyers, who seem to take little offense at Daumier's sharp criticism of their profession.

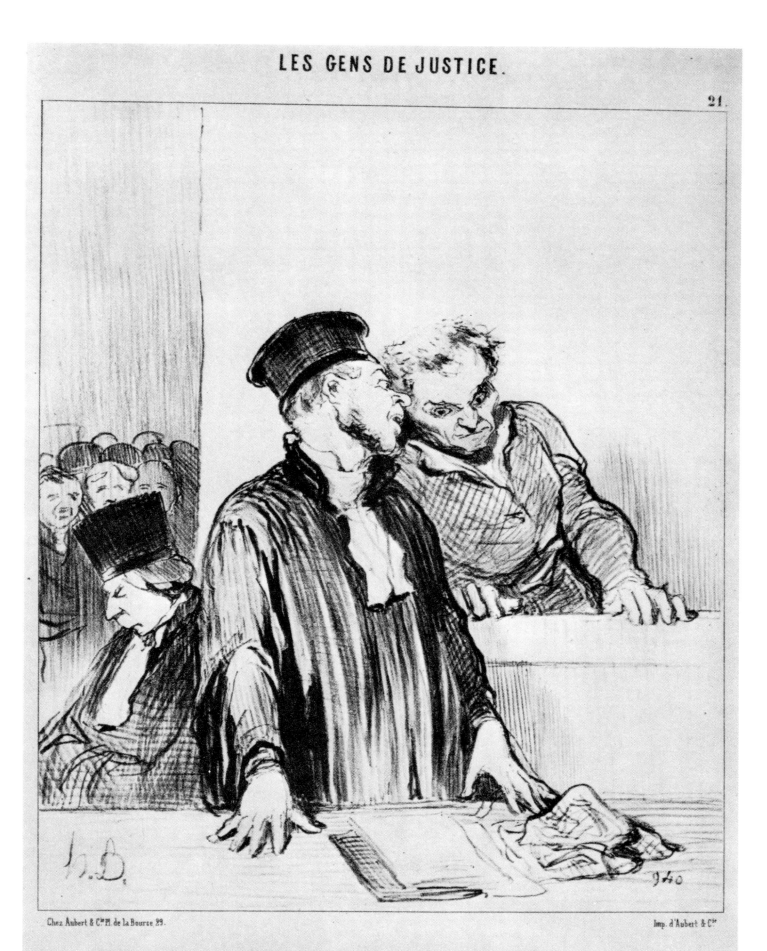

– Voilà le ministère public qui vous dit des choses très désagréables...... tâchez-donc de pleurer au moins d'un œil....... ça fait toujours bien!.......

Plate 62

Jean-François Millet. 1814–1875
PEASANTS GOING TO WORK

After 1855. Etching, 15¼ × 12⅛"

Millet is best known for his paintings of peasant life, honest representations that are beautiful in their truthfulness and dignity. An educated man, he never permitted his learning to interfere with the simple statements he chose to make about the peasant folk he loved, and the ambience in which they performed their hard but simple tasks. He studied in Paris, but the city never appealed to him; only at the Louvre, where he encountered the works of Mantegna, Michelangelo, and Poussin, did he find a congenial atmosphere.

Millet produced forty-four etchings. These include the small trial proofs which he etched on copper plates and printed himself; his major works, which number only thirteen, were larger in scale and professionally printed. All of them are significant prints, and he elaborated on most of them to produce his more famous oil paintings. But etching was not popular with the collector when Millet was doing his best prints. As a result, first-rate impressions are scarce, and may no longer be found on the market.

Although Millet loved the country, especially the area near the forest of Fontainebleau, his etchings depict peasant life—in the fields and cottages. In this print, *Peasants Going to Work*, the figures of a man and wife are silhouetted against the land they are about to till. It remained for Van Gogh, who was a great admirer of Millet, to endow the simple man again with this kind of dignity.

Millet's etchings are not mere imitations of drawings, as we can see when we examine the impression reproduced here. He understood his craft well and used it with efficiency. It is to be regretted that he has left us so few examples.

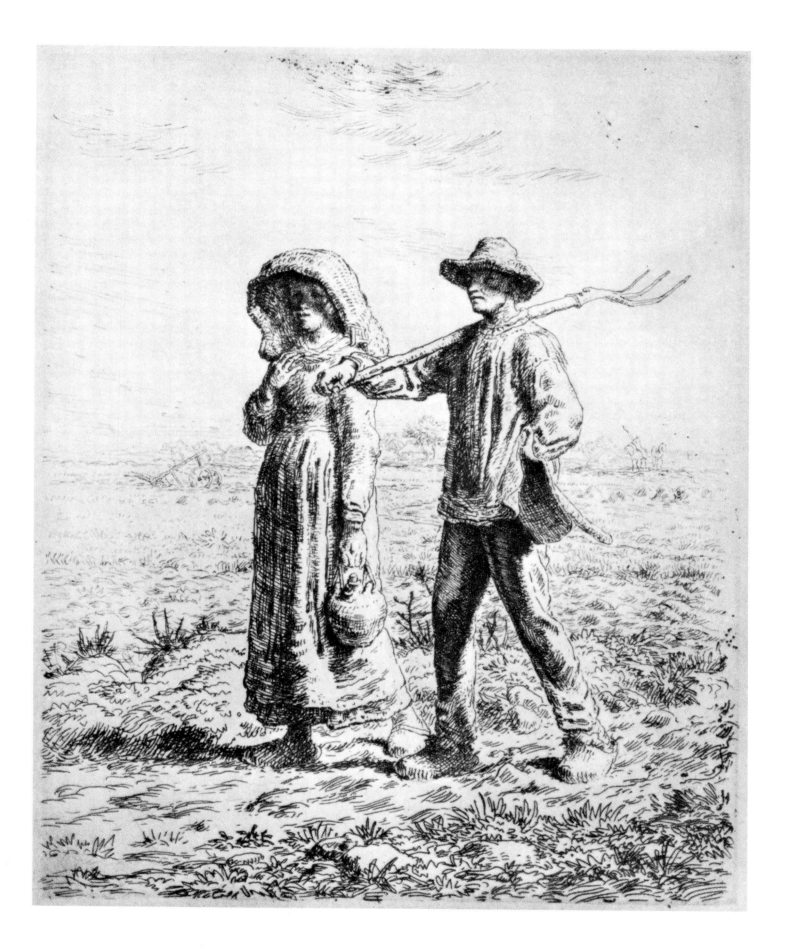

Plate 63

Charles Meryon. 1821–1868

THE APSE OF NOTRE DAME

1854. Etching, 6 × 11½"

Charles Meryon was born in Paris in 1821, the son of an English physician and a French ballet dancer. At seventeen he was enrolled in the Naval School at Brest. During a seven-year stint in the Navy he sailed to Australia, New Zealand, and many Mediterranean ports. But poor health forced him to resign his commission. He then moved to the Latin Quarter in Paris to study painting, only to discover that he was color-blind. He was completely disheartened until Eugène Blery introduced him to the art of etching.

Meryon loved the Paris of his time and was disconsolate at the destruction of its most colorful quarters when Baron Haussmann, under the direction of Louis Napoleon, began his replanning of the oldest parts of the city. Much of what we know today of these areas and their demolished buildings, we owe to Meryon's etchings of Paris, yet the series was refused when it was submitted to the Salon, and even the print publishers showed little interest. Only some of the more obscure shops of the Latin Quarter took his prints on consignment.

The print illustrated here is certainly one of his greatest—although all in the Paris set are superb. His method was to make numerous sketches, two or three inches square, before starting the larger final composition. Buildings might be raised or lowered to obtain the desired effect, and there is no single point from which the view, as shown on his prints, might be had.

It is rare to find even five impressions of any of Meryon's plates, for he was too poor to pay for the printing. Frederick Keppel, in his charming *Charles Meryon: A Biographical Sketch* (c. 1907), relates the following anecdote told to him by Monsieur Beillet, an aged printer who served the printmakers of his time:

> Meryon came stealing into my atelier, looking even more nervous and wild than usual and bringing with him two sheets of paper and the plate of his *Notre Dame*. "Monsieur Beillet," said he, "I want you to print me two proofs of this plate," and added timidly, "I cannot pay you till I sell them—don't refuse me."

Meryon never managed to pay the printer. Finally, in a fit of frenzy, he destroyed his best plates. In 1868, he was buried in the cemetery of Charenton, the Paris asylum.

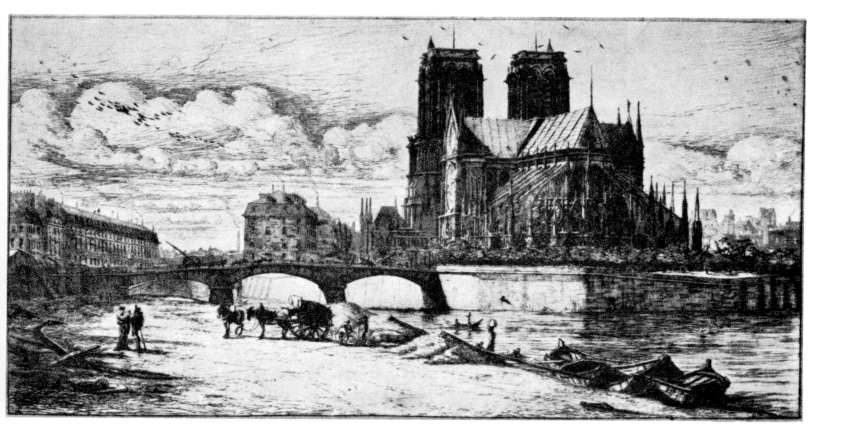

Plate 64

Edouard Manet. 1832–1883

THE RACES

1864. Lithograph, 14⅜ × 20⅛"

During a good part of his life Edouard Manet was severely, often maliciously, criticized by his contemporaries—artists, critics, and laymen alike. When he was buried in the small cemetery at Passy, Degas, who was always so economical with a compliment, was heard to remark: "He was much greater than we thought."

"You will never be more than the Daumier of your time." This was the judgment of the painter and art teacher Thomas Couture when he looked at young Manet's paintings, which departed in subject matter and technique from the sleek academic classicism of Couture and his less rebellious students. In his prints, Manet does indeed remind us of the great Daumier in his mastery of lithography.

Manet was not a prolific maker of prints. He made etchings after the works of Goya, and interpretations of his own paintings. When the publisher Codart, who was attempting to arouse interest in lithography, sent him some stones on which to experiment, he was enormously intrigued, and in the course of the next ten years produced about twenty prints.

The Races is probably his finest effort in this medium, and comes closer than any other graphic work to expressing the tenets of Impressionist theory. One is reminded of the black-and-white block prints by Hokusai and his contemporaries that were imported from Japan. The French artists of Manet's group knew, admired, and borrowed from these masterpieces. Like the Japanese, the Impressionists strove to suggest the movement, not the static quality, of all they observed—a tree or flower blown by the wind, a person walking, or a group of horses coming down the homestretch. Everything in this print is blurred; there are no strong defining lines, no sharp edges or limits. Yet all is clear to the observer—the excitement in the stands and along the rail, and the mad scramble of horses and jockeys.

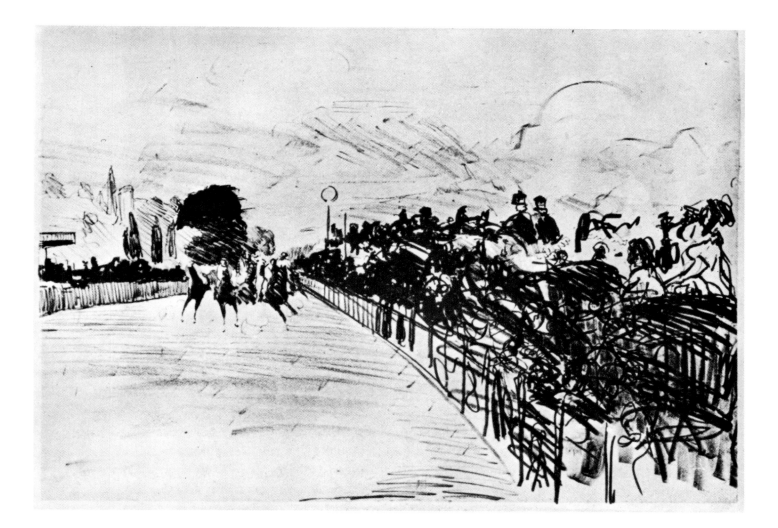

Plate 65

Henri de Toulouse-Lautrec. 1864–1901
Aux Ambassadeurs

1894. Color lithograph, 12×9½"

Toulouse-Lautrec has been described by many of the artists, poets, novelists, and entertainers whose paths he crossed during his brief life. His appearance was unforgettable and caused him to be called everything from a "Velázquez dwarf" to a "hunchbacked Don Juan."

Lautrec's first teachers were the best animal painters of the day—René Princeteau and John Lewis Brown. He quickly revealed his aptitude with pencil and brush, and was enrolled in the studio of L. Bonnat, a successful and fashionable academic painter of the time. There Lautrec ran into criticism, for Bonnat approved of his painting but thought his drawing "simply atrocious!"

But it was Montmartre that really instructed and molded Lautrec. And nowhere in the realm of art does this animated district of Paris come so truly to life as in his paintings and his lithographs (these include posters, song-sheet covers, and book illustrations). He felt at home in this atmosphere; he liked and understood its inhabitants. He set them down in grease crayon and paint, and rendered many of them immortal: Yvette Guilbert, Valentin, Jane Avril, May Belfort, La Goulue, the clown Footit, and a host of others.

Aux Ambassadeurs, one of Lautrec's major color lithographs, was issued in a small edition of only one hundred prints, signed by the artist. We reproduce here an almost unique proof print of an early state. The influence of Japanese prints is stronger here than in most other graphic works of the period. Lautrec and Mary Cassatt, in her color aquatints, came closest to comprehending the unique character of the Oriental wood-block print, and they successfully translated it into the idiom of their time and their individual personalities.

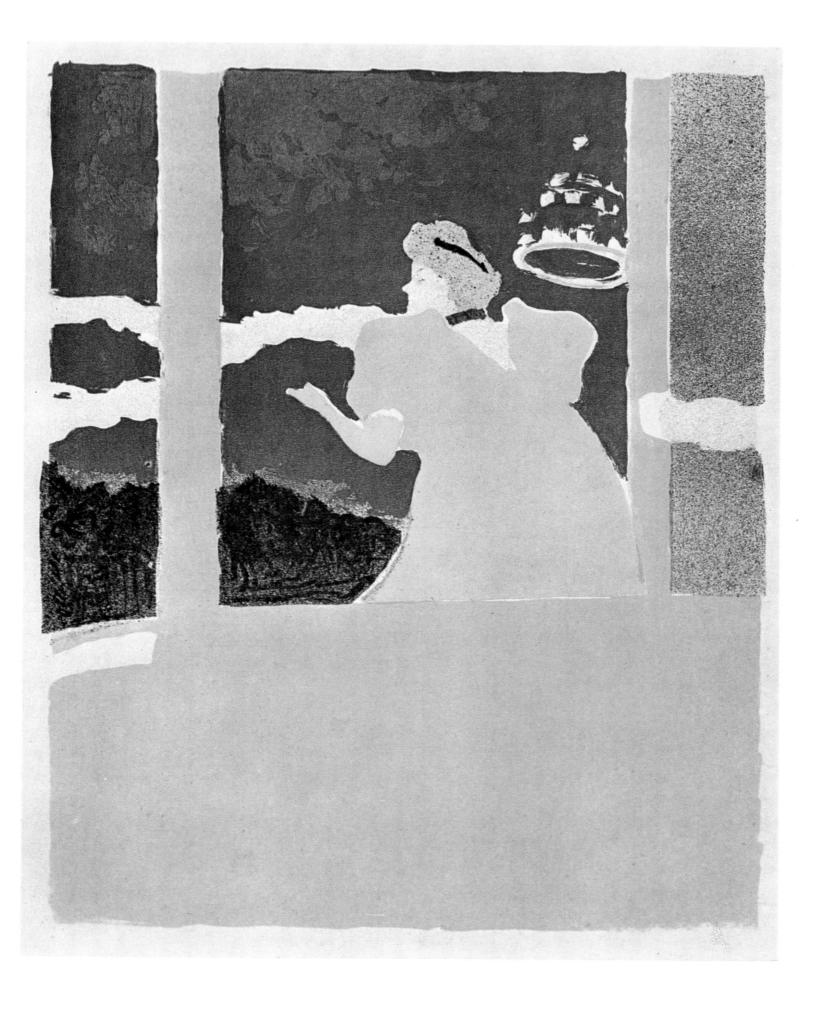

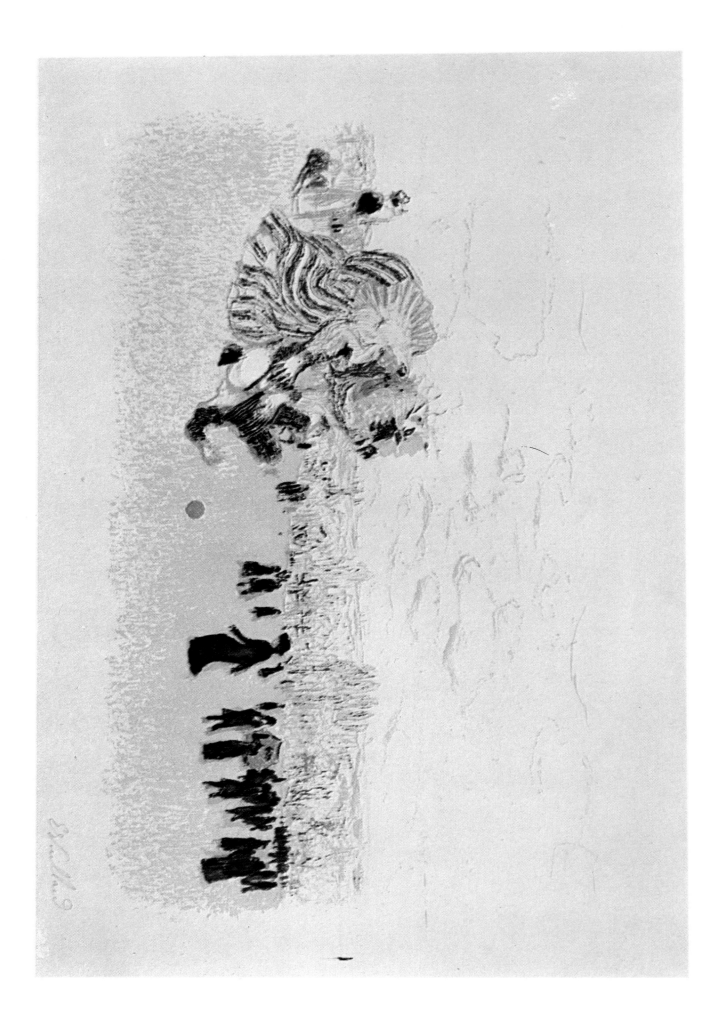

Plate 66

Edouard Vuillard. 1868–1940
CHILDREN'S GAME

From the second ALBUM DES PEINTRES-GRAVEURS, *1897*
Color lithograph, 13½ × 19¾"

Most art historians and all of Vuillard's biographers refer to him as an "intimist." What these writers wish to suggest is that he derives much of his subject matter from the contemplation, and loving depiction, of simple everyday surroundings—cluttered rooms, overladen tables, papered walls. Family and friends people his interiors and landscapes. He rarely refers to legend or history except in his occasional decorative panels designed as murals. Vuillard, more than any other artist of his time, brings order out of apparent chaos. If his work suggests the work of any writer, it is certainly that of Marcel Proust, and Vuillard's personal recollection of the circumscribed world of his paintings and prints might well be described as a "remembrance of things past."

Vuillard was early influenced by the theories of the Nabis, a group of young painters inspired by statements and works of their older contemporary, Paul Gauguin. The term Nabi derives from the Hebrew word for prophet. The movement as such was short-lived, but from its small membership came at least two great artists, Bonnard and Vuillard.

Vuillard was not a prolific printmaker, and the majority of his works were done within the limitations of the black-and-white proof. However, his *Paysages et Intérieurs,* published by Vollard in 1899, and a few other larger prints, all in color, place him in the top rank of graphic artists of his time. With Bonnard and Roussel, aided by the master printer Auguste Clot, Vuillard worked diligently on Vollard's project. It is ironic that these prints, now so rare and costly six decades after they were made, were almost completely ignored by laymen and collectors at first, even though the prices were exceedingly low.

Children's Game is one of the master's major prints. On a large "lawn," arbitrarily rendered in a strong yellow, a woman bends down to pick up her fallen child. Other silhouetted figures dot the receding landscape. Distant trees and sky are summarily represented. There is a semi-Impressionistic handling of color and outlines. The strong influence of Japanese prints is also apparent.

Plate 67

Edgar Degas. 1834–1917

SELF-PORTRAIT

1855. Etching, 9 × 5⅝"

Degas did few portraits in the graphic medium. There are several small plates of his family, three etchings portraying Manet, and a few copies, one after Velázquez and one, of a seated young man, after Rembrandt.

When Degas etched this self-portrait he was only twenty-one and recently enrolled in the Ecole des Beaux-Arts. A year later he received technical instruction from the engravers Tourny and Bracquemond. But Degas, like so many of his contemporaries, haunted the Louvre for inspiration and instruction. A frequent visitor to the print room, he was able to study the works of the greatest masters of graphic art—and from Rembrandt no doubt came the incentive to make this plate.

It is incredible that Degas could make a print of such technical excellence at the very outset of his career. The crosshatching in the garments and hat, very tight in some areas and more open in others, yields rich contrasts of black and white. To model the features of the face he combined straight and curvilinear strokes.

Degas produced about seventy works in various graphic mediums, including straight etching, drypoint, soft-ground etching, aquatint, and lithography. He also made between four and five hundred monotypes; probably no other major artist produced as many. Loys Delteil, the author of the stupendous catalogue of nineteenth- and twentieth-century graphic art, mentions these but does not describe or illustrate them, for, as he phrases it, they are not graphic works by his classification, but "drawings on copper."

As a printmaker, Degas showed extraordinary independence. He made endless experiments and rarely appeared satisfied with first results. Many of his plates went to five (such as this illustration), six, and eight states—one of them to twenty. He was always so reluctant to entertain and exhibit that most of his works were known to only a small circle of friends during his lifetime.

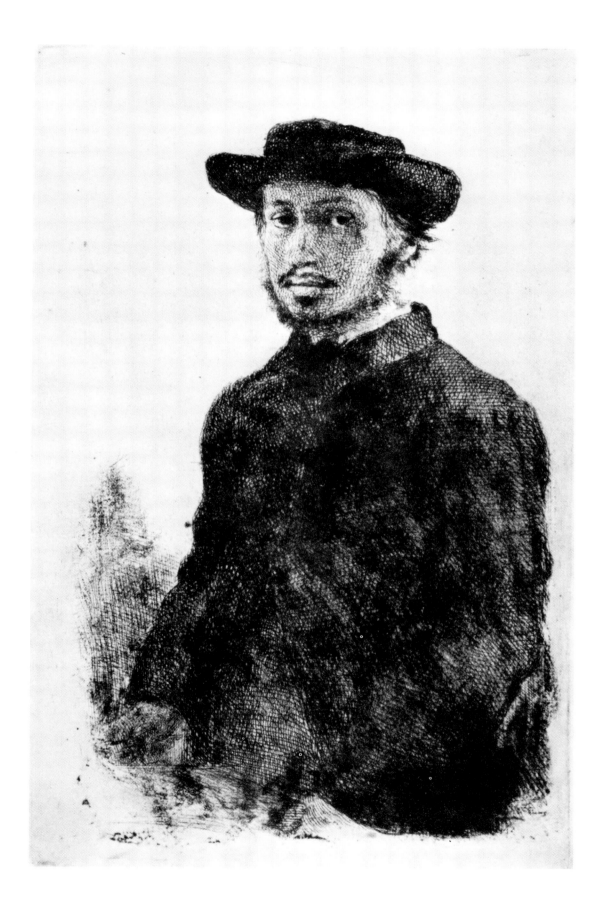

Plate 68

Edgar Degas. 1834–1917

MARY CASSATT AT THE LOUVRE

1876. Etching and aquatint, 11⅞ × 5″

On his deathbed, Degas, knowing the remaining hours to be few, turned to the painter Forain and said, "I don't want there to be any speeches!" Changing his mind in an instant, he added, "Yes, Forain, you will make one and you will say, 'He loved drawing very much.'"

One of Degas' idols was Ingres, and in his youth he made many drawings in the manner of the older master. In his graphic work this feeling for the clean, incisive, often pale line appears only in some of the earliest efforts. There is a small portrait of his father, Auguste de Gas, done in 1856, which recalls the pencil sketches of Ingres. In the same year he also executed, in a similar manner, the portrait of the engraver Joseph Tourny.

But the prints completed after 1875 no longer reflect the style of Ingres or the Beaux-Arts. As Lautrec did later, Degas turned for his subject matter to music halls, brothels, theaters, and opera houses. Although he made many sketches and paintings of the race track, he left no such records in graphic art.

Some twenty years after executing the self-portrait in plate 64, Degas began the preparation of *Mary Cassatt at the Louvre*. There are twenty known states of this print, and the transformation from the first to the twentieth is dramatic (the eighteenth state is reproduced here). Combining etching with aquatint, he added and subtracted details, strengthening some areas and weakening others. Yet he was probably not completely satisfied even with the final impression.

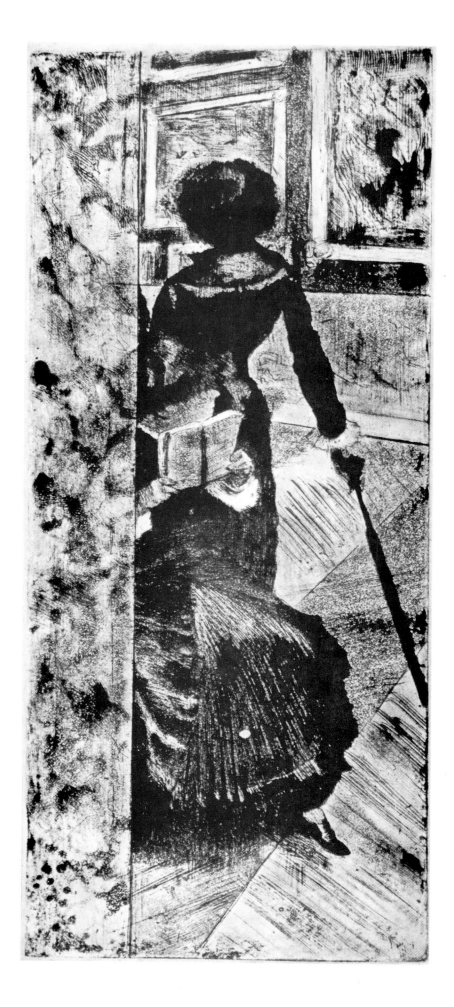

Plate 69

Edgar Degas. 1834–1917

STANDING NUDE DRESSING

c. 1890. Lithograph, 13⅛ × 9⅝"

Degas remains one of the most "underived" artists of his time. As he matured he relied less and less on the heritage of the past. He did, however, know the works of the masters well, and in his last years became a more and more avid collector. He treasured pictures (which he purchased) by Gauguin, Manet, Delacroix, and his favorite Ingres. It is said that in his bedroom there was an El Greco, over which he hung his trousers at night.

By 1890, the probable date of this print, Degas had completed his experiments with graphic art. His best efforts were in the realm of lithography and this, the last item illustrated in Loys Delteil's catalogue, is a masterpiece. It may be compared favorably with the many sketches, pastels, and paintings which he did of the same subject. In this print that he developed through four states, of which we illustrate the third, Degas not only draws (one is tempted to say that he sculpts) the nude figure, but creates the air and space around her.

In his many paintings and sketches Degas was constantly attempting to demonstrate that the unposed figure, even while performing simple and homely acts, was beautiful—that the natural rhythms of the body, in unrehearsed movements or postures, was superior to the posed models of the Academy. He was too honest to succumb to the convention of justifying the representation of a naked woman by naming her Diana, Venus, or Galatea. Most of his life he painted what he saw. He imagined little, embellished nothing, and never resorted to dreams and fantasies as did some of his contemporaries.

A succinct appraisal of his art was contained in a book which he once owned, a first edition of *Pierre et Jean*. There, in the handwriting of the author, was written: "To Edgar Degas, who paints life as I would have liked to be able to paint it." This was dated 1888 and signed: Guy de Maupassant.

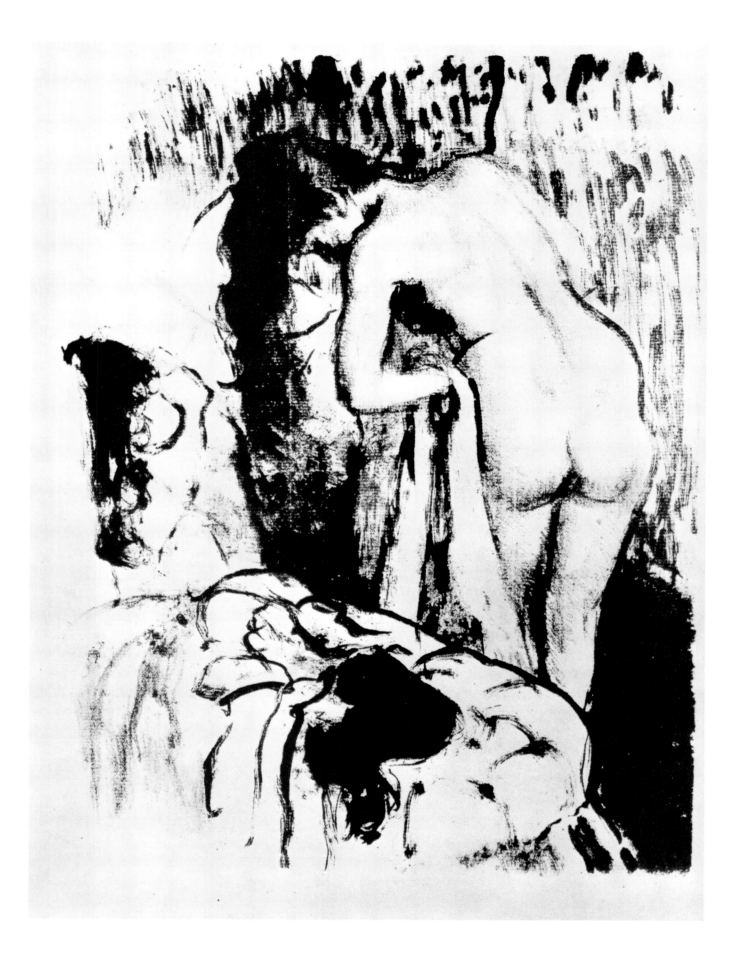

Plate 70

Edgar Degas. 1834–1917

After the Bath

c. 1890. Lithograph, 11 × 12"

Almost all of Degas' lithographs were executed after 1875, and, barring a few vignettes of men, they are dedicated to the female sex. There are several scenes in night clubs and the café-concert, and one or two in the corridors of the Opéra; the rest are intimate scenes of women bathing, drying themselves after the bath, or having their hair combed and coifed. Notoriously timid with women, Degas seems to have been almost obsessed by the nude female form. His representations are not erotic, and he preaches no moral; one has the impression that he made his sketches unobserved, as though hidden in some corner while the young girls performed the intimate acts of bathing and dressing.

The present lithograph was executed about 1890 and went through five states, all of them rare today. It would be most revealing to have the five states together for comparison. In the first the subject is drawn with rapid yet telling strokes, almost completely in broad lines; only the girl's hair is "finished." This print is the point of departure for the elaborations to follow. By the third state the body is modeled with shading around the thighs, shoulders, and face. The background is more complete and the bather's attendant, waiting with a towel, is clearly represented.

In the fourth state the lithographic stone yielded dramatic, velvety blacks; all attention now centers on the bending figure. There is a certain mystery about the subject, for the details of the background are vague and the attendant has been almost obliterated; only her hands are visible over the flowing hair of the bather. In the final state (illustrated here) Degas reworked much of the stone, making the figure larger, changing the position of her arm, and filling in the background with much detail. One needs no further proof of Degas' unwillingness to compromise, of his relentless pursuit of perfection.

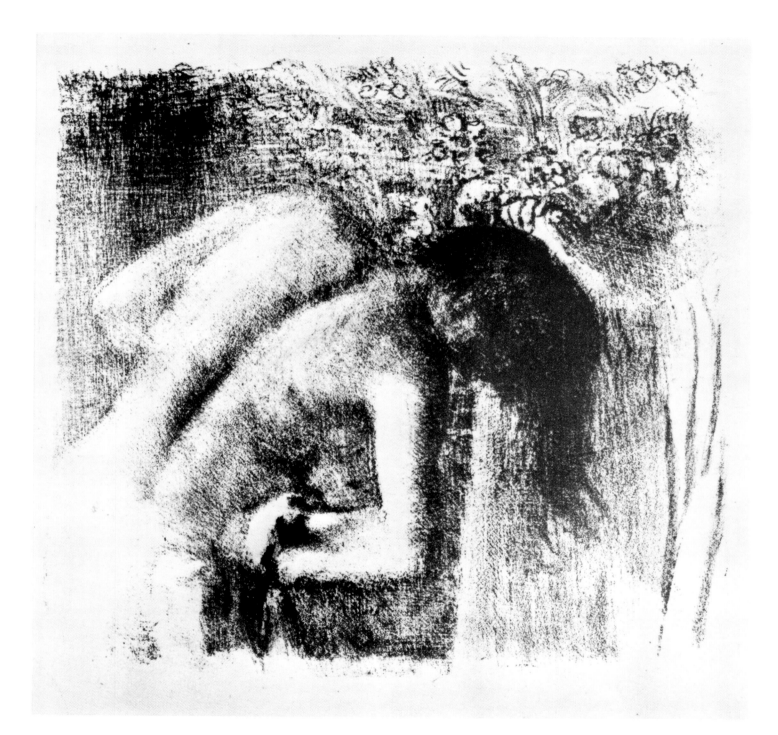

Plate 71

Paul Cézanne. 1839–1906

THE BATHERS

1898–99. Lithograph, 16¼ × 20¼"

Paul Cézanne lived a life of self-torment, but dominant throughout was the urge to work at his craft. After the conventional start at various art schools and academies, where he was influenced by teachers, fellow students, and the recognized old masters, Cézanne began to seek his own road. It was his desire to see, feel, and paint for himself, with no further regard for teachers, popular idols, or the "isms" of his own time. He broke completely with the Impressionists, saying that he was not concerned with science. He never cared for storytelling pictures and would characterize these as "bad literature." For Delacroix, however, he had great admiration, saying: "You may speak of him even after Tintoretto and Rubens." But then he added, "He has, perhaps, filled himself too full of Shakespeare and Dante, read too much of Faust!"

A favorite expression of Cézanne's was "I must find a motif." Once it was found, he would approach it in his own manner, whether the human form, the everyday objects around him, a majestic mountain like Mont Sainte-Victoire, a row of poplar trees, or a group of bathers at the edge of a stream. Bathers, already a motif for many paintings, were the basis also for several prints, both in color and in black-and-white.

Cézanne has not left us many prints—only a few etchings and lithographs. He was encouraged to try his hand at lithography by his dealer, Vollard, and was aided by the master printer Auguste Clot, who helped most of the painters of the period when they tackled the medium for the first time.

The present print remains one of the great prints of the period. Twenty years earlier, Cézanne had completed a painting of this subject; here he reinterprets it but does not copy it. He has managed to retain, or recapture, all the majesty and classic character of the original work in oil. There is a second version, smaller in format, which occurs in two modes, black-and-white and color.

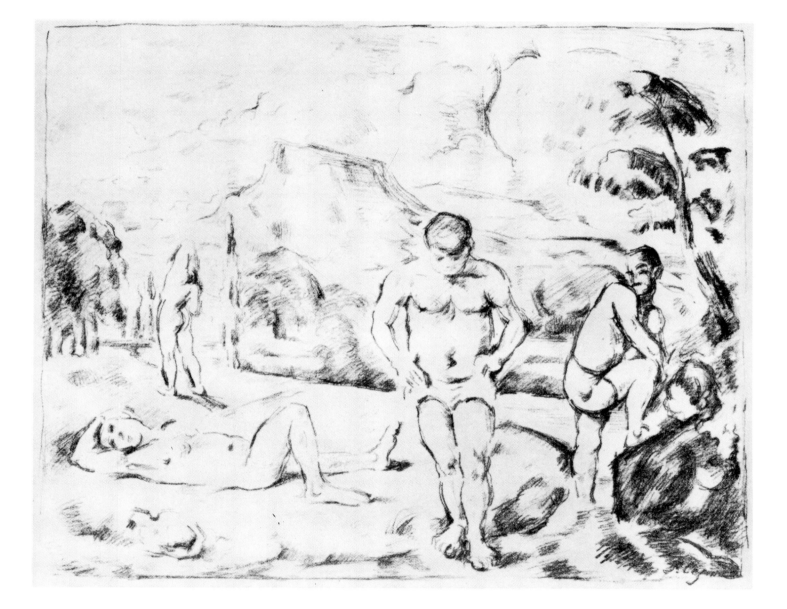

Plate 72

Odilon Redon. 1840–1916

A Sea Anemone Opening Its Petals Revealing an Eye Surrounded by Lashes

From the series ORIGINS. *1883*
Lithograph, 8³⁄₄ × 6⁷⁄₈″

The work of Odilon Redon stands apart from that of his contemporaries in style and content. His pictures reveal him as both a poet and a dreamer. In 1891, Albert Aurier, the Symbolist writer, said of Symbolism in painting that nature was to be observed by way of the dream. This phrase can well serve as the most apt and succinct description of Redon's art.

By the time Redon reached the age of fifteen, he had decided to be an artist and had begun lessons with a watercolorist named Gobin. At the same time, the botanist Clavaud introduced him to the wonderland of biology; the mystery of plant and animal life was to fascinate him to the end of his days. Although he was well aware of the works of his contemporaries, he ultimately threw off most early influences and made his work express literary ideas as he interpreted them, and dreams and visions as they appeared to his hypersensitive imagination.

There is rich material for the psychoanalyst in Redon's art. Redon himself would have been most interested in psychoanalytical interpretation, since he was so intrigued by the study of dream symbols and images, probing constantly into the realm of phantasmagoria.

This lithograph is from a series called *Origins* that deals with the very beginnings of life. The frightening image is listed in the catalogue of the artist's graphic works as *A Sea Anemone Opening Its Petals Revealing an Eye Surrounded by Lashes*. This title was probably contributed by Redon himself.

The splendid impression of this print, so rich in the velvety black for which the artist was noted, carries the notice in the lower left that it was drawn and lithographed by Odilon Redon.

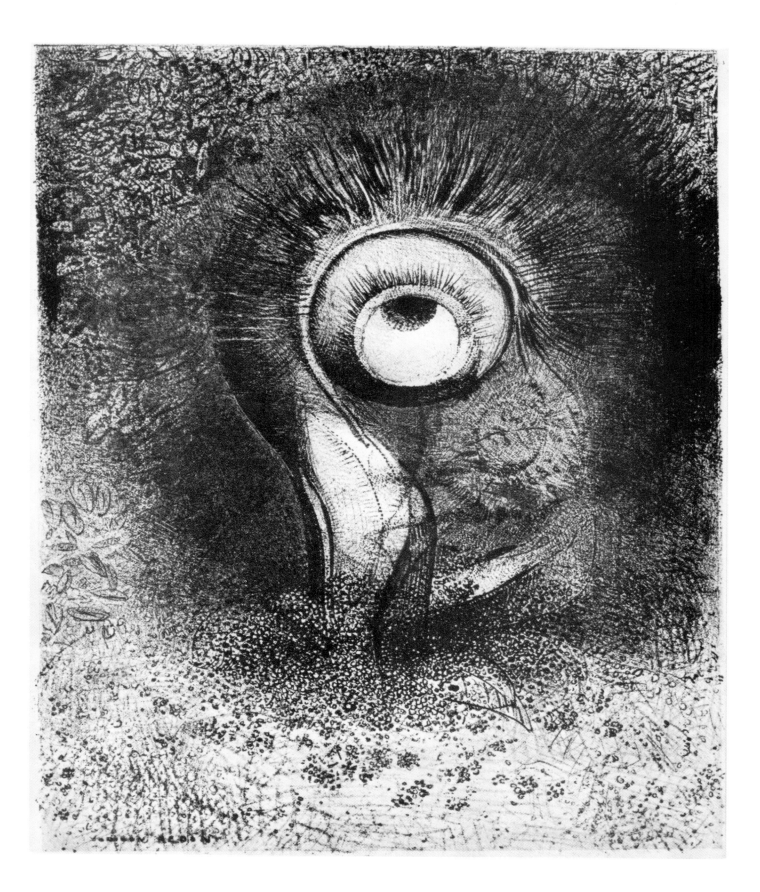

Plate *73*

Odilon Redon. 1840–1916
PROFILE OF LIGHT

From the series NIGHT. *1886*
Lithograph, 13½ × 9⅝"

Redon spent most of his solitary hours with music and books, and by the time he was twenty-eight he was well-read in the literature of many countries. It was his unquestioned skill in writing that earned him a position as art critic for the newspaper *La Gironde*. Delacroix was his god at that time, and he admired the great painter for his writing as much as his painting. Corot, Courbet, and Fantin-Latour were his friends, of whom the last, closest to him in temperament, had the most profound influence on his career. With Latour he made many visits to the Louvre, and from him he received his first lessons in lithography.

This beautiful lithograph is one of a series of six published in Paris in 1886 under the title *Night*. It is one of those haunting, chaste, mystical faces which Redon favored. They materialize out of the enveloping darkness, the countenance magically lighted.

Recognition came slowly to Redon. Toward the end of the century he exhibited in several Salons, winning praise from such critics as J.-K. Huysmans. In 1899, a great exhibition was arranged in his honor at the Durand-Ruel Gallery. At this time he also concentrated more and more on color, producing some of his finest works in paint and pastel.

But, like so many great men, Redon was never certain that he had made a real contribution. In 1907 he addressed a letter to his friends Marius and Ary Leblond, in which the following sentences appear: "It is a long time now that I wield the fateful crayon. Will it have traced anything of lasting worth? This is the worried self-questioning that occurs at life's end; I don't yet know the answer." The answer, of course, is to be found in the museums and collections of the world.

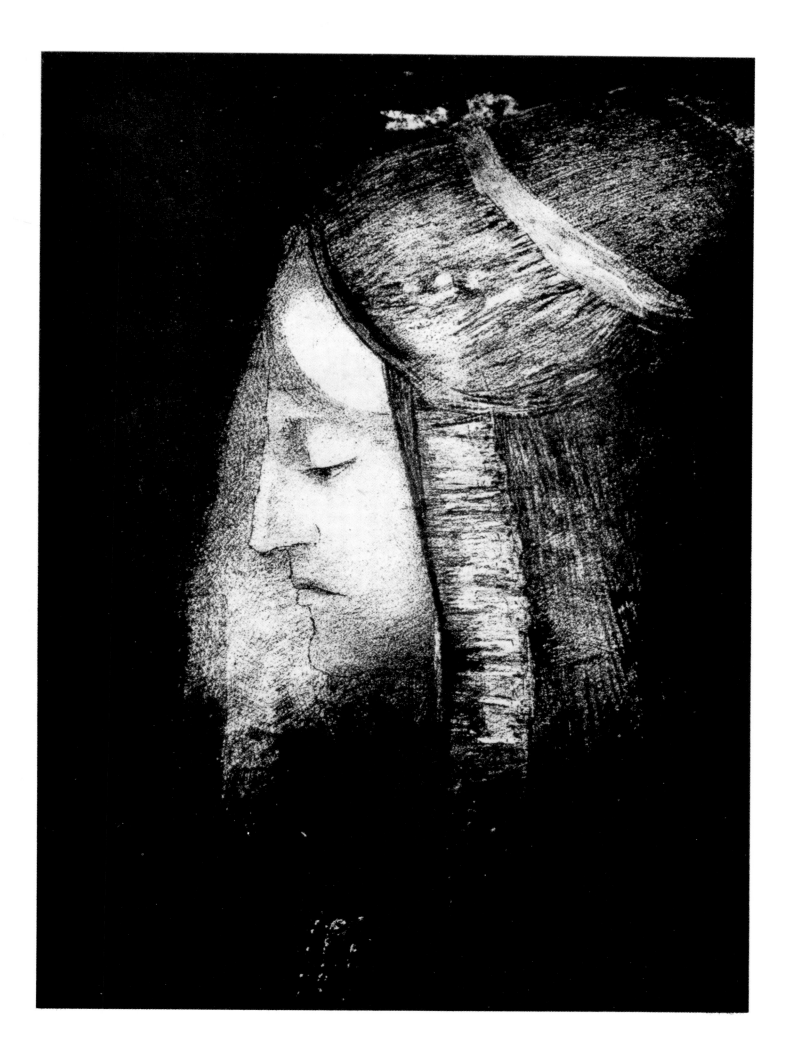

Plate 74

Georges Rouault. 1871–1958
JUDAS

Illustration for André Suarès' PASSION. 1936
Color etching and aquatint, $12\frac{1}{4} \times 8\frac{1}{2}$"

In a number of his art classes in 1892, Rouault encountered Henri Matisse, an independent thinker with whom he felt a common bond and in whom he recognized a spirit of rebellion against the Academy. The two met again later and helped to found the Salon d'Automne in 1903, planned as an unrestricted place of exhibition, where artists of diverse philosophies and techniques could offer their works to the public and critics. As might have been expected, the academic world damned the artists and the public laughed at their pictures.

One of the few champions of the Impressionists had been Charles Baudelaire (1821–1867). His writings, brilliant and prophetic, were almost always in support of the artistic revolutionaries, many of whom we have discussed in this book. Rouault did a series of illustrations for the edition which Vollard planned to issue of Baudelaire's *Les Fleurs du Mal*.

Ambroise Vollard, the most astute art dealer of his time, became an important force in Rouault's career. As the artist's sole agent, he induced Rouault to dedicate his talents to illustrating books, most of which hold their place among the finest publications of this century. Rouault made black-and-white plates for Alfred Jarry's *Les Réincarnations du Père Ubu (see fig. 21)*, as well as plates in color for André Suarès' *Passion* and a number of other texts. Some of the lavish works planned by Vollard, including *Les Fleurs du Mal*, never saw the light of day as completed books, but after Vollard's death the illustrations intended for a number of them were issued as separate prints.

The color print here reproduced was one of the seventeen illustrations for *Passion*, finally published in 1939 after some years of preparation. Carl O. Schniewind has contributed a learned study of "The Technique of Georges Rouault's Prints" to James Thrall Soby's monograph published by the Museum of Modern Art. The complicated method by which the prints were made is clearly described there.

Inspired by the text of Suarès in his dramatic narration of the Passion of Christ, Rouault introduces a deep sentiment which evokes the memory of stained-glass windows and other elements of medieval religious art.

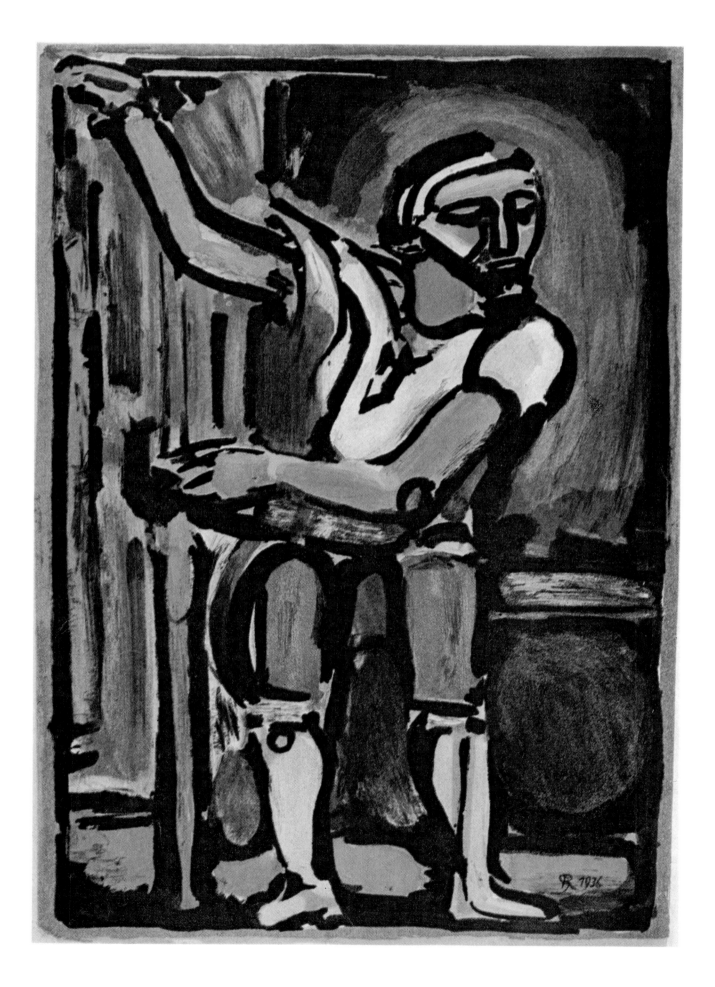

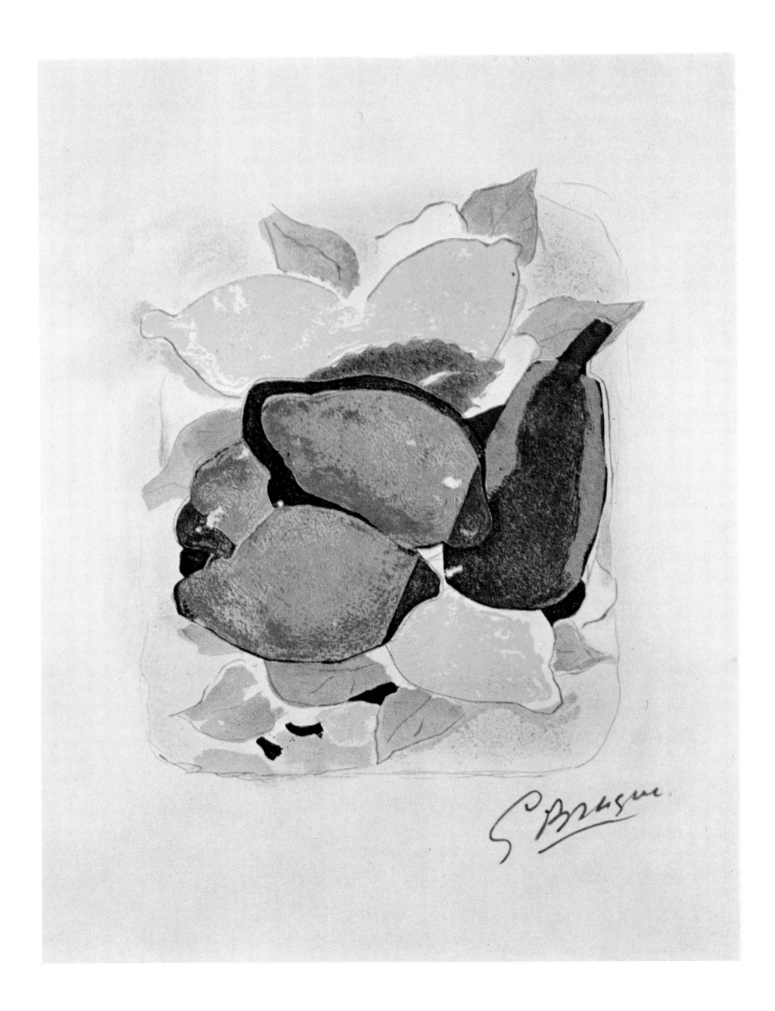

Plate 75

Georges Braque. 1881–1964

LEMONS

Illustration for René Char's LETTERA AMOROSA. *1963*
Color lithograph, 10¼ × 7⅝"

When Braque was once questioned about his method of painting he replied, in part: "A picture is an adventure each time. When I tackle the white canvas I never know how it will come out. This is the risk you must take. I never visualize a picture in my mind before starting to paint." He brought this same attitude to the art of printmaking. In this color lithograph, as in many of his prints, there is a suggestion of spontaneity: his are not planned compositions. In the illustrations (1932) for Hesiod's *Theogony* (*plate 94*), one feels that Braque did not control his etching tool but permitted it, as he phrased it, "to go its own way," as though it understood and carried out the master's impulses. This applies also to the lithographic crayon or color wash.

For Braque, painting and drawing were like musical improvisation, not created for eternity but intended to capture and express the mood of a moment. "When a picture leaves my house, it is for always. When I see one in a collection, I sometimes even have the impression it is not by me." But a glance through the illustrations in the books dedicated to his painting reveals that the arrangement of forms and color in many of his compositions was carefully considered. The unrehearsed quality of the creative act characterizes Braque's prints more than it does his paintings.

The numerous photographs of Braque in his home often show him surrounded by huge plants that extend from floor to ceiling and dwarf the artist standing beside them. These leaves and tendrils furnished the subject matter for many of his later prints. The fruit, teapots, and other utensils he so often employed in his paintings are also to be seen.

Birds enchanted him, as they do Picasso, and they fly across the pages of many etchings and lithographs. For Braque they seem to have had a deeper significance: in their endless variety they serve as a variation on a theme, or as the leitmotif of his graphic expression.

Toward the end of his life, Braque worked with diligence on a series of lithographs for *Lettera Amorosa* by René Char. In the composition illustrated here, a number of lemons are turned into a simple but subtle design. This final effort, a group of twenty-nine prints, reveals Braque to be a master of understatement. His knowledge of what to leave out yields the refinement and economy that only great artists manage to achieve.

Plate 76

Auguste Renoir. 1841–1919
Two Bathers

1895. Etching, 10¼ × 9½"

Renoir, more than any other artist of his epoch, was the painter who expressed on canvas and in his own life a genuine *joie de vivre*. During his long and vigorous career he painted only what he liked and enjoyed—the happier aspects of nature, healthy and attractive people, flowers, fruits, other good things.

Renoir's production in the field of graphic art was not particularly large. He experimented with etching, drypoint, some soft-ground etching, and lithography (in black-and-white, as well as four in color). We do not know who taught him to handle the various mediums. Presumably, however, he learned something of the intaglio process from his friend, the painter and engraver Roux-Champion; in 1908 he did a small portrait head of the latter, in soft-ground etching on zinc, and Delteil's catalogue of Renoir's graphic works lists a number of the original plates as being in the possession of Roux-Champion.

When one glances through the catalogues of some fifty-odd prints by Renoir, one finds the familiar subject matter of his paintings (*see fig. 23*)—portraits of friends and people he admired, several impressions of his children, and a series of bathers and reclining nudes.

This print showing two bathers is rendered with a freedom usually associated with the skillful handling of the pen. The figures and background are drawn in supple, sketchy lines, and here and there a single stroke is used to define a contour. Like many fine works of art which appear to have been effortless, this remains one of the gems avidly desired by amateurs and collectors.

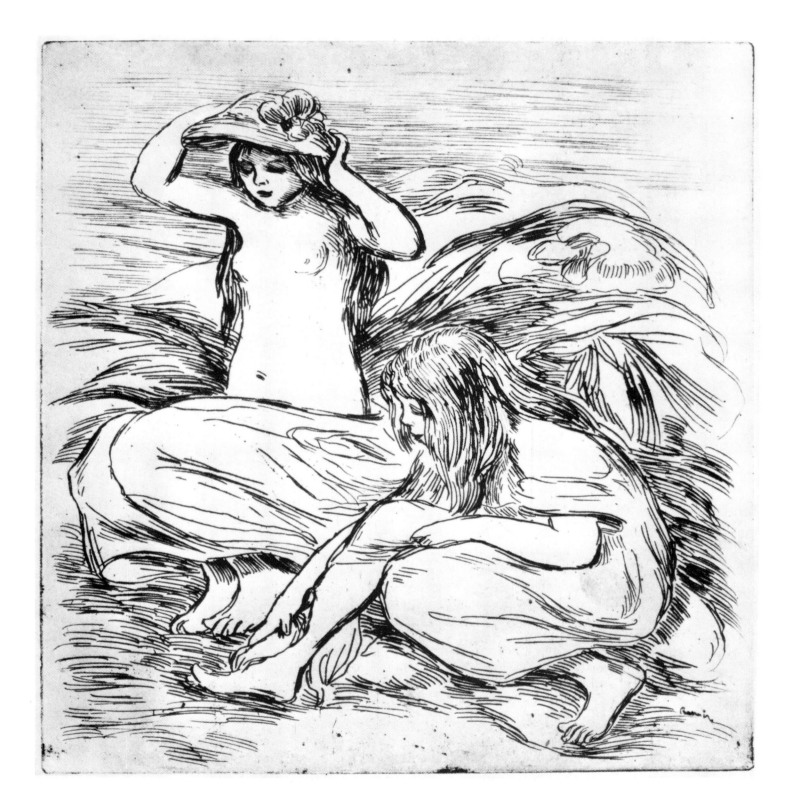

<p style="text-align:center;">*Plate* **77**</p>

<p style="text-align:center;">Mary Cassatt. 1845–1926</p>

<p style="text-align:center;">MOTHER AND CHILD</p>

<p style="text-align:center;">*1891. Drypoint, 10¼×7″*</p>

Mary Cassatt, like two other American expatriates (John Singer Sargent and James A. M. Whistler), was honored abroad before she was acclaimed at home. She is generally considered a member of the French School, for in the circle of the Impressionists she found friendship, inspiration, and instruction. It was she who said that Pissarro, the oldest and most articulate member of the group, was so great a teacher "that he could have taught stones to draw correctly!"

Mary Cassatt was born in Pittsburgh and left the United States to study art in Europe in 1875, making Paris her home. Manet and Degas were to become her close friends, and her correspondence is rich with references to them.

Mary Cassatt experimented with a number of graphic techniques, her most ambitious production being a series of color aquatints. Like many of her colleagues in the Impressionist circle, she greatly admired the Japanese wood-block prints then being shown in Paris. In a number of her aquatints she strove to produce something of the quality of the block print, modeling her composition with it in mind and working out her designs with strong outlines and areas of flat color.

Among the finest of her graphic works are those in drypoint, almost all of which deal with the subject of mother and child. This motif sometimes invites sentimentality and the manufacture of pretty pictures; but Mary Cassatt, although she found many attractive subjects, often among her family and friends, also made numerous sketches of plain women and homely children (*see fig. 30*). These are more of a test of her talent, and in examining them one is struck by the honesty of her statement. The babies are not posed for magazine covers or family portraits; they are infants as everyone has seen them—some pretty, some almost ugly.

The print illustrated here is particularly charming, the mother and child lovelier than most of the models in the series. The technique is simple: a few suggestive lines, and the rich blacks that are the special gift of the drypoint.

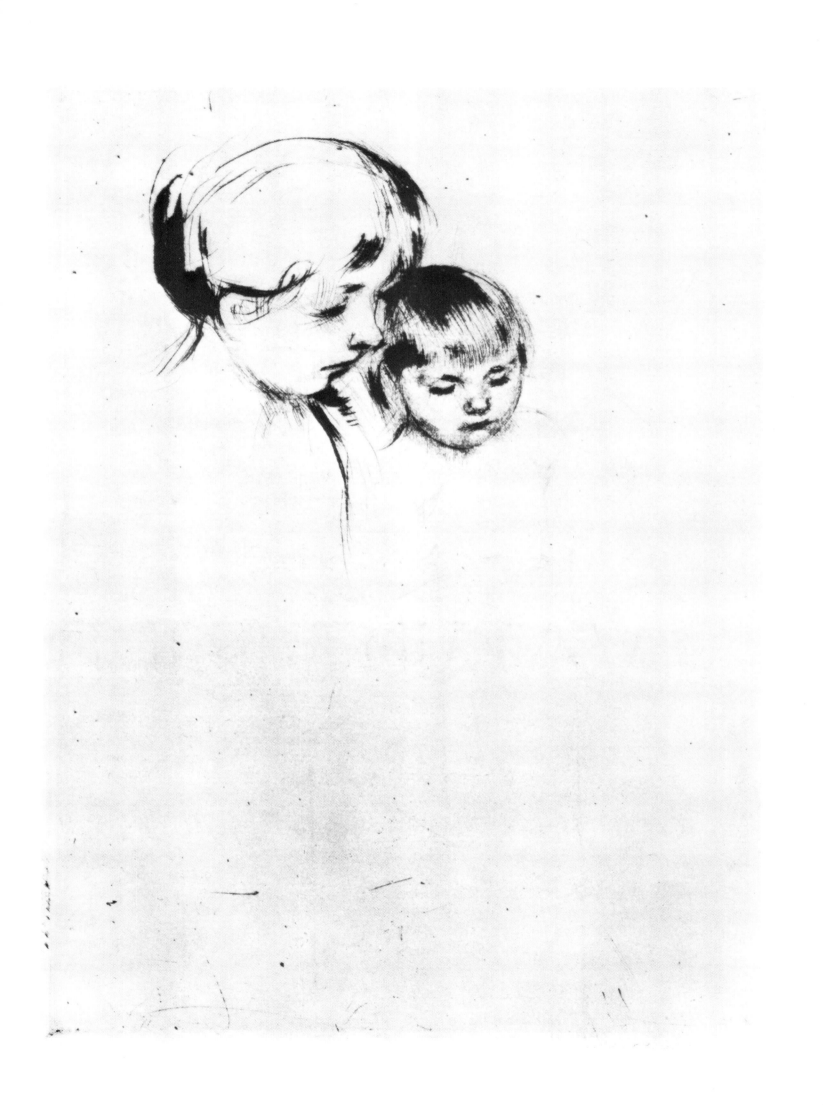

Plate 78

Paul Gauguin. 1848–1903

Nave Nave Fenua

c. 1894. Woodcut, 13¼ × 8⅛″

Gauguin was as rebellious a printmaker as a painter. He learned etching, woodcutting, and lithography from his friend Bracquemond, the author of a book outlining the conventional methods of printmaking (Gauguin broke every rule). In 1901, Gauguin wrote to his friend Daniel de Monfreid about his woodcuts: "It is just because these prints recall the primitive era of wood engraving that they are interesting, woodcuts as illustrations having now become more and more like photogravure: loathsome. I am convinced that in time my woodcuts, so different from anything that is being produced in that medium, will have some value."

Gauguin could not know what high value would ultimately be placed on his "different" woodcuts. Ignoring all book instructions, he attacked his wood block with unconventional tools and materials. His methods were experimental, but not haphazard. He continued to make prints up to the time of his death.

This print is one of a series of woodcuts that reveals Gauguin at his best. There were a number of states (three in the case of this subject, of which this is the last). Some were printed or heightened with color, and occasionally the artist washed tone directly onto the print. Fortunately, the blocks of this series were preserved; in 1921 they were printed by Gauguin's son Pola, and issued in a portfolio limited to 100 copies, signed and numbered by Pola. The printing in itself was masterful, and these impressions have become quite rare. As examples of the art of the woodcut they are surely among the finest of their time. *L'Oeuvre gravé de Paul Gauguin,* the excellent two-volume catalogue by Maurice Guérin, illustrates and describes most of his prints; unfortunately it does not include his monotypes.

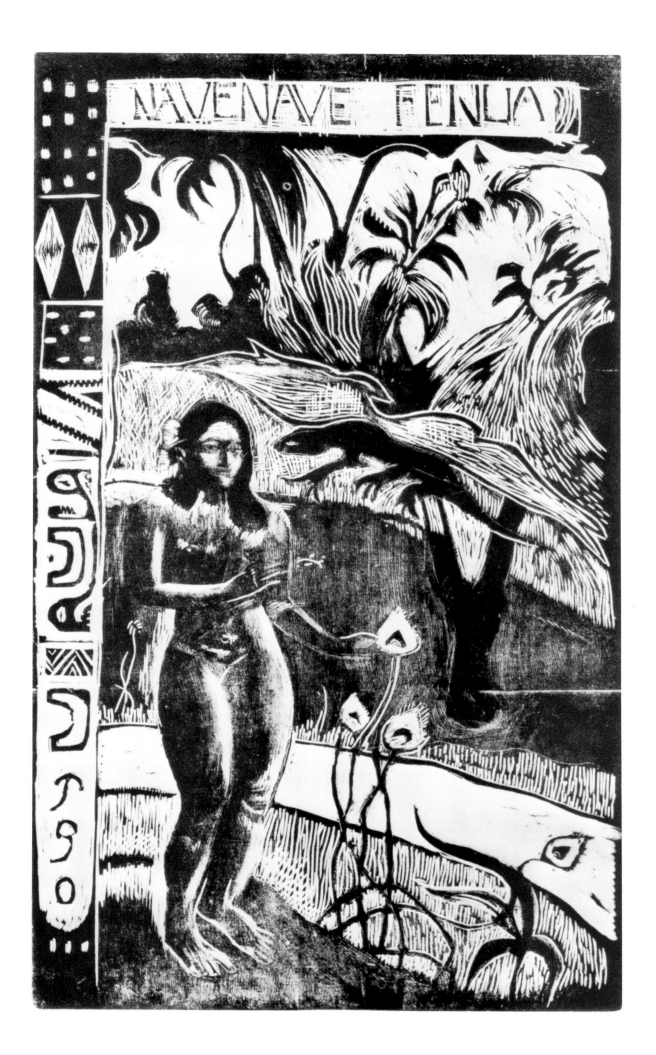

Plate 79

Paul Gauguin. 1848–1903
TWO MARQUESANS

c. 1901–2. Monotype in browns, 17⅞ × 13⅝"

The life of Paul Gauguin offers the stuff out of which legends are made. Novels, romantic biographies, and at least one film have had this enigmatic man as protagonist. He has received the same popular attention as his sometime friend Van Gogh. The interested reader can find adequate material to make an appraisal of his inner life as well as his external one, for he left behind a personal record consisting of journals, letters, and commentaries of various kinds, together with many canvases, woodcuts, ceramics, and occasional pieces of sculpture.

Rare, and therefore not well known, are Gauguin's monotypes. In his hands, these were a kind of painted drawing made directly on glass, from which a single impression could be made. The present print, done in tones of brown, is often labeled *Two Tahitian Women*; but Richard Field, who has done much research in establishing dates for Gauguin's work, holds that these are two Marquesans. He dates the monotype about 1901–2, near the end of the artist's life.

A close study of this print will reveal the striking and unusual effects made possible by the use of the medium. Unfortunately, the method of monotype does not lend itself to making multiples of the original; no two of the transferred paintings can be alike. At times, an artist finds himself dissatisfied with the result and simply begins the process all over again.

Gauguin's last days were unhappy, for his activity on behalf of the natives brought him into conflict with the authorities and he was sentenced to a short term in prison. A letter to his friend and biographer Charles Morice, dated April, 1903, from Atuana, includes portions which tell of his struggles; one sentence might well serve as his epitaph: "A man's work is the explanation of that man."

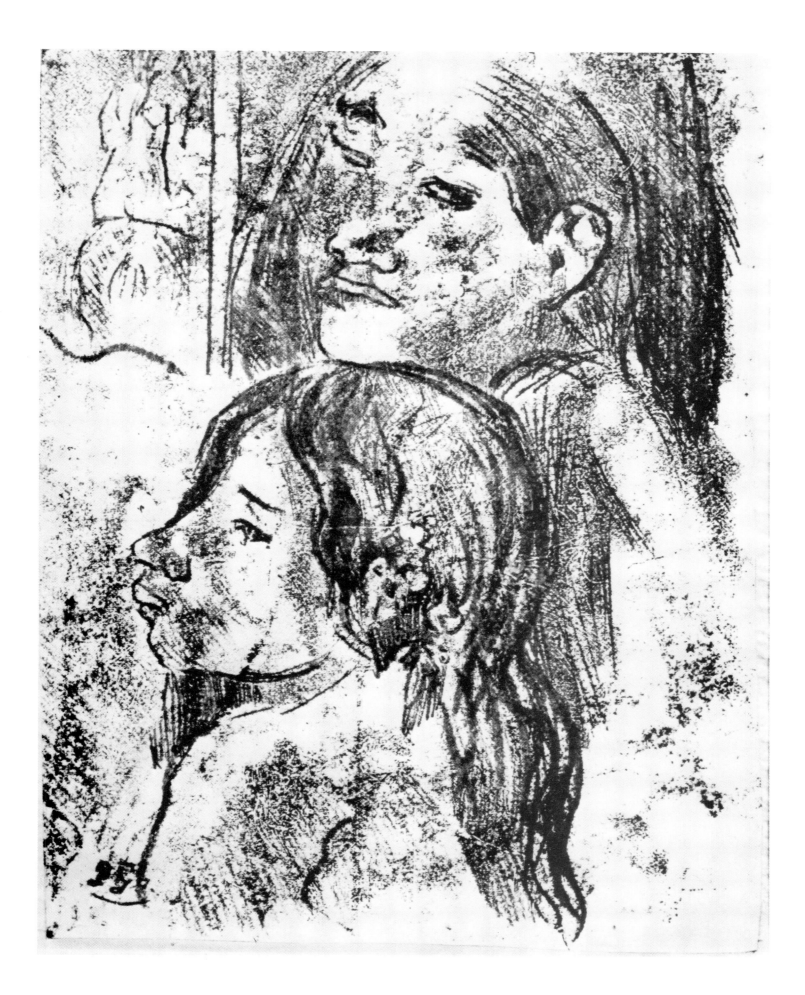

Plate 80

Vincent van Gogh. 1853–1890

THE POTATO EATERS

1885. Lithograph, 10⅜ × 12½″

The tragic life of Vincent van Gogh is too well known to require any biographical mention here. His own letters remain the best source of information. During the year 1885 he painted his first important pictures, of which the most impressive and best known is *The Potato Eaters*. It is a haunting picture, a dramatic statement of how the artist felt about the hardships of peasant life.

Van Gogh did an interpretation of this painting in a black-and-white lithograph that is extremely rare. All that has been said about the painting may be applied to the lithograph, for with the crayon he came very close to duplicating every quality of the better-known painted work. Only four impressions are known to have been pulled, for the impoverished artist could not afford to buy paper or pay the printer's fee. It is therefore one of the rarest prints by any major artist of the period.

Van Gogh was one of the most enthusiastic believers in the print as a means of offering good art at low prices to the poor and the middle classes. When he first learned about the opportunities offered by the lithographic process, he wrote to his brother Theo, in Letter 251: "What I wanted to say is this. The idea of drawing types of workmen from the people for the people, distributing them in a popular edition, taking the whole as a matter of duty and public service—that, and nothing but that. . . ."

It is tragic that he did only eight lithographs (according to the De la Faille catalogue), none of which were issued in editions large enough to reach the public he sought. And his etched work consists of a single example, the portrait of his friend Dr. Gachet.

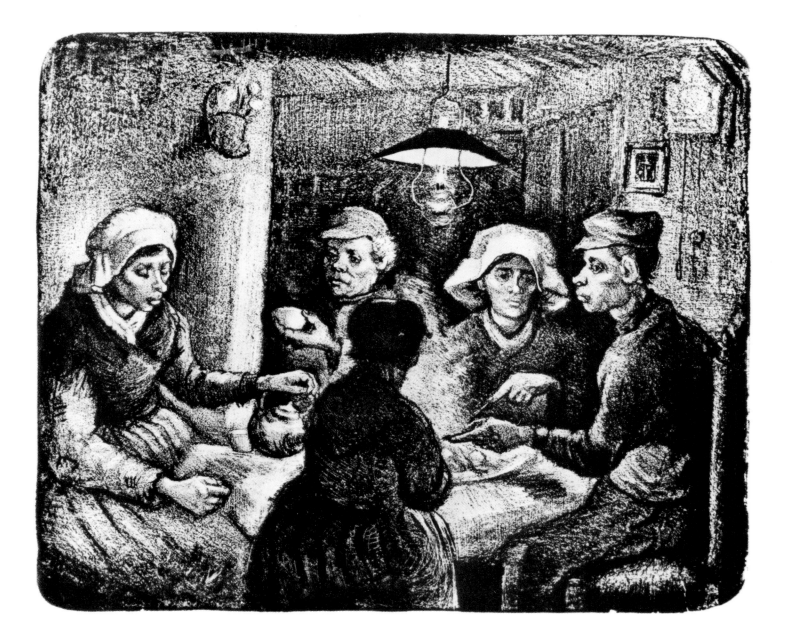

Plate 81

Aristide Maillol. 1861–1944
STANDING NUDE

Illustration for Ovid's ART OF LOVE. *1935*
Lithograph. Dimensions of page 15 × 11"

It has been suggested that the character of Maillol's art partly reflects his having been born on the shores of the Mediterranean, the cradle of Greek and Roman culture. Maillol seems, more than any other sculptor, to have rediscovered or at least restated the principles of Classical art. Inspired by the same love of nature and of the nude form that is expressed by the carvers of antiquity, he solved his problems much as they did. He was no imitator; rather, he felt and created in a similar manner. The history of art has witnessed this before: there are striking similarities between Archaic Greek carvings and Romanesque sculpture, for example, but the medieval carvers could hardly have imitated Greek statues that had not yet been excavated.

It is interesting that Maillol, who is now thought of as a sculptor, began his career as a student of painting; he turned to the designing and production of tapestries, then achieved a measure of fame by making his own paper for printing lithographs and woodcuts, and did not take up sculpture until about 1900.

John Rewald, in his excellent monograph *The Woodcuts of Maillol* (1943), writes: "If today he is asked how he came to take up sculpture he answers frankly that he does not know; he tried his hand at it one day and enjoyed it; he continued because he still enjoyed it. And when the day came on which he had to give up his tapestry work, he continued with sculpture because he had time to spare and because he could not sit with idle hands. It was only at the age of forty that Aristide Maillol became a sculptor in the true sense."

Maillol, a superb graphic artist, produced many lithographs and some of the finest woodcuts of his time. The hand of the sculptor is nearly always apparent, and in the present illustration for Ovid's *Art of Love* the female body is given the roundness and volume of a statue. In his woodcuts (*see fig. 6*), delicacy and flatness replace three-dimensional modeling; the sensitive rhythms and subtle design recall Roman carvings of intertwined animal and human forms.

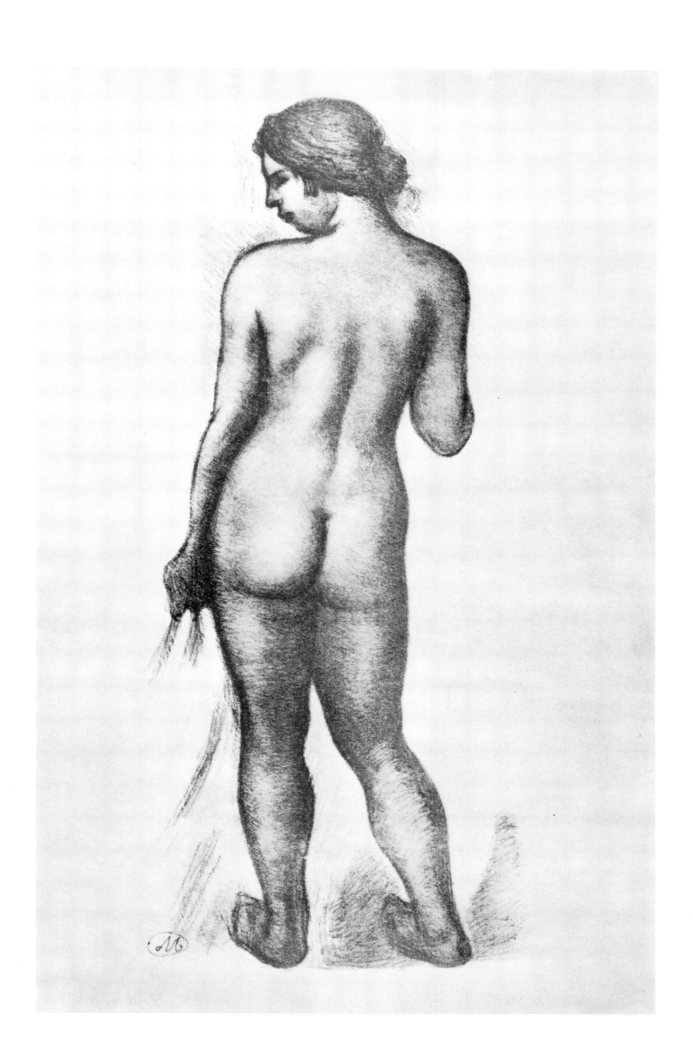

Plate 82

Henri de Toulouse-Lautrec. 1864–1901

A LA GAIETÉ-ROCHECHOUART:
NICOLLE EN PIERREUSE

1893. Lithograph, 14½ × 10¼″

The graphic work of Toulouse-Lautrec comes close to being a picture-autobiography, for where he went, what he did, and, in a measure, what he thought are all reflected in the many impressions he transferred to paper. The two illustrated catalogues of his prints compiled by Loys Delteil tell the story.

One of Lautrec's most dramatic lithographs is this portrait of Nicolle at La Gaieté. Here one sees the influence of the Japanese print and an adaptation of its Oriental character to Western needs. The ambience in which the entertainer stands is created by a few suggestive crayon strokes on the stone. Attention is concentrated on the startling silhouette rendered almost entirely in deepest black.

The performer, hands in pockets, stares straight ahead. The clownlike appearance of her face is produced by the sharp division of the upper and lower portions of the head. By employing the pure white of the paper for the lower half of the face and darkening the area from the eyes to the forehead, Lautrec establishes the fact that Nicolle is standing close to the footlights. He has captured the harsh effect that was no doubt planned by the entertainer.

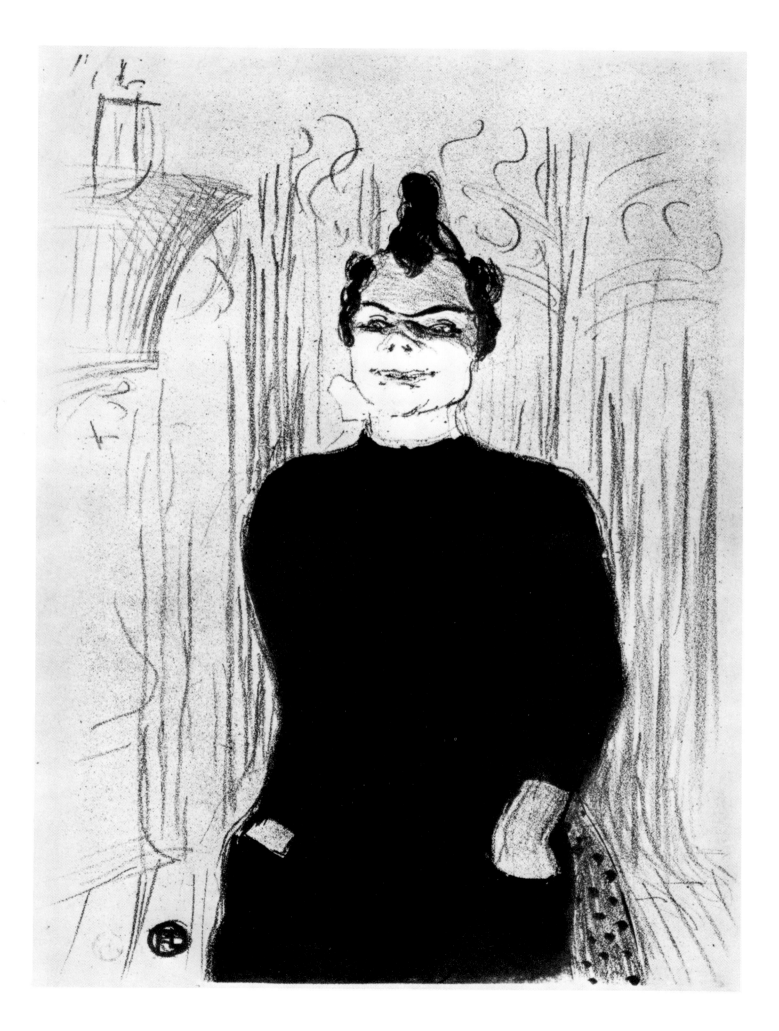

Plate 83

Pablo Picasso. Born 1881

PORTRAIT OF A LADY,

AFTER LUCAS CRANACH THE YOUNGER

1958. Color linoleum cut, 25⅝ × 20⅞″

The whole world knows that Picasso loves women. In his fancy he has loved the beauties found in history, legend, and myth, and he has represented them in many paintings and prints—but not more often than his own inamoratas, who appear in his work often accompanied by the children they bore him.

There were long periods when Picasso considered lithography the most congenial of all mediums and turned out stone after stone, at times developing his theme through many states (*see fig. 35*). He enjoyed experimenting with new methods and delighted the workmen at the press by his daring and his childlike enthusiasm. It is said that he was driven to renewed activity in the field of lithography by the excessively cold winter of 1945–46 in Paris; to keep warm he sought a comfortable corner in the busy lithograph atelier of F. Mourlot. So entranced did he become with lithography that, in spite of the cold, he took stones back to his studio and produced many works. This same enthusiasm was later transferred to ceramics and linoleum cuts. Mourlot, the master printer of lithographs, has thus far issued four illustrated catalogues of Picasso's works in the field of lithography alone. It is worth noting that for each catalogue issued by Mourlot, Picasso designed original lithographs for the back and front covers.

The great series of linoleum cuts was begun in 1958, and the example illustrated here, the first to be produced, is probably the finest in the series. Certainly it is the most sought-after by collectors. Whereas many of the impressions were made with two or three colors, Picasso in this case employed six—black, red, green, yellow, brown, and blue. He took his inspiration from a masterpiece by Cranach, but, as was his wont, used the work of the older artist only as the point of departure for a brilliant translation into his own inimitable vernacular.

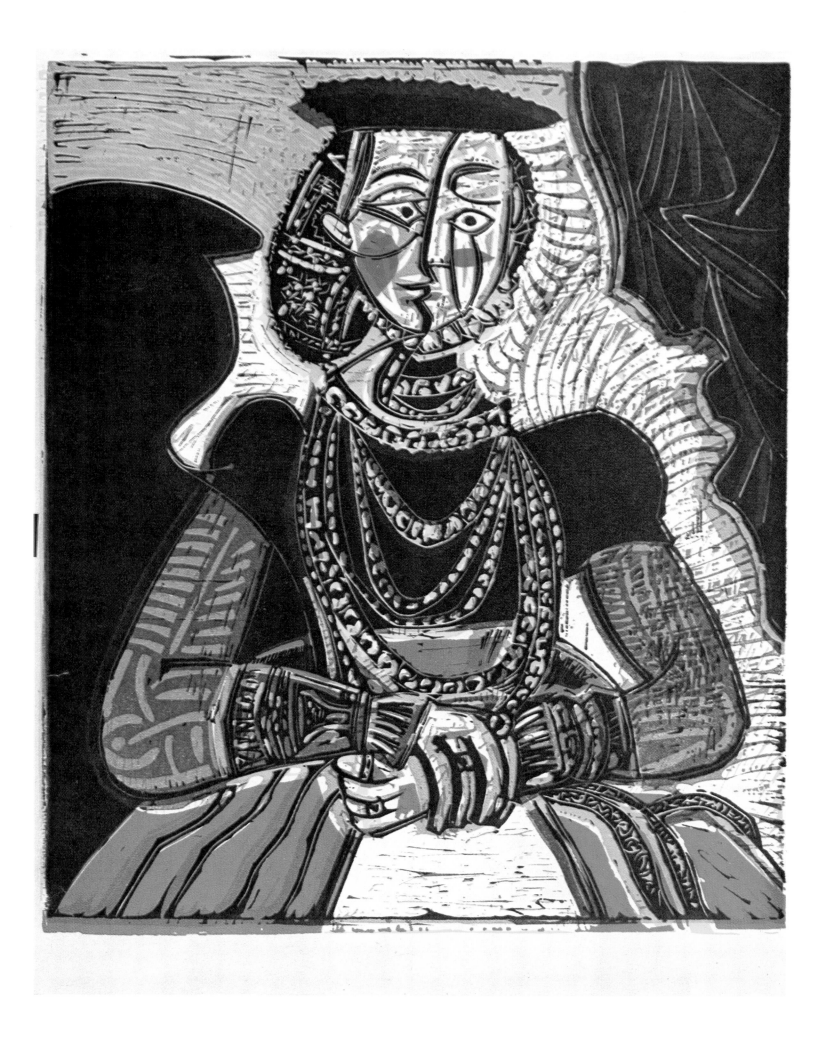

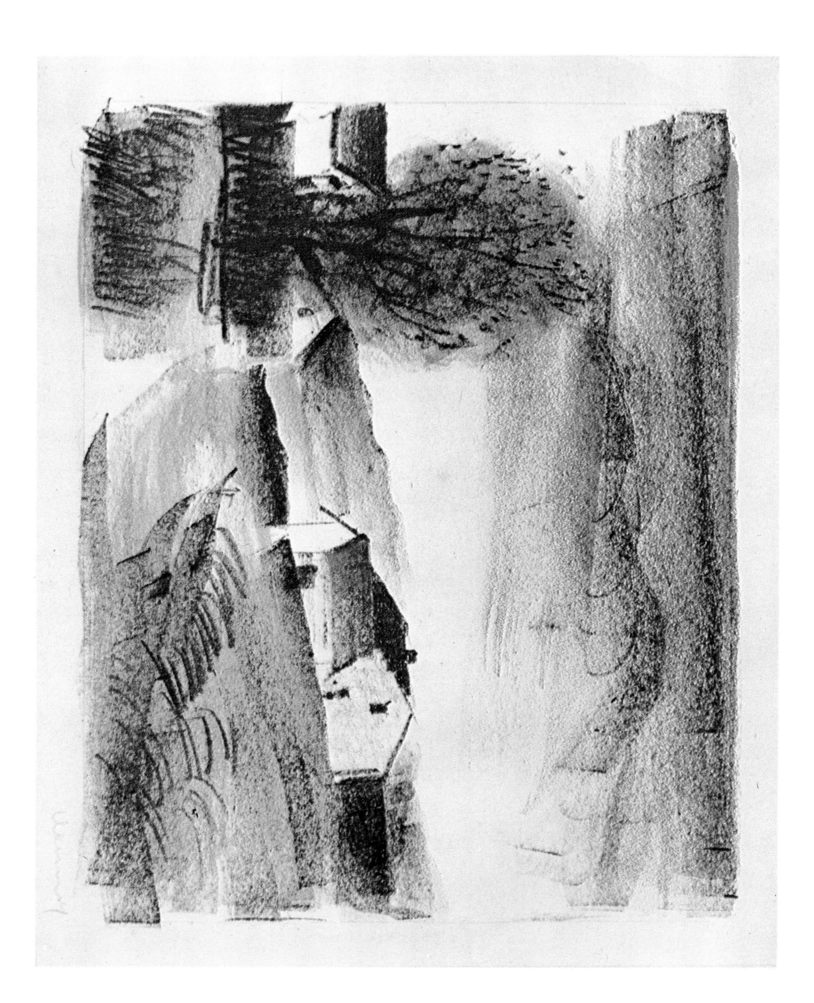

Plate 84

Maurice de Vlaminck. 1876–1958
LANDSCAPE

c. 1925. Color lithograph, 9 × 11½"

Although the group of painters active in France during the late nineteenth and early twentieth centuries did not lack "color," Vlaminck takes his place among the more eccentric of them—to use this term in its nicest sense.

Vlaminck began to study drawing as early as 1895, but his major interest at that time was athletics. As a cyclist he soon won prizes and renown. His parents, both musicians, trained him sufficiently in their field to enable him to earn his living from music lessons. At the Exposition Universelle of 1900, in France, he appeared as a music-playing gypsy in a restaurant, and later he was a violinist in a theater.

During these early years Vlaminck was attracted by the exhibitions of paintings at the various Paris galleries, and especially by the works of the Impressionists. An important event for his future career was his meeting the painter Derain. For a time they lived and worked together, and together they "discovered" Van Gogh. Later, Matisse was also to influence him strongly.

Although aware of the most recent French movements and "isms," Vlaminck rejected Cubism and remained a Fauve, but ultimately he developed the personal style that most viewers recognize immediately. The color lithograph illustrated here reflects the ultimate style of his paintings, watercolors, and gouaches. Vlaminck's landscapes are nearly always dramatic (*see fig. 29*); their mood suggests impending violence. Empty streets or winding country roads seem to offer themselves as stage sets for ominous happenings. In Vlaminck's vigorous art one will not find the lyricism of Monet, Pissarro, or Sisley. But its impact is strong and his images are not quickly forgotten.

Plate 85

Henri de Toulouse-Lautrec. 1864–1901

MAY BELFORT TAKING A BOW

1895. Lithograph, 14⅝ × 10½"

Miss May Belfort, a music-hall entertainer of English extraction, favored the prim type of costume shown in this print, but there was nothing innocent or childish in the songs or recitations she offered. Lautrec did a number of splendid lithographs of her, as well as a superb poster.

Lautrec was able to make sketches like the one in this print from memory, after his nocturnal wanderings in Montmartre. He slept little, drank enormous quantities of every type of alcoholic beverage, and hated to go home. Arthur Symons, in *From Toulouse-Lautrec to Rodin* (1929), recalled meeting him for the first time in the Moulin Rouge on a June night in 1890:

> No one who was acquainted with Toulouse-Lautrec could ever forget him; nor have I ever seen a man so extraordinary and so sinister as he was. Every night one came on him somewhere in Paris, chiefly in Montmartre, in the streets, in the cafés, in the theaters, in the music halls, in the circuses. He walked, his huge head lowered, the upper part of his body, which was in perfect proportion, leaning heavily on his stick; he stopped—owing to the difficulty he had in walking—started this way and that way; his black eyes shone furiously, eyes that amused themselves enormously; he began to speak in his deep biting voice and always in some unimaginable fashion—jests or jokes or bitter sarcasms, or single phrases, in which each word told; simple or brutal, mocking, serious and sardonic.

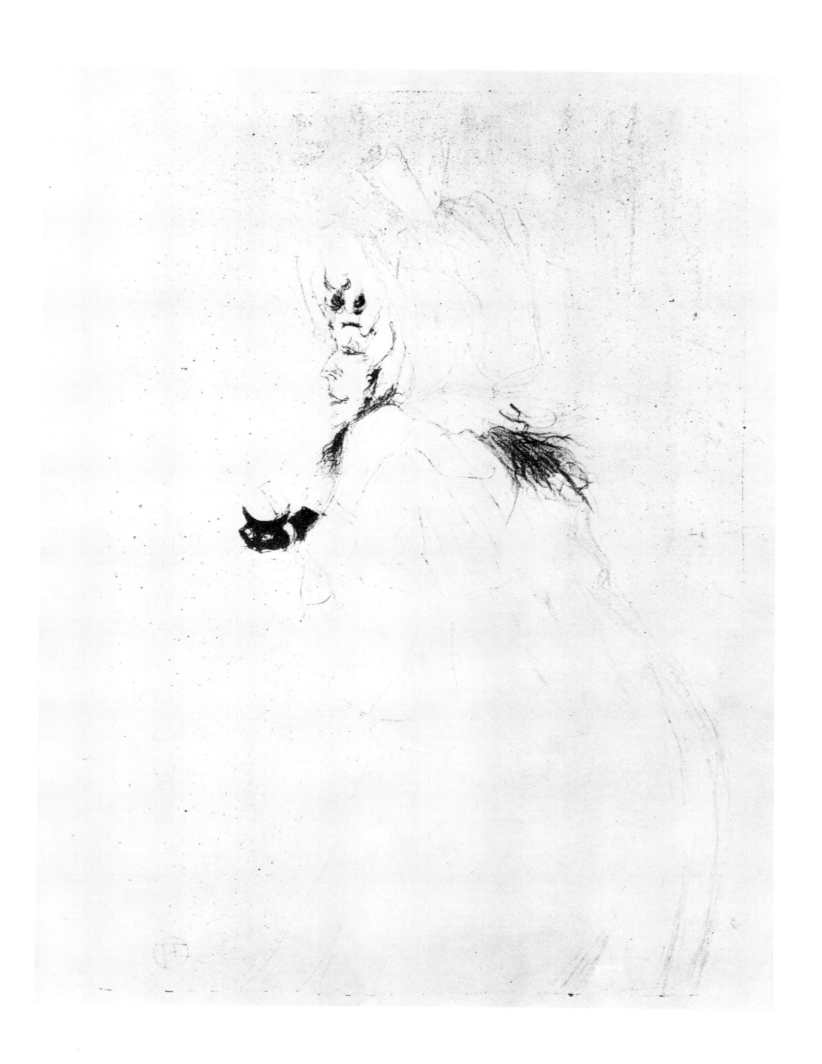

Plate 86

Henri de Toulouse-Lautrec. 1864–1901

POLAIRE

1898. Lithograph, 13½ × 8¾"

No better appreciation of Lautrec has been written than the following excerpt from the essay in Arthur Symons' *From Toulouse-Lautrec to Rodin* (1929):

> To be great, to be a man of genius, to be famous, to be much praised and much dispraised; to have a passion for creation and a passion for women; to be descended from one of the oldest French families; to be abnormal and inhuman; to be neither dissipated nor degenerate; to have sardonic humour and intense presence of mind; to squander much of one's substance in riotous living; to have a terribly direct eye and as direct a force of hand; to be capable of painting certain things which have never yet existed for us on canvas; to be angry with his material, as his brutal instincts seize hold of him; these, chosen at random, are certain of the distinguishing qualities of Lautrec—certain of his elemental emotions.

Symons was a friend of Lautrec and himself not dissimilar in temperament and behavior. He appeared in the same places as the artist, adored women and strong drink, and in the early hours of the morning returned to his room to compose poetry, essays, and memoirs.

The brilliance of Lautrec's characterization of Polaire, another popular *fin-de-siècle* entertainer, may not be immediately apparent. The sketch was done rapidly, perhaps on the spot and in one of the small sketchbooks which Lautrec always carried with him; Lautrec then transferred it to a lithographic stone, masterfully retaining the spontaneous quality of the original sketch. The few strokes which suggest the costume may have been made hastily, but he lingered long enough on the drawing of the face to produce a portrait equal in brilliance to any he ever made of his favorite, Yvette Guilbert.

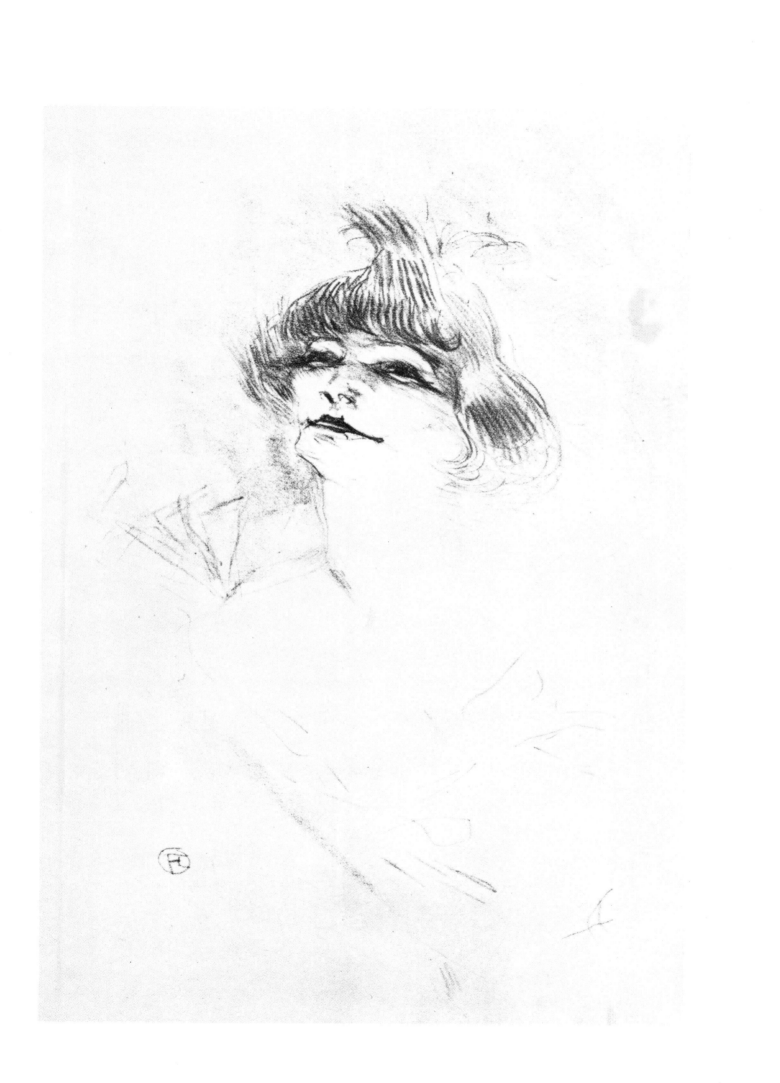

Plate 87

Pierre Bonnard. 1867–1947

THE BATH

c. 1923. Lithograph, 13 × 8⅞"

When the critic and art historian Claude Roger-Marx was first preparing a biographical sketch on Bonnard, he wrote to the artist for information. Bonnard's reply, despite his apology for a certain "vagueness" because of age, furnished the biographer with valuable data on his activity in the field of printmaking. He indicated that his first works were done between about 1890 and 1895, and that his first lithograph was a poster advertising France brand champagne, commissioned in 1889, before Lautrec's posters startled Paris. Bonnard stated that he was aided by the great printer Auguste Clot, who aided most of Bonnard's colleagues as well. He mentioned the prints, posters, and books for which he had made designs, and commented also on his masterpiece in color lithography, the album published by Vollard under the title *Some Views of Parisian Life*. Bonnard enjoyed working with lithography and employed it for many purposes, including a four-panel screen.

Many great works of the period were ignored by the public, and although they are priceless today, they remained unsold for so long that most of the publishers and their artists lost heart. The publisher E. Frapier began in 1923 to continue the efforts of Vollard, and it was he who induced Bonnard, Rouault, Maillol, Marquet, Utrillo, Pascin, Vlaminck, and others to attempt a renaissance of the lithograph. The present print, *The Bath*, a subject favored by Bonnard, is one of the so-called Frapier Prints.

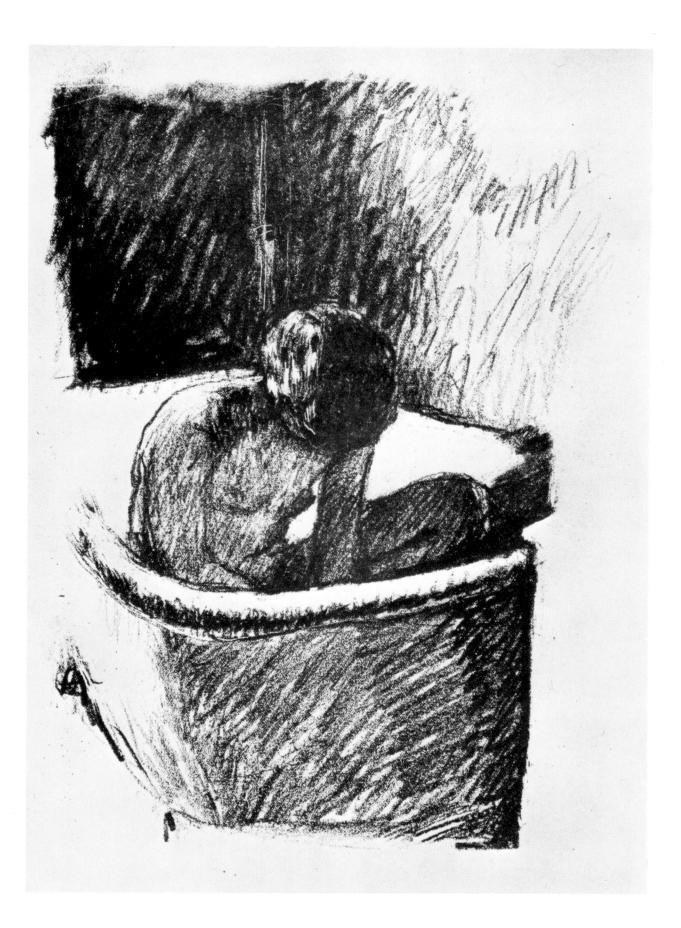

Plate 88

Henri Matisse. 1869–1954

ODALISQUE

1929. Lithograph, 17⅝ × 12½″

Like Lautrec, Degas, and many other artists, Matisse posed his friends or models in unusual garments—generally of a texture or style which the artist admired. The models for the nude studies he chose to call Odalisques had surely never seen the interior of a harem. But, yielding to the master's fancy, his favorite models—and this is one of the most beautiful—dutifully donned such costumes and assumed the poses he requested (*see plate 88*).

The Oriental influence is also apparent in Matisse's paintings of the period. Whoever has seen his canvases will read into the black-and-white tones of this lithograph the rich reds, blues, and greens which so inspired the artist. Here is another example of how a master of lithography, limiting himself to the black crayon, could suggest the vibrancy and contrasts of intense colors.

In the course of his lifetime, Matisse was intrigued by many graphic processes. Among the black-and-white mediums he employed etching, aquatint, and drypoint for intaglio prints, and he also made linoleum cuts, lithographs, and monotypes. His magnificent book *Jazz* contains handsome reproductions of collage designs—pasted cutouts of brightly colored paper—made toward the end of his career.

The illustrations offered here are too few to represent the variety and richness of this master print-maker. Fortunately, his graphic works are to be found in all major collections and museums. Noteworthy, too, are the books which he illustrated with linoleum cuts, lithographs, and etchings.

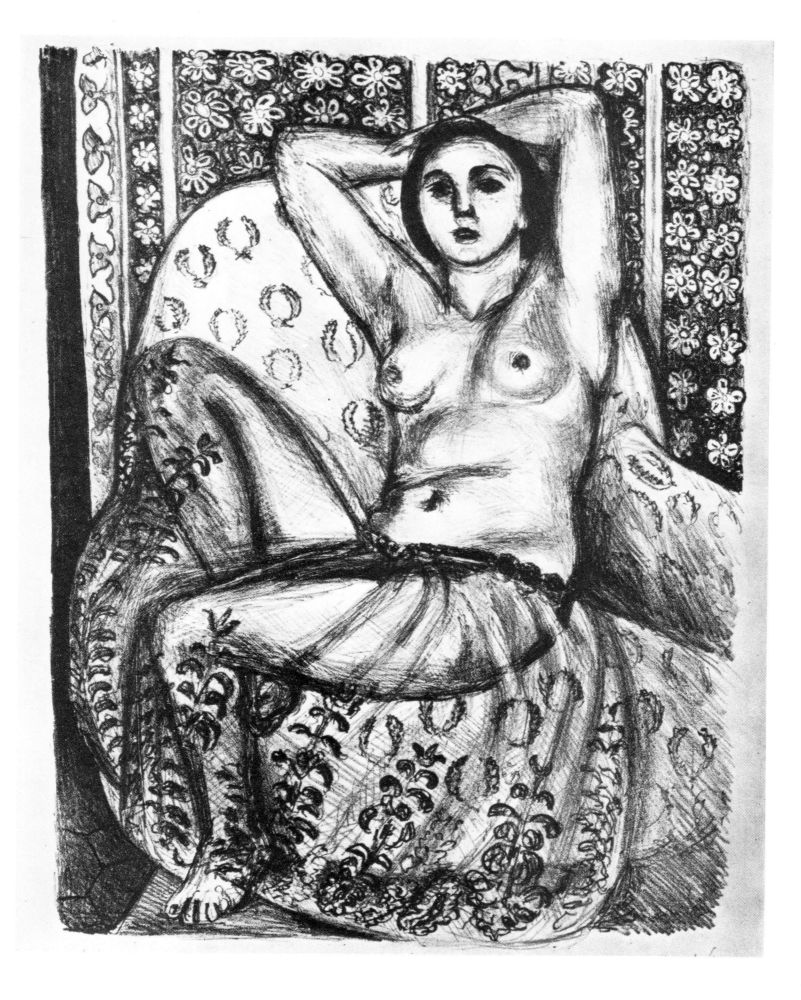

Plate 89

Henri Matisse. 1869–1954
THE PERSIAN

1929. Lithograph, 17½ × 11⅜″

In all of his pictures Matisse reveals his love of nature, defined very broadly to include land and sky, flowers and trees, as well as human beings. Above all, he was affected by the beauty of women, painting and drawing the female form over and over again, posing his models in a thousand different ways to make designs of incredible subtlety. When Matisse traveled to the Orient he found rich material in the mosque tiles, ceramics, and costumes of exotic women.

The two lithographs selected for inclusion here are completely realized portraits; they suggest color and vie with his best paintings in oil. They also convey sexuality more than do most of his works.

The Persian girl seated in a chair, daringly robed, appears to be some prize beauty of a seraglio. She gazes directly at the viewer, an inviting, sensual expression on her face. The black values in this lithograph are deep and rich, and contrast dramatically with the light flesh of the hands, breasts, and face, in which the whiteness of the paper shows through.

When Matisse lived in Montmartre and gave Parisians their first glimpse of his innovations in painting, such comments as "Matisse makes you crazy" and "Matisse does more harm than alcohol" were scribbled on the walls of nearby buildings. Today France venerates him as one of her great men.

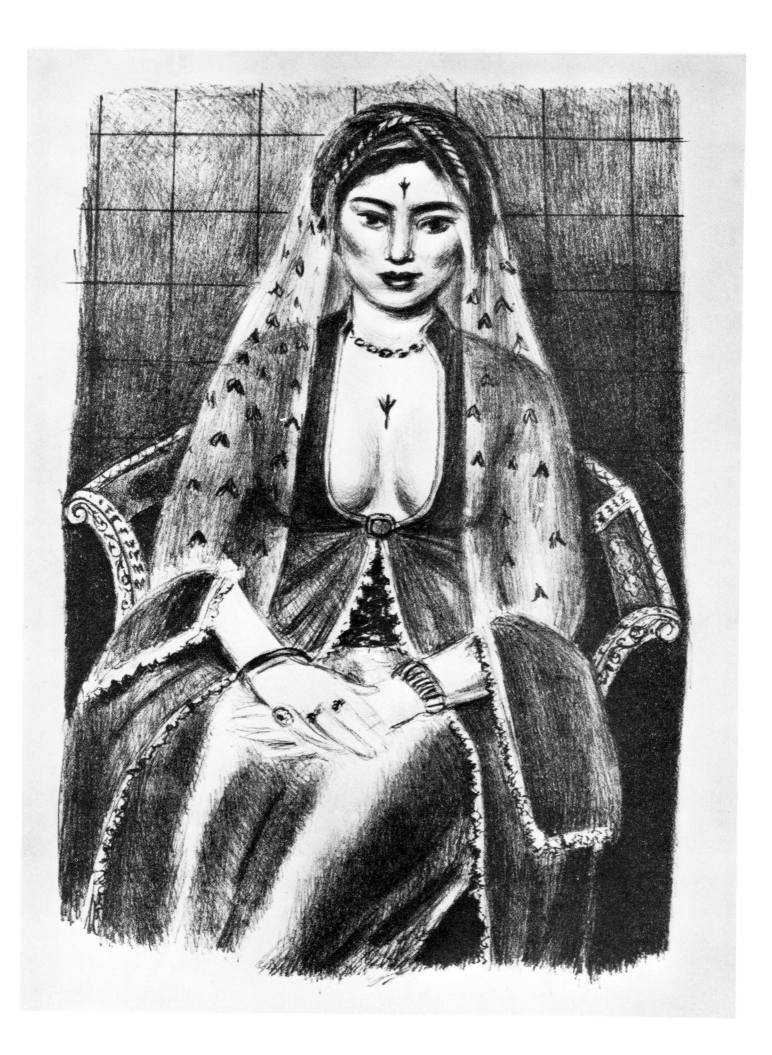

Plate 90

Georges Rouault. 1871–1958

SELF-PORTRAIT WITH CAP

1926. Lithograph, 9⅛ × 6¾″

Georges Rouault was introduced to the world of fine prints by his grandfather, an avid collector who spent many hours showing young Georges the graphic work of Manet, Courbet, and especially Daumier. It was perhaps from the last named that he learned to respect the quality of the black-and-white print, for in his *Souvenirs Intimes* he comments on Daumier's lithographs: "What a painter he is, with his rare quality of blacks and whites. . . ."

Influenced by Vollard and later by the publisher E. Frapier, Rouault produced a substantial number of prints. Some of these were lithographs handled in a fairly conventional manner. His intaglio prints, however, about which much has been written, are difficult to classify as to method, for Rouault experimented freely and was quite secretive about his inventions. Perhaps the best term for Rouault's technique is that used by the distinguished American print authority Elizabeth Mongan, *process etching*. The major intaglio prints, both in black-and-white and color, were begun by photomechanically transferring Rouault's original painting or gouache onto a metal plate. Using this image as an underpainting, Rouault worked with various etching and engraving tools until little of the original image remained. Etching, drypoint, and mezzotint were combined to yield the effects he desired.

Between 1924 and 1927, Rouault produced for Frapier a series of graphic works generally known as the Frapier Prints. Many of these were numbered and signed by the artist, whereas the works done for Vollard, generally intended as illustrations for books, were signed in the plate.

Among Rouault's best prints issued by Frapier were the lithographic portraits of the artist's contemporaries and distinguished friends: J.-K. Huysmans, the critic and novelist, and Gustave Moreau, the painter and teacher, who had been so fine an influence in Rouault's life.

In this self-portrait, Rouault has produced a master print, with its strong contrasts of dark and light, minimal detail, and subtle three-dimensional quality.

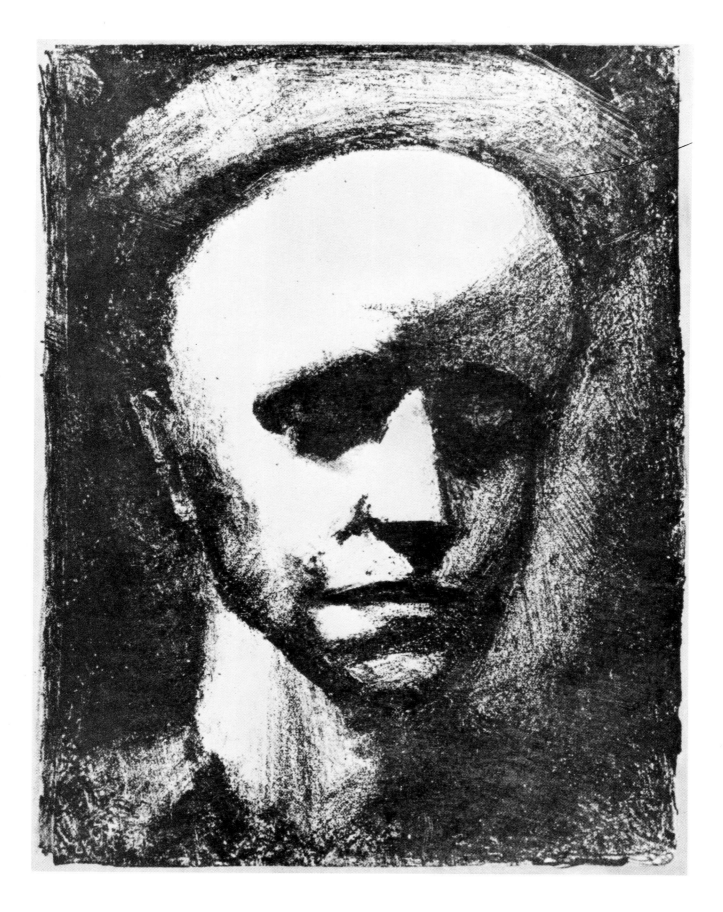

Plate 91

Raoul Dufy. 1877–1953

Fishing

1910. Woodcut, 12½×15¾″

The art of Dufy makes most people think of brilliant color, rapid calligraphic brush strokes, and of Dufy's very personal vocabulary. His style, once it matured, underwent few changes. Dufy's work is easy to recognize even at a distance, but, like Chagall's, it almost defies imitation.

At the turn of the century Dufy, who was born in the seaport town of Le Havre, became a student at the Ecole des Beaux-Arts there. He was awarded a scholarship to study in Paris and was quickly influenced by what he saw—the exhibitions at the Salon des Indépendants, and the canvases by Matisse and the other Fauves. For a short period he was influenced also by the sober, analytical works of Cézanne and, later, by the Cubists.

The woodcuts made in the Orient, commonly believed to be the world's earliest, were used for printing textiles. Dufy returned to this practice and designed and supplied magnificent prints for the apparel business of Poiret and Bianchini. He had financial success, but he became bored with business and released all rights to Bianchini. About that time he made woodcut illustrations for Guillaume Apollinaire's *Le Bestiaire*.

Dufy found the subject matter for his art in many things and many places. Almost everything he painted exudes a *joie de vivre*. Like Renoir, he preferred to represent what to him was the pleasant side of life: the color and action of the harbor, the regatta, the race track. He left many such paintings in oil, gouache, and watercolor.

Fishing, the woodcut illustrated here, is an example of his skill in black-and-white. Dufy converts the fishing scene into a sophisticated design, two-dimensional and broad in treatment, that suggests the carving techniques of the primitive print. But the subtle balance of black and white areas, the variety of shapes, and the depiction of a man and woman enjoying the sport of fishing make this print anything but naïve.

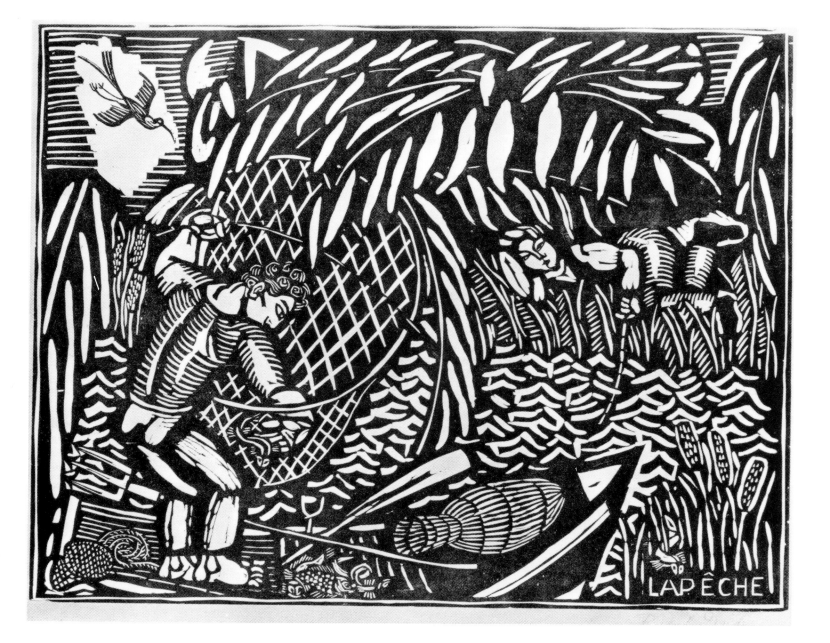

Plate 92

Marc Chagall. Born 1887
PROFILE PORTRAIT OF VAVA IN A RED BLOUSE

1961–62. Color monotype, 11 × 9½″

Chagall did his first important series of prints in 1922. Much of his best work was commissioned by Vollard and completed, after Vollard's death, by Tériade. For Gogol's *Dead Souls,* he completed about a hundred etchings over a period of four years (1923–27), but the book was not published until 1948. La Fontaine's *Fables* contained one hundred illustrations scattered through two volumes of text (1927–30; book published 1952). He produced 105 etchings for a Bible (1956), and hand-colored and signed a limited edition. They are stronger and more impressive, however, in the black-and-white edition.

Chagall was introduced in 1948 to the wonderful possibilities of color lithography by Fernand Mourlot, owner of one of the world's great lithography workshops, and his talented staff. He then completed several series of large and small prints, many of them based on his paintings. The set illustrating *Daphnis and Chloë,* by Longus, shows him at the height of his power in the medium.

Chagall has recently completed a set of color monotypes which are perhaps his most inspired creations in the field of printmaking. They are in reality "transferred" paintings; Chagall executed one hundred different themes in a wide range of rich color, making *one* impression of each. A more extensive description of the technique of the monotype appears in the introductory section of this book.

Chagall worked on these monotypes over two years. Most of the images were painted directly on copper or plexiglass plates before they were run through a hand press by the artist, aided by the master printer Jacques Frélaut.

The themes which appear in this series are familiar ones. Chagall's favorite fantasies reappear: his recollections of the early years in Russia, his native village, his flying lovers, and the mythical creatures of folklore and legend—the donkey- and rooster-headed inventions—which Chagall has made so much his own. But we may note that the portrait here reproduced is at once a likeness taken from reality and an image of fantasy. The physical appearance of his wife is caught, but we wonder whether it is a person or a spirit that we observe. Here, as in many of the monotypes, gay bouquets of flowers and baskets of fruit form part of the composition. For Chagall they need bear no specific relationship to the subject of the rest of the picture.

At an advanced age Chagall still designs stained-glass windows, paints ceilings, and submits sketches for costumes and stage sets for the opera. This extraordinary man, like his contemporary, Picasso, today seems more restless and active than ever.

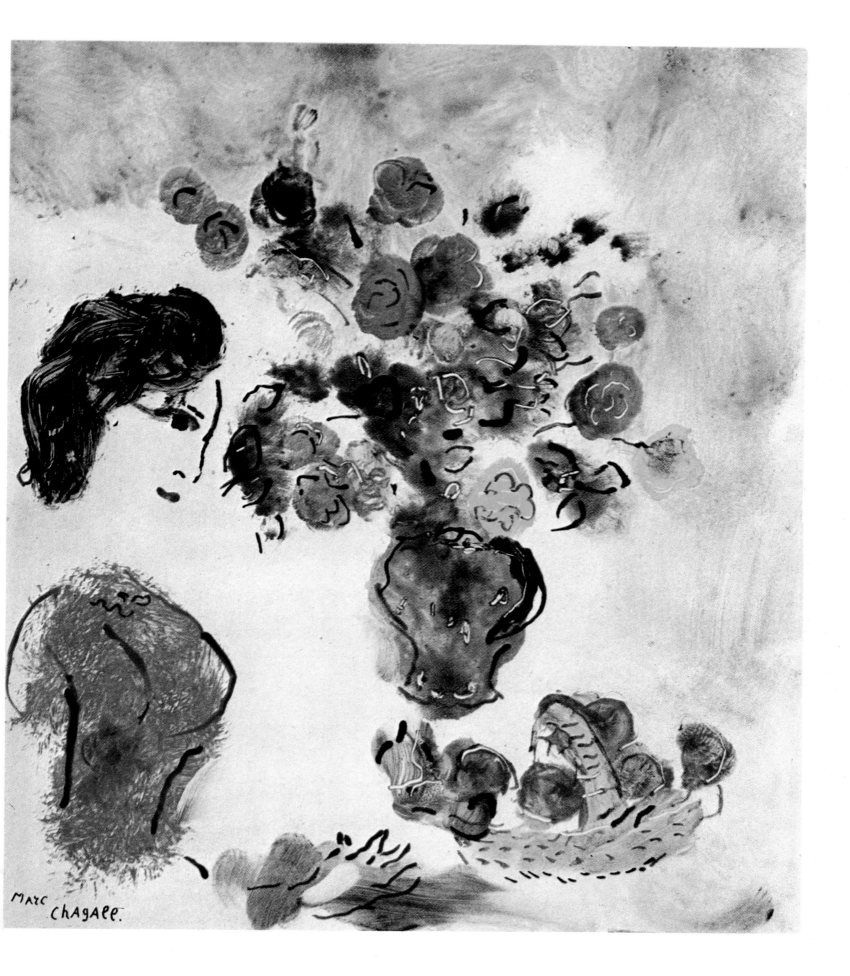

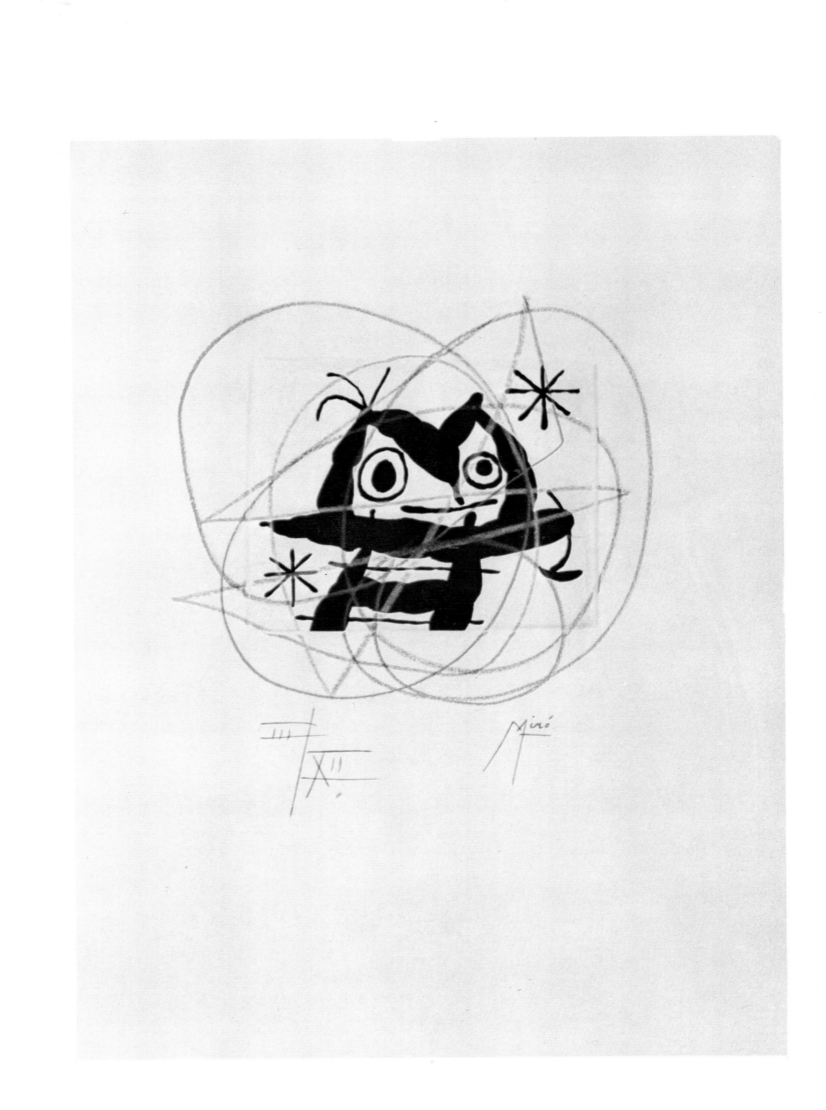

Plate 93

Joan Miró. Born 1893

La Bague d'Aurore

1958. Etching, hand-colored by the artist, 5¼ × 4½"

How does one explain the art of Joan Miró? In 1933, in an article in the magazine *Minotaure,* he wrote: "It is difficult for me to speak of my painting, for it is always born in a state of hallucination, provided by some shock or other, objective or subjective, for which I am entirely unresponsible." At the time of this statement, he, like other contributors to this journal, was deeply involved with Surrealism.

Later, in 1948, he said to James Johnson Sweeney, "Nowadays I rarely start a picture from a hallucination. . . . What is most interesting to me today is the material I am working with. It supplies the shock which suggests the form just as cracks in a wall suggested shapes to Leonardo."

A photograph of Miró in Majorca, taken in 1956, is confirmation of his yielding to suggestions and impulses: seen on a rocky landscape, he is busy painting a star on a rock. Having already created some "sculpture" out of other rocks and fragments found on the site, he has decorated these too with paint.

Certainly hallucinations and dreams—pleasant or nightmarish—inspired much of Miró's art. He has also abundant humor and a delightful capriciousness. One must learn to read and interpret Miró almost as one must learn to translate hieroglyphics, for his own symbols and ideograms constantly recur in his pictures. Actually, apart from its meaning, the excitement and charm of his art is felt by everyone who does not search for a message but allows himself to react to what he sees. His titles invariably challenge us, but we would suggest that the viewer need not try to find all the objects mentioned in them.

The present etching is one of a series of twenty-two issued in a supplementary portfolio for *La Bague d'Aurore* of René Crevel. After the regular edition was printed in color, Miró chose to hand-color a limited edition of twelve proofs, which carry Roman numerals. By combining the etched impression with a colored drawing of his own, Miró created a series of unique proofs.

Plate 94

Georges Braque. 1881–1964

Illustration for Hesiod's THEOGONY
1932. Etching, 14½× 11¾"

Georges Braque was born in Argenteuil, near Paris. His grandfather and father were house painters (and the latter was also a skilled Sunday painter). Georges, too, was prepared for a life of painting, although it was intended that he would beautify bourgeois houses rather than paint canvases to puzzle and shock the bourgeois intelligence. At the age of eighteen, he began his apprenticeship; what he learned was useful in his future career, for he became skilled in the technique of simulating marble, grained woods, and unusual textures on the plaster walls of middle-class homes, in imitation of costlier materials. With this knowledge, Braque later introduced many unorthodox but effective innovations into his painting and his printmaking. He varnished over etchings and lithographs, often sprinkling sand into the varnish before it dried. He simulated wood grains and other textures. He was as much an iconoclast in the handling of graphic mediums as in his experiments with Cubism.

Among Braque's first prints were two drypoints done for the art dealer Daniel-Henry Kahnweiler, and like his paintings of this period (1911) they were Cubist in style. For this dealer, and for Vollard two decades later, he worked in all the graphic mediums, taking much of his inspiration from the Classics. The print shown here is one of a series of sixteen illustrations for the *Theogony* of Hesiod. These reflect his study and appreciation of Archaic Greek and Etruscan vase paintings. The etchings were commissioned by Vollard to be issued separately in a portfolio, but at his death this work was still unpublished; it was issued, with three additions, in 1953.

This print is almost a free-form abstraction in which a figure is discernible moving among the interlacing of continuous curving lines and arabesques. A pattern of tones is created by filling the areas of the abstract design with crosshatching and series of parallel lines that run in different directions.

To understand this print one may refer to one of Braque's reflections on art: "The senses deform, the mind forms. Work to perfect the mind. There is no certitude but in what the mind conceives."

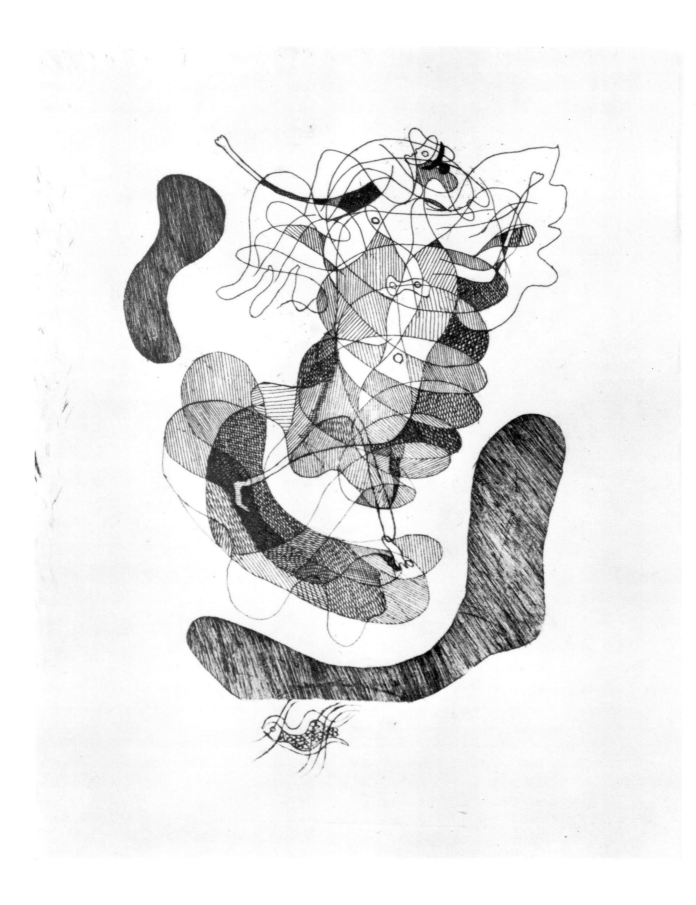

Plate 95

Pablo Picasso. 1881–1973
THE FRUGAL REPAST

From the series LES SALTIMBANQUES. *1904*
Etching on zinc, 18¼ × 14¾"

The term "many-sided" has often been used to describe the genius of Pablo Picasso. Even if we confine our study to prints we find a seemingly endless succession of styles in his work. He refuses to think of these changes as representing an evolution, but speaks of them rather as his "several manners." ("Whenever I had something to say I have said it in the manner in which I have felt it right to be said.") In six centuries of printmaking, no other artist has expressed himself in so many "manners." A casual perusal of the many catalogues illustrating his works can make this fact apparent.

Picasso has offered the following definition of the artist's function: "A painter paints to unload himself of feelings and visions." Change the word "painter" to "printmaker" and the statement still has validity, for in the unprecedented variety of his graphic works he gives us many insights into his feelings and visions.

Picasso's earliest manner represents his youthful thoughts and feelings about the world and mankind. These prints have for their subject the underdogs of society—poorly nourished, cadaverous figures of the circus and sideshow, strolling beggars and mountebanks. For all of these people he felt deep compassion.

One of the most sought-after prints in Picasso's vast oeuvre is *The Frugal Repast*. It was made in 1904, shortly after he had learned the etching technique, and his friend, the printer E. Delâtre, issued a small edition. The Parisian dealer Clovis Sagot attempted, with no success, to sell these works. In 1913, Ambroise Vollard purchased the plate, steel-faced it, and, including it with fourteen other works by Picasso of the same period, similarly treated (*plate 96*), he issued a series under the title *Les Saltimbanques*. Today these prints are all rare and costly.

The mood of this great print is that of Picasso's Blue Period. It requires little comment, for it speaks to the viewer with the directness of the related paintings.

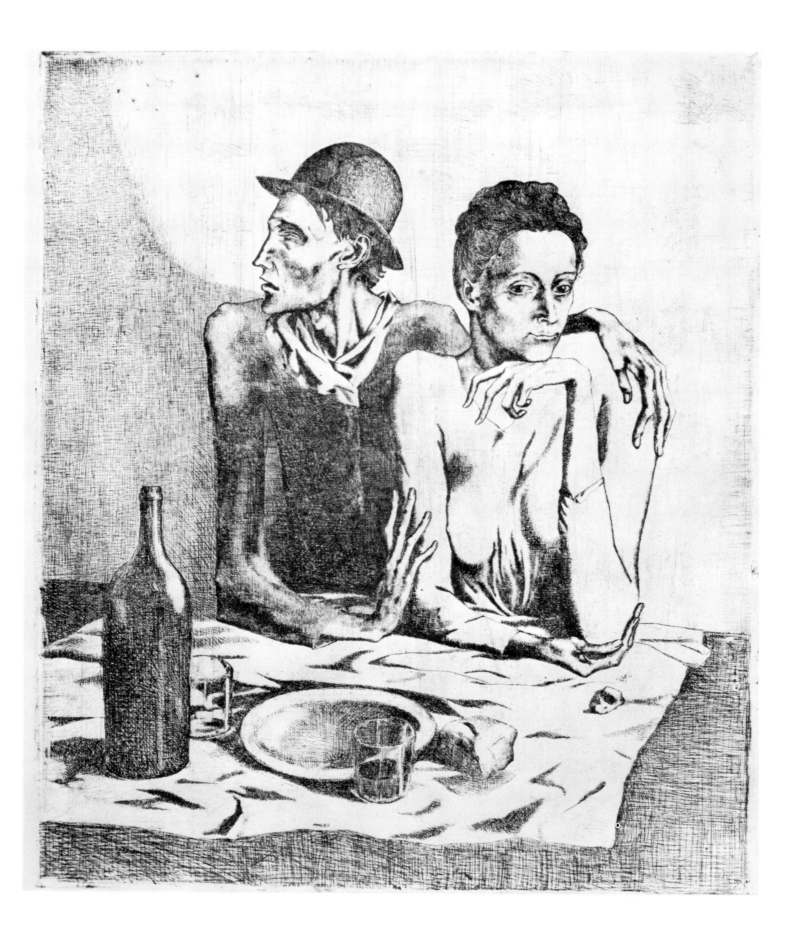

Plate 96

Pablo Picasso. 1881–1973
The Poor

From the series LES SALTIMBANQUES. *1905*
Etching on zinc, $9\frac{1}{4} \times 7\frac{1}{8}''$

Pablo Picasso was one of the few artists of his group who did not have to fight his family for the right to become an artist; this career was taken for granted from the start. His father, José Ruiz Blasco, was an art teacher and recognized his son's unusual talent. When Picasso applied for admission to the advanced classes in the foremost school in Barcelona, he completed in one day the entrance examinations that took most students a full month.

Ricardo Canals, a friend of the young Picasso in Spain, induced him to make his first etching. This he did on a copper plate in 1899. From the plate, the only graphic work of Picasso's Spanish period, a single impression exists today. In Paris, five years later, Canals urged Picasso to take up the graver and etching needle again. With a minimum of instruction he was sufficiently competent to produce such works as *The Frugal Repast* (*plate 95*) and the present print, *The Poor.*

In the period when these prints were done Picasso was poor, but he was not unhappy living in Montmartre, surrounded by good and talented friends. He always had understanding and sympathy for the poor, and some of the characters in his first prints were inspired by the pathetic circus folk who performed in Paris or its environs; others, perhaps the family seen here, were remembered from his youth in Spain. Gloom pervades this scene. Only the children, magnificently drawn, seem oblivious to their parents' sorrow.

Drawing directly on the zinc plate, Picasso covered almost the entire lower surface with heavy cross-hatching. In the upper portion of the composition the standing figure is partially silhouetted against a sky where lighter parallel strokes create a sharp contrast with the gloomy earth.

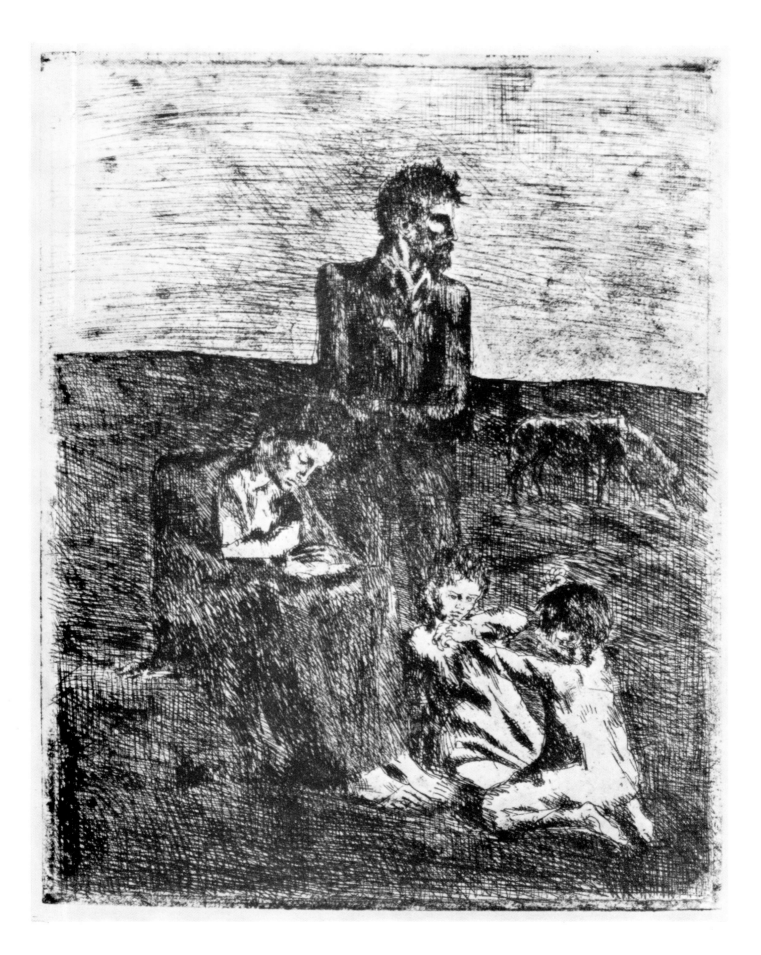

Plate 97

Pablo Picasso. 1881 -1973

Three Women

1922. Etching on zinc, $6\frac{7}{8} \times 5\frac{1}{8}''$

For over sixty years Picasso has worked and experimented with almost every graphic medium, never satisfied to follow the conventional methods. For example, he has used linoleum cuts in recent years to make a large series of color prints. He insists that linoleum offers a quality that is not inherent in wood, and that the effect, when printed, is both new and superior.

For many of his illustrations for Buffon's *Natural History (see fig. 22)*, commissioned by Vollard, Picasso employed the sugar process, a form of lift-ground aquatint. This method was known to professional printers rather than to artists; but Picasso, when he saw it demonstrated at the shop of Roger Lacourière, quickly mastered the technique and insisted on operating the press himself.

Picasso often preferred zinc to copper for his etchings. The present print was taken from a zinc plate made in 1922. Bernhard Geiser describes this print as the artist's effort to introduce "time as a fourth dimension into his pictures." By showing figures from the front, back, and side, and in successive states of dress, he hoped to suggest the temporal element, the fugitive nature of moods.

This print is delicately etched with slightly bitten lines in the central figure, and has deeper, darker crosshatching in the bodies and heads of the other figures. It has the quality of a magnificent pen drawing and again provides evidence of how the graphic arts make it possible for more than one owner to enjoy a masterpiece.

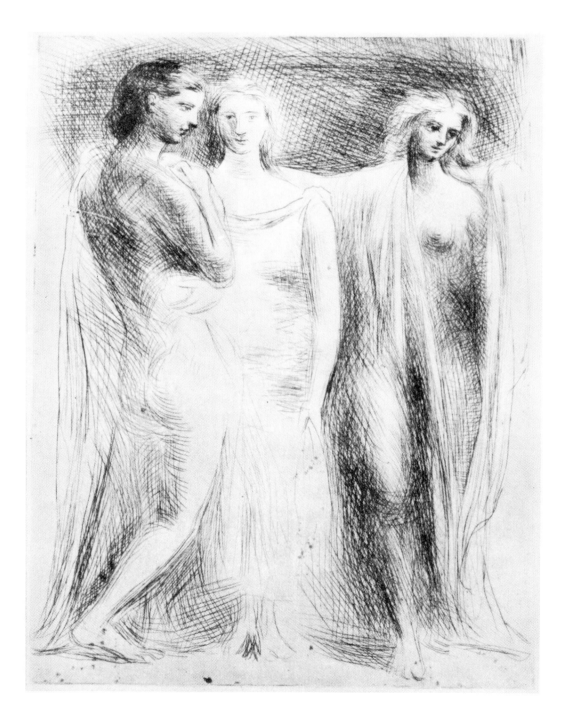

Plate 98

Pablo Picasso. 1881–1973

S A T Y R A N D S L E E P I N G W O M A N

1936. Etching and aquatint, 12½ × 16½"

This superb print was one in a series of one hundred which Picasso was commissioned to execute for Vollard in 1930. These are commonly known as the *Suite Vollard,* and a complete book (*Picasso for Vollard,* 1956) has been dedicated to the illustration and description of them. There are ninety-seven prints in several categories of subject matter—variations on Rembrandt, the Sculptor's Studio, the Minotaur, etc.—and three portraits of Vollard (*plate 99*). The publisher probably had some idea of integrating these into a book or portfolio with accompanying text, but at his death this had not been accomplished.

Picasso, a great lover of the legends and myths of antiquity, often identifies himself with satyrs, the Minotaur, and similar lusty combinations of man and beast.

Satyr and Sleeping Woman is unquestionably one of Picasso's greatest prints. Here we find a complete mastery of the technique of aquatint, where line and tone combine to "paint" the picture. The contrasts of dark and light are dramatic; as the satyr uncovers the sleeping female nude, strong sunshine lights part of her body. Etched lines are combined with the tonal areas, and in the satyr's head the detailed treatment results in a startling representation.

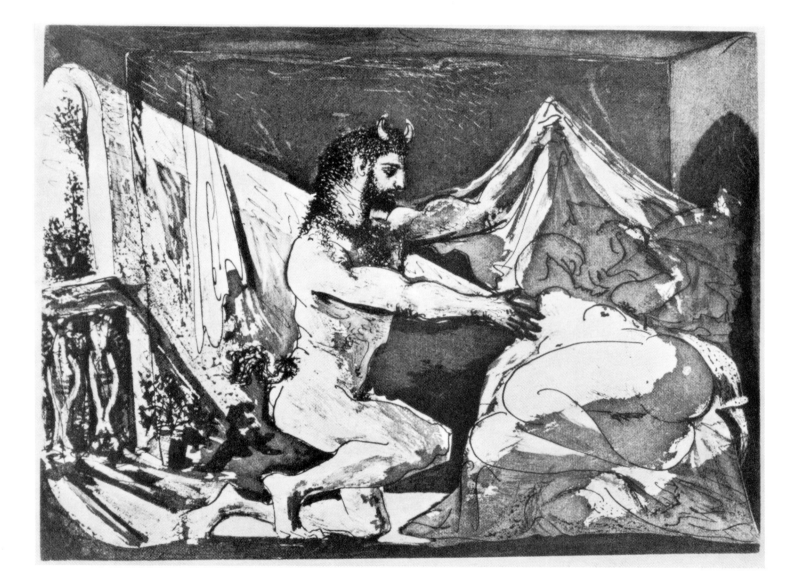

Plate 99

Pablo Picasso. 1881–1973

PORTRAIT OF VOLLARD, I

1937. Aquatint, 13¾×9¾"

Ambroise Vollard surely belongs in the history of French painting together with the artists who formed the schools and created the movements of the late nineteenth and early twentieth centuries.

Dealer-artist relationships have never been simple to arrange or to maintain. But Vollard seems to have had the instinct for selecting talented unknown artists. Maintaining his faith in them, he lived to see most of them acclaimed the world over. He was by no means the only perceptive and courageous art dealer of his day; through his commissions and publications, however, he was the most successful.

To his everlasting credit it must be conceded that he planned and published some of the most beautifully conceived books of our time, and had them illustrated by his artists—Bonnard, Vuillard, Rouault, and many others. In furthering these projects he was energetic and restless. When a rival publisher, the young Albert Skira, induced Picasso to illustrate the *Metamorphoses* of Ovid, Vollard resented the competition and raced Skira to produce Picasso's next works. Vollard's death in 1939 prevented him from accomplishing some of his major projects, but most of them have eventually been completed and issued.

Almost every painter of the period made one or more portraits of Vollard. Picasso did many, and this portrait from the *Suite Vollard* is one of the best. A masterly handling of aquatint yields the finest qualities of a wash drawing. This is primarily a character study, and rarely does Picasso probe so deeply. The reader who wishes to know more about the extraordinary Vollard should read Vollard's own *Recollections of a Picture Dealer*.

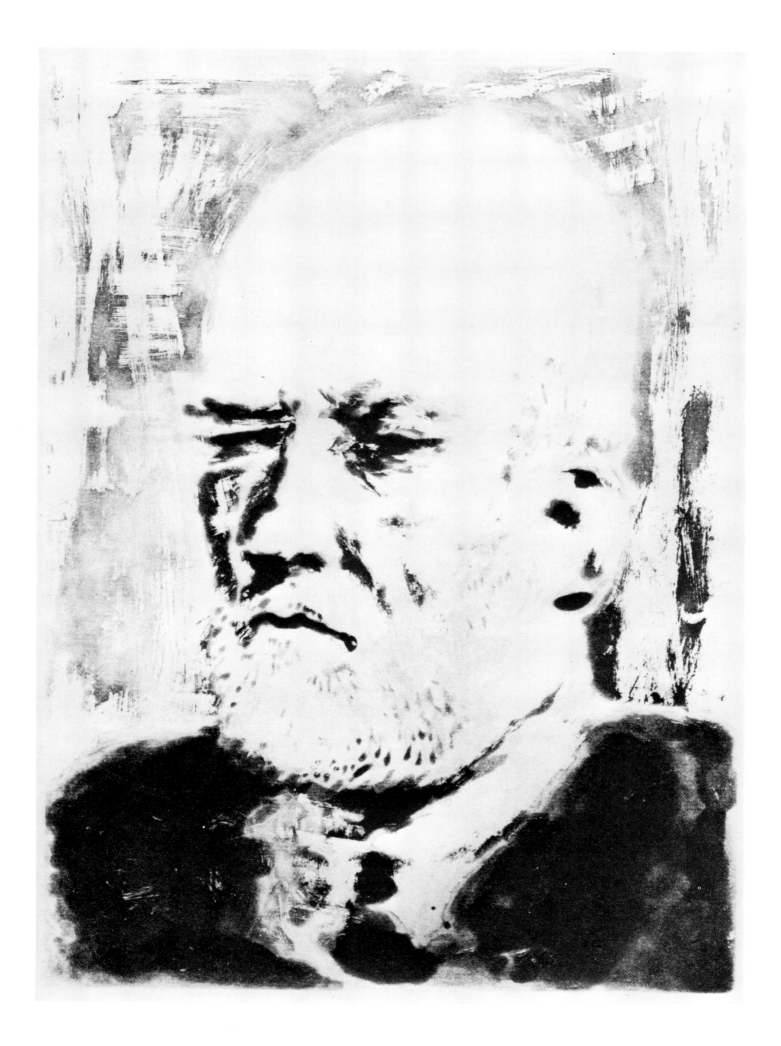

Plate 100

Marc Chagall. Born 1887

At the Easel

1922. Drypoint, 9¾ × 7½″

There is no better introduction to the art of Marc Chagall than the autobiography, *My Life,* that he wrote in Russian during his stay in Moscow in 1921–22. Chagall intended to accompany the text with twenty original etchings and drypoints, but the prints were issued in a separate portfolio that lacks the benefit of Chagall's record of his life up to that time. Years later, translations in various languages appeared, illustrated with reproductions of the original plates and of other works.

Chagall's philosophy and attitudes are clearly stated, often with great humor. Writing about his aunts, he says, "I shan't try to say more than a word or two about my aunts, one of whom had a long nose, a good heart and ten children; the other a shorter nose and half a dozen children, but she loved herself best, I think—why not?"

One of the illustrations, *Grandfather's House,* was inspired by a practice described in the first pages of the book: "It turned out that, because of the fine weather, Grandfather had climbed up on the roof, had sat down on one of the chimney-pipes and was regaling himself with carrots, not a bad picture."

Grandfather is sitting on the roof in many of Chagall's works, for even now the artist still draws on early memories for his subject matter.

Chagall has repeatedly said that he does not believe in the terminology which places him in a school or movement or tries to classify his works. Though he refuses to be named a Surrealist, he nonetheless draws inspiration from dreams. In his book he writes, "My legs hold me upright, but my head is floating off." People, animals, and objects all fly in his paintings, with the law of gravity offering no obstacle. He also explains why he often separates a head from the body: it is really quite simple; he merely "needed an empty space in that particular place."

The drypoint reproduced here is obviously a self-portrait of the artist at his easel.

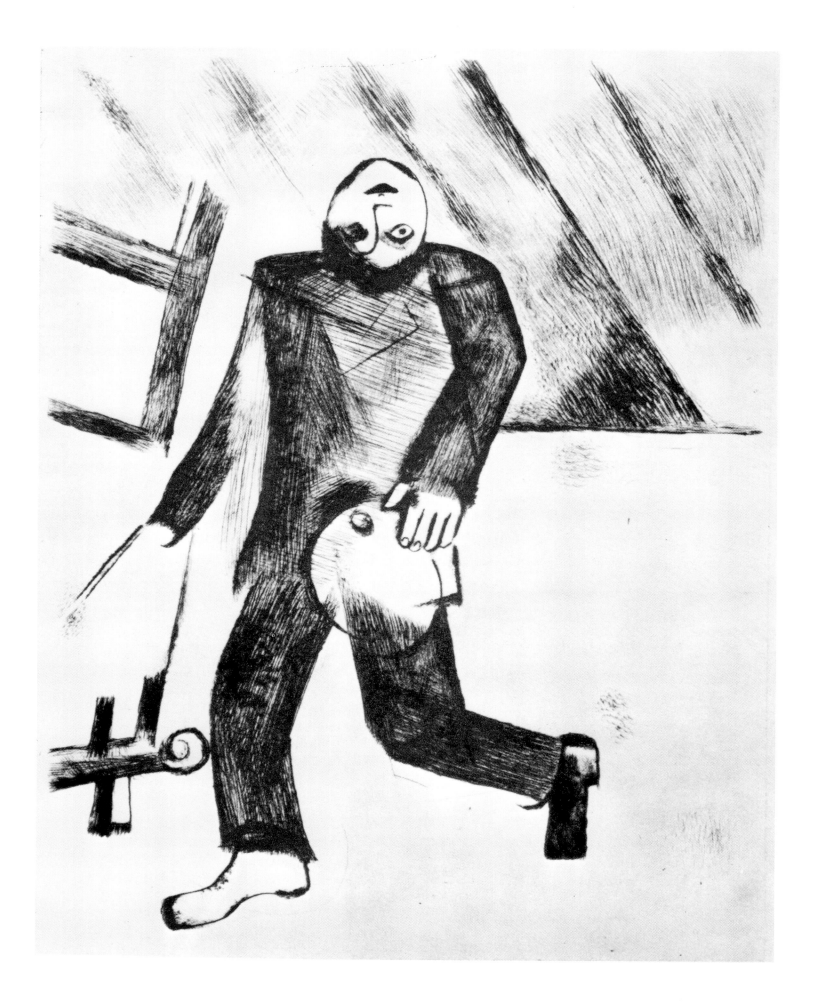

BOOKS FOR FURTHER READING

Below is a list of books for the reader who wishes further information
about prints and printmakers. Some cover, in whole or in part, a history and appreciation of the
print; others are concerned with methods and techniques. All contain splendid
bibliographies which will serve as a guide to the achievements of artists and craftsmen.
(*An asterisk [*] denotes profusely illustrated books.*)

* ADHÉMAR, Jean. *Toulouse-Lautrec: His Complete Lithographs and Drypoints.* Harry N. Abrams, Inc., New York, 1965

BARTSCH, Adam von. *Le Peintre-graveur* (15th to 17th century). 21 vols. Verlagsdruckerei Würzburg G.m.b.H., Würzburg, 1920

BLISS, Douglas Percy. *A History of Wood Engraving.* J.M. Dent & Sons, Ltd., London, and E. P. Dutton & Co., New York, 1928

* BOLLIGER, Hans. *Picasso for Vollard.* Trans. by Norbert Guterman. Harry N. Abrams, Inc., New York, 1956

* BOON, K. G. *Rembrandt: The Complete Etchings.* Harry N. Abrams, Inc., New York, 1963

BUCKLAND-WRIGHT, John. *Etching and Engraving.* Studio Publications, London, 1953

CARRINGTON, Fitz Roy, and Campbell DODGSON (eds.). *The Print Collector's Quarterly.* 30 vols. New York and London, 1911–51

* DELTEIL, Loys. *Manuel de l'amateur d'estampes des XIXe et XXe siècles (1801–1924).* 4 vols. Dorbon-Ainé, Paris, 1925

————. *Le Peintre-graveur illustré (XIXe et XXe siècles).* 31 vols. Published by the author, Paris, 1906–30

* FERRARI, Enrique Lafuente. *Goya: His Complete Etchings, Aquatints, and Lithographs.* Harry N. Abrams, Inc., New York, 1962

* HAMERTON, Philip Gilbert. *Etching and Etchers.* Macmillan & Co., London, 1876

HAYTER, Stanley W. *New Ways of Gravure.* Pantheon Books, Inc., New York, 1949

HELLER, Jules. *Printmaking Today.* Holt, Rinehart and Winston, Inc., New York, 1958

HIND, Arthur M. *History of Engraving and Etching from the 15th Century to the Year 1927.* Dover Publications, Inc., New York, 1963

————. *An Introduction to a History of Woodcut.* 2 vols. Dover Publications, Inc., New York, 1963

HOFER, Philip. *The Artist and the Book.* Harvard University Press, Cambridge, 1961

IVINS, William M., Jr. *How Prints Look.* The Metropolitan Museum of Art, New York, 1943

* KLEIN, H. Arthur (ed.). *Graphic Works of Peter Bruegel the Elder.* Dover Publications, Inc., New York, 1963

* KNAPPE, Karl Adolf. *Dürer: The Complete Engravings, Etchings, and Woodcuts.* Harry N. Abrams, Inc., New York, 1965

* LARAN, Jean. *L'Estampe.* 2 vols. Presses Universitaires de France, Paris, 1959

LUGT, Frits. *Les Marques de collections de dessins et d'estampes.* 2 vols. Nijhoff, The Hague, rev. ed., 1956

McMURTRIE, Douglas C. *The Book: The Story of Printing and Bookmaking.* Oxford University Press, Inc., New York, 1943

* MAYOR, A. Hyatt. *Giovanni Battista Piranesi.* H. Bittner & Co., New York, 1952

MONGAN, Elizabeth, and Carl O. SCHNIEWIND. *The First Century of Printmaking, 1400–1500.* R. R. Donnelley & Sons Co., Chicago, 1941

* PANOFSKY, Erwin. *Albrecht Dürer.* 2 vols. Princeton University Press, Princeton, N.J., 1948

PETERDI, Gabor. *Printmaking.* Macmillan Co., New York, 1959

POLLARD, A. W. *Early Illustrated Books.* K. Paul, Trench, Trübner & Co., London, 1893

* *The Print Connoisseur* (a quarterly magazine for the print collector), New York

* ROGER-MARX, Claude. *French Original Engraving from Manet to the Present Time.* The Hyperion Press, London and New York, 1939

SACHS, Paul J. *Modern Prints and Drawings.* Alfred A. Knopf, Inc., New York, 1954

SHOKLER, Harry. *Artist's Manual for Silk Screen Print Making.* American Artists Group, New York, 1946

STRANGE, E. F. *Japanese Colour Print.* Board of Education, London, 1931

VOLLARD, Ambroise. *Recollections of a Picture Dealer.* Little, Brown, and Co., Boston, 1936

WEITENKAMPF, Frank. *How to Appreciate Prints.* Charles Scribner's Sons, New York, 4th ed., 1942

ZIGROSSER, Carl. *The Book of Fine Prints.* Crown Publishers, Inc., New York, rev. ed., 1956